CODEX BODLEY

Treasures from the Bodleian Library

The Bodleian Library, founded in 1602, is the principal library of the University of Oxford and one of the world's great libraries. Over the past four hundred years, the Library has built up an outstanding collection of manuscripts and rare books which make up part of our common cultural heritage. Each title in this lavishly illustrated series, *Treasures from Bodleian Library,* explores the intellectual and artistic value of a single witness of human achievement, within the covers of one book. Overall, the series aims to promote knowledge and to contribute to our understanding and enjoyment of the Library's collections across a range of disciplines and subjects.

CODEX BODLEY

A Painted Chronicle from the Mixtec Highlands, Mexico

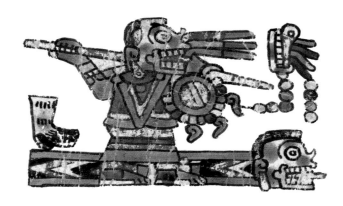

Maarten Jansen and
Gabina Aurora Pérez Jiménez

Treasures from the Bodleian Library, 1

Bodleian Library
UNIVERSITY OF OXFORD

First published in 2005 by The Bodleian Library, Broad Street, Oxford OX1 3BG

ISBN 1-85124-095-0

A study of Oxford, Bodleian Library, MS. Mex. d. 1

Designed by Melanie Gradtke
Printed and bound by The University Press, Cambridge

British Library Cataloguing in Publication Data
A CIP record of this publication is available from the British Library

The Bodleian Library gratefully acknowledges the generosity of the Netherlands Foundation for Scientific Research which made possible the digitization of Codex Bodley through its funding of the Mixtec City States research project.

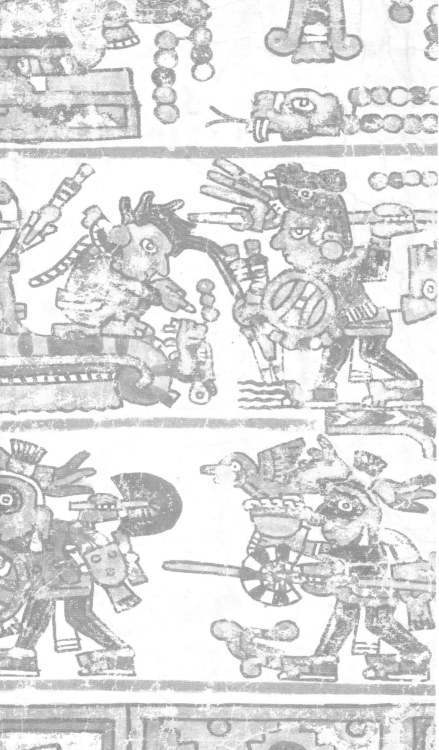

Contents

List of Illustrations .. 7

Preface ... 9

Introduction ... 11
 Rosetta Stones ... 20
 Codex Mendoza ... 20
 The Map of Chiyo Cahnu ... 24

Codex Bodley .. 29
 How to read Book 1 ... 32
 How to read Book 2 ... 34
 The narrative of Codex Bodley ... 36
 The sociopolitical system ... 42
 List of the main identified places in Codex Bodley 44
 The House of Ñuu Tnoo ... 47
 The House of Ndisi Nuu ... 48

Further Reading .. 49

Book One ... 51

Book Two ... 71

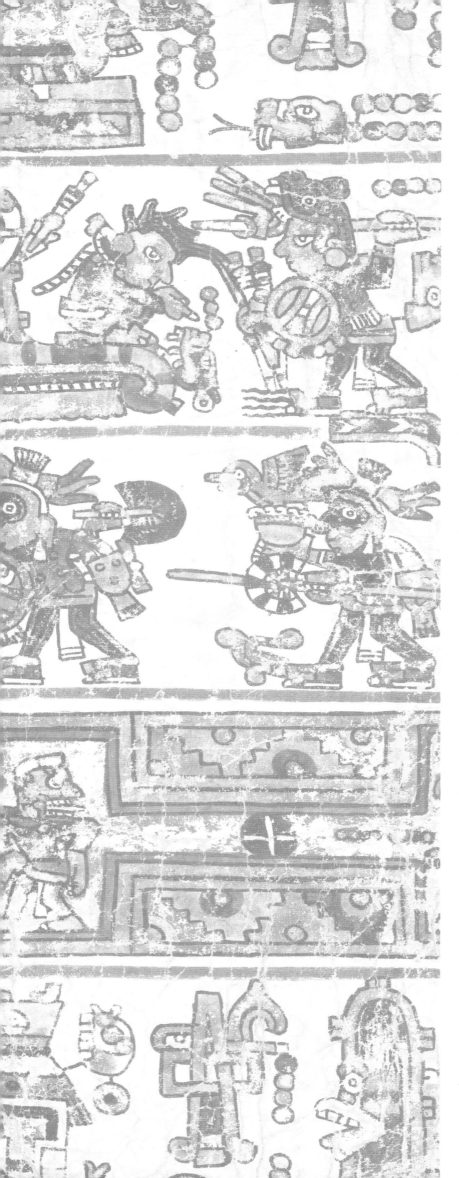

List of Illustrations

Map of Mixteca © Gilda Hernandez Sanchez8

Images of the region © Project Mixtec City-States...................12,13

Codex Laud,
 Bodleian Library, MS. Laud Misc. 678, p.219

Codex Mendoza,
 Bodleian Library, MS. Arch. Selden. A. 1, fols. 43, 61, 63.........21–23

The Map of Chiyo Cahnu © Peter Deunhouwer...........................25

Edward King, viscount Kingsborough, *Antiquities of Mexico,* vol. 1
 (London 1830/1) Mexican Case [vol. 1], Codex Bodley, p. 31 30

1605 Catalogue,
 Bodleian Library, Antiq. e.E. 1605.2, pp. 348–931

Codex Selden,
 Bodleian Library, MS. Arch. Selden. A. 2, p. 6.........................39

Codex Nuttall,
 London, British Museum, Dept. of Africa,
 Oceania and the Americas, Add. MS. 39671, pp. 44, 81
 © The Trustees of The British Museum37, 40

Tracing of Codex Columbino © Cees Nieuwland41

Mexico City

Gulf of Mexico

Cholula

PUEBLA

Tepeji

Río Nejapa

1 Mogote del Cacique
2 San Miguel Adeques
3 Sachio
4 Nochixtlan
5 Andua
6 Suchixtlan
7 Yucuita
8 Yanhuitlan

Mixtec
Lowlands

Cuyotepeji

GUERRERO

Tuctla Apoala

Tonala

Tezoatlan 8 7 San Pedro Cántaros

6 2 Huauclilla
5 4 3 Sosola

Achiutla

1 Huitzo
Tlaxiaco Tilantongo Jaltepec Etla Valley of Oaxaca

Mitlatongo

Chalcatongo Teita

Yujia Teozacoalco Monte Albán 17°

Zaachila
Mixtec
Highlands
OAXACA

Juquila

Tututepec
Pacific Coast

⎬ Present-day state border

⋮ Geographic region Pacific Ocean

0 50 100 km

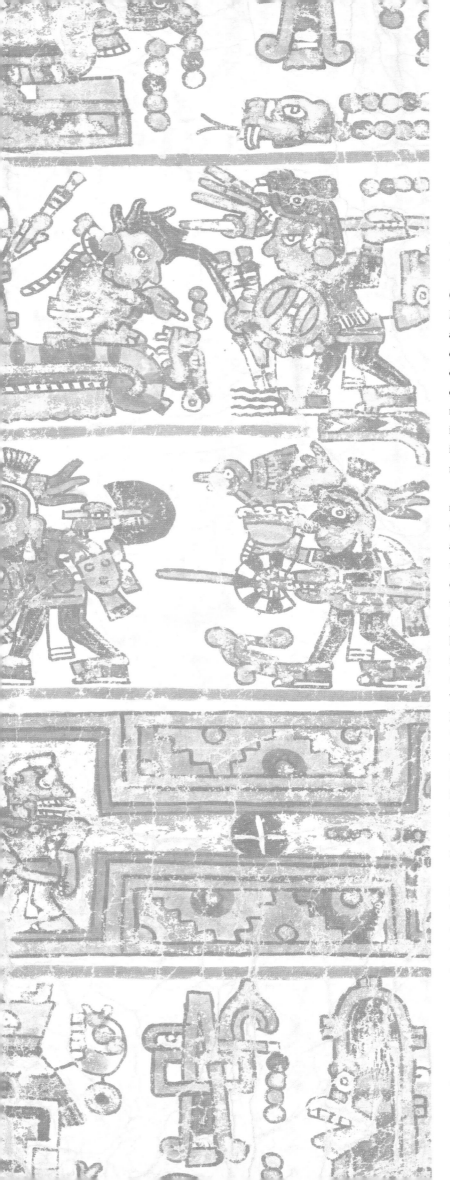

Preface

Codex Bodley is a screenfold pictorial manuscript, painted in Southern Mexico shortly before the Spanish conquest (1521 AD). It is a magnificent and fascinating example of ancient Mexican pictorial writing, and contains the history of the kings and queens who ruled the city-states, or rather village-states, of Ñuu Dzaui: the Mixtec people from the tenth century to the early sixteenth century. Here we present a full-colour reproduction of the original, which is preserved in the Bodleian Library in Oxford (MS. Mex. d. 1). The introduction situates the manuscript in its historical and cultural context and explains how to read it. A commentary (pp. 53–96) provides a translation of the pictorial scenes.

Our text forms part of a larger project, in which we try to reconnect this and other related manuscripts to the culture that created them. Over the years, numerous people in the Ñuu Dzaui region have inspired and oriented us with their expertise and hospitality, and in particular with their knowledge of the native language ancient traditions, local geography, and religious world-view. We especially honour the memory of the late Doña Crescencia Jiménez Quiroz and the late healer (curandera) María Jiménez Quiroz, who have shaped our understanding. Similarly we have had received many fruitful comments from students and colleagues in different countries. The late Wigberto Jiménez Moreno, Luis Reyes García, and Mary Elizabeth Smith, as well as Ferdinand Anders, Nancy Troike, Ronald Spores, and Kevin Terraciano are among those who have contributed to our analysis of the manuscripts and their history. We have been privileged to be able to carry out this long-term study of the history and culture of Ñuu Dzaui at the Faculty of Archaeology of Leiden University, with the support of the Netherlands Organization for Scientific Research (NWO). Peter Deunhouwer made the drawing of the Map of Chiyo Cahnu (Teozacualco), while Laura van Broekhoven, Alex Geurds, and Gilda Hernández Sánchez assisted us in fieldwork and research.

Dr Samuel Fanous, at the Bodleian Library, has been the inspiring and stimulating force behind this project to publish Codex Bodley. The professional team that prepared this edition also included Melanie Gradtke and Emily Jolliffe. We also thank Dr Bruce Barker-Benfield, at the Bodleian Library, for permitting us to study the original manuscript and for clarifying several aspects of its history.

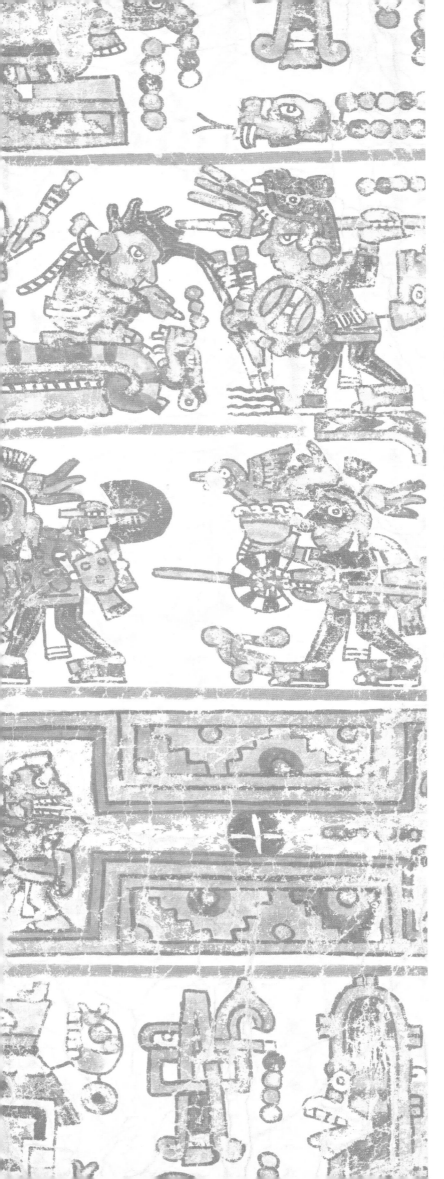

Introduction

The books of ancient Mexico

Middle America, also known as Mesoamerica, is home to one of the great original civilizations of the world, created and cultivated by scores of interacting peoples, of which the Aztecs and Mayas are the most famous. An important part of its cultural achievement was the invention of different writing systems. On carved stones and in painted books, these Native American societies registered their historical experiences and religious ideas, sometimes in hieroglyphs, i.e. phonetic writing, as developed by the Maya, sometimes in a sophisticated system of figurative painting, pictography, as employed by the Mixtecs and Aztecs. The latter is the topic of this introduction. Far from being an 'incipient' or 'primitive' form of writing, pictography had a long tradition in Middle America: we already encounter it on the frescos of the ruined palaces of Teotihuacan. This huge archaeological site in Central Mexico is today a major tourist attraction, but once was a centre of civilization, a metropolis, which flourished between ± 200 and 600 AD. Here a sophisticated system of pictorial conventions and specific signs developed, which enabled speakers of distinct languages to communicate with each other. This was an advantage as the Teotihuacan realm or sphere of influence was a multiethnic one. Pictography was not only capable of transcending linguistic boundaries, but also could adapt better to the technical needs of registering those languages than a purely phonetic system (such as syllabic or alphabetic writing). Most of the peoples in the areas where pictography was developed spoke—and still speak—tonal languages, i.e. languages in which words pronounced with different tones have markedly different meanings: Chinese is such a language. A phonetic writing system would have had to invent special notations to distinguish the tones. The situation becomes even more complicated as the sentence melody intervenes in the tonal patterns: in specific cases the tones of a word may change the tones of the following word, thereby making a consistent phonetic register quite difficult. The use of pictorial signs was a relatively easy solution. This pictographic system developed over the centuries and reached a high level of perfection. More than a thousand years after the signs and conventions appear in Teotihuacan, the Aztecs, and other peoples in Central and Southern Mexico used this system in paintings, carvings, and other forms of visual art, but particularly in pictorial manuscripts. There were fundamentally two types of these:

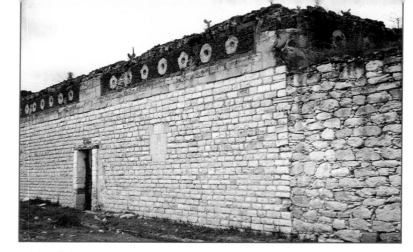

Palace of the Cacica in Yucu Ndaa (Tepozcolula).

1) True books (generally referred to as codices), consist of segments of either bark paper or deerskin, glued together to form screenfold strips, and are covered with a thin layer of chalk on which colourful figurative scenes were painted.

2) Large pieces of cotton cloth (called *lienzos* in Spanish), also painted with the same figures and signs.

In 1521 the Spanish conquerors under Hernán Cortés took over the Aztec empire and, soon afterwards, the whole of Middle America. Most of the native texts were destroyed then. The books dealing with religion were considered 'works of the devil' and burned by the missionaries, while those with a more secular content rapidly lost their relevance in the new sociopolitical environment and fell into oblivion, leaving the descendants of the original population as 'peoples without history'. The knowledge of how to read pictography was lost, as was the aesthetic appreciation for its art. The highly stylized character of the signs, and the unexpected combinations provoked by linguistic expressions, seemed 'barbarian' in the eyes of the vast majority of colonial beholders. It was not until the twentieth century, with its open eye for visual communication, notably in film and television, and its in-depth analysis of sign systems, that scholars rediscovered the special possibilities and values of this way of registering thought and communicating information.

Once there must have been thousands of manuscripts in circulation, but today less than twenty precolonial books survive, presumably all from the early sixteenth century. Their number is augmented by a few hundred documents painted in the old tradition during the early colonial period. These later works often include alphabetic texts in Spanish or Native American languages as notes or comments explaining the meaning of the pictorial scenes, thereby becoming an extremely valuable tool for interpretative studies.

The corpus as a whole, now dispersed among different libraries in Mexico, the USA, and Europe, constitutes a precious literary heritage that offers unique insights into Native American antiquity. The originals are extremely delicate, the materials being affected by the tooth of time. Direct light may affect the colours, while changes in temperature or humidity can contribute to the degradation of the organic material. The codices are 'portable frescos'. Thinking of the endangered condition of medieval frescos on stable walls, one may imagine how fragile these paintings on flexible surfaces are. Turning the pages one may destabilize the thin layer of chalk and cause irreparable damage. With good reason, most libraries take extreme care in handling these unique objects and are reluctant to bring them out in the open for consultations or expositions.

The Bodleian Library in Oxford is a major depository of ancient Mexican manuscripts outside of Mexico, conserving no less than five of these treasures, all of the highest quality and importance: Codex Bodley, Codex Selden, the Selden Roll, Codex Laud, and Codex Mendoza. Here we present a full photographic reproduction and a complete reading of the Codex Bodley, one of the most comprehensive and impressive examples of pictorial historiography, both an artistic masterpiece and an indispensable key to understanding precolonial politics and ideology.

Ñuu Dzaui, People of the Rain

Codex Bodley forms part of a small, coherent group of manuscripts produced by a specific indigenous people in Southern Mexico: 'the People of the Rain God', Ñuu Dzaui (today also pronounced Ñuu Savi, Ñuu Sau, or Ñuu Davi, according to dialect variability). They are also known as Mixtecs, according to the name given to them by the Aztecs in their own language (Nahuatl): *mixtecâ,* which means 'inhabitants of the land of the clouds'. Today more than 450,000 people still speak the Mixtec language, Dzaha Dzaui (Sahan Savi, Sahin Sau, Daha Davi). Their ancestral

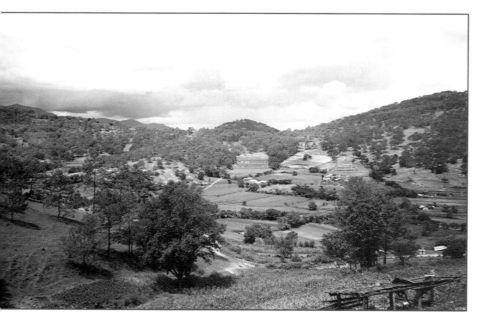

The Mixtec Highlands.

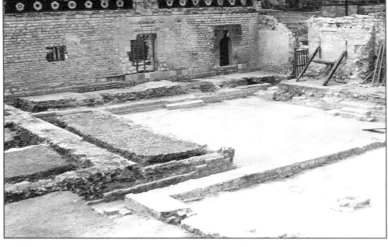

Courtyard of the Cacica's palace in Yucu Ndaa.

territory is also called Ñuu Dzaui, 'Land of the Rain God', but generally referred to in Spanish as 'la Mixteca'. It is situated in Southern Mexico, in the Western part of the state of Oaxaca and the adjacent states of Puebla and Guerrero. Generally it is subdivided into three ecological zones:

1) The Highlands (Mixteca Alta), the northern and central part of the region (in the state of Oaxaca), a mountainous area more than 2,000 metres above sea level, where high cliffs, covered with pine forests, surround slopes and small valleys that are intensively used for agriculture (maize fields). Very important is the centrally located large valley of Nochixtlan-Yanhuitlan.

2) The Lowlands (Mixteca Baja), situated to the west, in Oaxaca and the neighbouring states of Puebla and Guerrero, a somewhat lower mountainous area, generally under 2,000 metres above sea level, which is hot and eroded.

3) The Coastal Region (Mixteca de la Costa), the humid tropical lowlands along the Pacific Coast of the states of Oaxaca and Guerrero.

The civilization that flourished in Ñuu Dzaui before the Spanish conquest was similar to that of its northern neighbours, the famous Aztecs (now Nahuas). In fact the Aztecs had conquered part of the Mixtec land and incorporated it into their empire shortly before they in turn were defeated and colonized by the Spanish under Hernán Cortés. In those days the Ñuu Dzaui artisans were famous for their beautiful goldwork, fine jewellery, turquoise mosaics, and brightly painted pottery, as well as for their pictorial manuscripts. Throughout the region numerous archaeological sites—mostly unexplored temple pyramids, plazas and ballcourts—bear witness to this past splendour. The colonization brought many cultural changes. On top of the ancient sanctuaries, the Dominican missionaries built several huge convents, now in a ruinous state but still very impressive monuments. They developed a way to write the Mixtec language, Dzaha Dzaui, with the Latin alphabet: Friar Antonio de los Reyes produced a detailed grammar and Friar Francisco de Alvarado compiled a voluminous dictionary—both works were published in Mexico in 1593. Mexican archives contain numerous documents written this way in Dzaha Dzaui during the colonial period.

Many elements of the ancient technology, knowledge, and religious world-view still survive as oral traditions in an impressive landscape. Although rapidly retreating before an industrialized, monetary economy, in many parts the traditional trade and exchange have not disappeared completely. Traditional craft production in the region is still alive (e.g.

ceramics, basketry, weaving, embroidery), as are the phases and manners of working the land in the different seasons, the concepts of land possession and inheritance, and those used in the construction of communal life, kinship, rituals, mutual assistance, etc. Ancient deities have fused with Catholic saints and divine advocations. For example Jesus Christ and God the Father correspond to Lord Corn *(Iya Nuni)* and Lord Sun *(Iya Ndicandii),* respectively. Several precolonial rituals and ideas have been accommodated in Christian liturgy. The 'axis' of the religious year, for example, is not determined by Christmas and Easter, but lies between the Days of the Dead (1–2 November)—a remnant of the precolonial ancestor cult—and the Day of the Holy Cross (3 May), which is a feast for Lord Rain *(Iya Dzaui),* celebrated in specific caves, the 'Houses of the Rain'. Clearly this continuing cultural tradition is a vital asset for understanding the ancient art and writing.

The overall picture of the consequences of colonialism is, however, a bleak and depressing one. Artistic creativity waned, as did the economy, victim to economic exploitation coupled with general discriminatory attitudes. Today Dzaha Dzaui is not formally taught in schools and is in the process of being replaced by the national language, Spanish. The cultural heritage, both material and spiritual, is rapidly eroding, giving way to advancing modernization and globalization. The traditional cultivation of corn, squashes, and beans in the mountainous area is insufficient.

Market in a Mixtec village.

Poverty, malnutrition, and violent conflicts, together with a lack of work and opportunities, have resulted in vast numbers of people emigrating to the large cities, the Northern Mexican states, and the USA. In this situation of crisis and diaspora, historical studies acquire an educational and emancipatory dimension, as the knowledge of roots and cultural values fosters identity and a sense of direction.

The Ñuu Dzaui manuscripts

Before the Spanish conquest, the Mixtec region was divided into a series of city- or rather village-states. These were politically independent units: each was ruled by a specific noble house or dynasty. This type of polity was known in Middle American languages as 'mat and throne' (*yuvui tayu* in Dzaha Dzaui). In colonial times these feudal entities were referred to in Spanish as *cacicazgos,* a term taken from the native term for 'chief' or 'ruler', *cacique,* in the Caribbean. Simultaneously they were recognized as 'republics of Indians'. In Ñuu Dzaui's precolonial landscape of sovereign communities, the most influential was Ñuu Tnoo, 'Black Town', better known by its Aztec name Tilantongo. This town is strategically situated in the mountains on the southern border of the large valley of Nochixtlan and Yanhuitlan. Behind it rises the impressive Yucu Tnoo or Monte Negro, 'Black Mountain', on top of which a very ancient ceremonial centre is located, which dates from before the beginning of our era.

As the community gathered in the main plaza between the temple-pyramids, dedicated to the Patron Deities and the Divine Ancestors, specially trained artists of oral literature brought out the pictorial manuscripts, using them as the point of departure for the declamation and dramatic performance of the ancient stories during public events or rituals. The 'flowery language' of those occasions survives today in prayers and formal discourses: it includes the use of parallelisms (hendiadys), metaphors, and respectful references to the sacred powers of the universe.

The surviving codices tend now to bear the names of libraries, collectors, scholars, or other personages who had something to do with them. The resulting designations are alien to the region and culture that produced these documents, and quite enigmatic to the modern Mixtecs. We therefore propose a new nomenclature, more appropriate in view of the contents and provenance of these important manuscripts. Codex Bodley itself receives the designation Codex Ñuu Tnoo – Ndisi Nuu, as it mainly deals with the ancient history of these two communities. The

other important pictorial books from Ñuu Dzaui in an entirely precolonial style are the following:

- Codex Vindobonensis Mexicanus 1 contains two distinct pictorial texts, one on the obverse (52 pages), which tells how the founders of the Ñuu Dzaui noble houses were born from a huge Mother-Tree in the sacred valley of Yuta Tnoho (Apoala), and another on the reverse, dealing with the dynasty of Ñuu Tnoo. The codex is preserved in the Austrian National Library in Vienna (Latin: *Vindobona*), but probably comes from Ñuu Tnoo. Because of the dominant theme of its contents, an appropriate name would be: Codex Yuta Tnoho.
- Codex Zouche-Nuttall, now in the British Museum, London, comes originally from Chiyo Cahnu (Teozacualco). It contains different genealogies of rulers and a large part of the biography of one specific hero of Ñuu Tnoo (Lord 8 Deer 'Jaguar Claw'). We propose to call it Codex Tonindeye after the Dzaha Dzaui term for 'lineage history'.
- Codex Selden, originally from Añute (Jaltepec) in the Mixtec Highlands, is now preserved in the Bodleian Library in Oxford (MS. Arch. Selden. A. 2). It tells the genealogical history of the rulers of Añute. Because of its provenance and contents it might be referred to as Codex Añute.
- Codex Colombino-Becker comes originally from Yucu Dzaa (Tututepec) in the Mixtec coastal region. One fragment (Colombino) is in the Biblioteca Nacional de Antropología in Mexico City, and the other (Becker I) in the Museum of Ethnology in Vienna. After the Dzaha Dzaui name of the main hero of its story (Lord 8 Deer 'Jaguar Claw') we call it Codex Iya Nacuaa (distinguishing the Colombino and Becker fragments with the numerals I and II respectively).

These are the main codices of Ñuu Dzaui, five in total. Their information is complemented by several minor manuscripts from the early colonial period, by Dominican chroniclers such as Friar Gregorio García and Friar Francisco de Burgoa, by descriptions and reports of the Spanish administration (the *Relaciones Geográficas*), as well as by a wealth of archival documents. Together these sources provide a detailed picture of the history of the Mixtec Highlands in the six centuries before the Spanish Conquest.

Pictorial conventions

In registering the history of interacting village-states in the Mixtec Highlands, the different codices follow the same pictographic system. They

present their narratives in the form of sequences of scenes ordered in a linear format. The pages are generally subdivided by red 'guidelines', which leave an opening at one side for the reading to continue. This creates a sequence of horizontal bands or vertical columns to be read in an alternating pattern known as 'boustrophedon', i.e. from the Greek: 'as the ox ploughs'. A horizontal band that reads from left to right continues in a higher or lower band that is read from right to left, and so on, while in other manuscripts a vertical column that is read from the top downwards is followed by one that is read from the bottom up, and so forth. Each document has its specific reading order. In some cases the pages have been numbered the wrong way, at a time when this form of writing was inadequately understood. Generally the pages and the bands or columns are differentiated by using Arabic and Roman numerals. In the case of Codex Bodley, the pages on the obverse side are numbered in the correct order, 1–20, but those on the reverse side run backwards, 40–21, while the horizontal bands are indicated with Roman numerals from the top down: i–v.

The large pieces of cloth *(lienzos),* on the other hand, have a very different composition: clusters of information are distributed over the surface, without a specific linear sequence. Sometimes footsteps or lines connect the scenes, but the overall picture is one of simultaneous presentation of events and persons in space. Genealogies of rulers may be listed as a 'column of married couples' (to be read from the bottom upwards) next to the sign of their village-state. The linearity of the codices lends itself very well to stories that follow a chronological sequence, while *lienzos* are particularly suited for representing geographical information and often contain maps.

The texts were painted on the instruction of rulers and priests, and contained the sacred, epic, and genealogical history of noble houses that ruled the village-states. Their specific political aim was to insist on the moral implications of this history, to identify the intricate family relationships between the dynasties of the different polities, and to establish the rights to tribute as well as to succession and inheritance.

The real protagonists of the story are the communities themselves: they are always mentioned in the beginning, with a specific sacred date of origin. The rulers are seen as temporary authorities and emblems, moving through time, while the place remains constant. Rulers are represented as seated on the place-sign, their 'mat and throne'. They were addressed as 'lord' *(iya)* or 'lady' *(iyadzehe),* titles which they shared with the deities and which have a connotation of sacredness. As authori-

ties they were considered the 'father and mother' of the community. All individuals are identified by two types of names. First by the 'calendar name', which was their day of birth. The precolonial calendars of Middle America consisted of a sacred cycle of 260 days, formed by the combination of twenty signs, in a fixed sequence, with numbers from 1 to 13. To this 'calendar name' a more poetic 'given name' was added. So we encounter names such as Lord 8 Deer 'Jaguar Claw' (Iya Nacuaa *'Teyusi Ñaña'*) or Lady 10 Flower 'Spiderweb of the Rain God' (Iyadzehe Sihuaco *'Dzinduhua Dzaui'*). This 'given name' often appears as a separate sign close to or on top of the person's head.

The female given names refer usually to flowers, jewels, jade, delicate cobwebs, and other beautiful aspects of nature. A special case is that of the woman's upper garment, which is used as a basic element for female names. It may represent just that, a garment as a metonym for 'lady', but we suspect it should be read in a phonetic way. In Aztec pictorials it has a characteristic triangular shape, and in Nahuatl it is called *quechquemitl.* Actually in Ñuu Dzaui codices this poncho-like garment often seems to be an upper dress combined with a skirt. The Dzaha Dzaui term was *dzico.* This word does not only designate that type of dress, but also the concepts of nobility, beauty, honour, bravery, fame, virtue, and authority. So combinations like 'Star Garment' or 'Jade Garment' may actually have been read as references to the beauty of stars and jewels respectively, while 'Jaguar Garment' may be understood as 'Brave as a Jaguar' and 'Blood Garment', and as 'of Noble Blood', etc. The combination of the poncho-like garment with a plumed serpent may be read as *'Dzico Coo Yodzo'* or *'Dzico Coo Ndodzo',* 'Virtue of the Plumed Serpent'. This was the given name of the most important female protagonist of Ñuu Dzaui history, Lady 6 Monkey (Iyadzehe Ñuñuu), princess of Añute (Jaltepec). When the concept of 'fame', 'nobility' or 'virtue' *(dzico)* occurs in the name of a man, it is represented by the tunic (*xicolli* in Nahuatl), which is also called dzico in Dzaha Dzaui.

Another female name-sign contains the drawing of a skirt. We find, for example, a lady named 'Skirt of Rain'. The position of the determining sign on the skirt suggests that, more precisely, the border or fringe of the skirt is the main element. That part of the garment is called *huatu* in Dzaha Dzaui, a homonym of a term that means 'nice', 'happy', 'content', and 'grace'. Thus 'Skirt of Rain' may be understood as 'Pleasant Rain' and even as 'Grace of Ñuu Dzaui'. The same word may be depicted as a woman's braids (also *huatu* in Dzaha Dzaui). Clearly the skirt *huatu* and the upper garment or tunic dzico represent parallel concepts.

The given names of the lords often include animals that function as symbols of strength and courage, such as jaguars and eagles, but also divine powers such as sun and rain. Underlying such representations is the idea that each individual has an 'animal companion'. In their dreams humans may experience taking another identity and becoming one or more animals or other beings, such as whirlwinds or lightning, a phenomenon called 'alter ego' in the scholarly literature and referred to as 'nahual' by the Middle American peoples themselves.

The concept is still very much alive in present-day communities. There is a strong bond between the individual and his or her *nahual*. When the animal or being is hurt, the human also suffers or dies. Several given names express the power of such a *nahual*. A very powerful, vampire-like *nahual* is the *yahui,* a ball of lightning which flies through the air and is able to perforate rocks. It is painted as a 'fire serpent', i.e. a red serpent with an upturned snout, a tortoise shell covering its body, and a tail of pointed scales.

The names of ladies and lords alike may contain references to places that were of specific significance to them. The beloved land of origin itself appears in names such as 'Fan of Ñuu Dzaui', or 'Jaguar of Ñuu Dzaui'. In the dynasty of Ndisi Nuu (Tlaxiaco) we find given names like 'Sharp-Eyed Jaguar' *(Cuiñe Ndisi Nuu),* and 'Sharp-Eyed Eagle' *(Yaha Ndisi Nuu),* which also may be understood as 'Jaguar of Ndisi Nuu', 'Eagle of Ndisi Nuu'. The expression 'burned eyes' *(sahmi nuu)* refers to the speakers of the Nahuatl language—i.e. successively the Toltecs and the Aztecs: it is represented as black paint around the eyes or as a combination of flames *(sahmi)* with an eye or a forehead (nuu). Names such as 'Jaguar of the Burned Eye' *(Cuiñe Sahmi Nuu)* are probably to be understood as triumphant names similar to Germanicus, Brittanicus, or Gothicus among the Romans, and may refer to battles with the people in question.

Early colonial sources describe these lords and ladies of the Ñuu Dzaui noble houses as elegant in appearance. They dressed in white cotton clothes embroidered with colourful motifs, such as flowers and birds. They wore sandals and used jewellery such as rings, necklaces, bands around wrists and ankles, and nose-, ear- and lip-plugs of gold, crystal, and precious stones. Indeed such jewellery is used in the codices to make explicit their high status: yellow metal is, of course, gold, while blue and green represent turquoise and jade, generally with a rim of small white squares indicating their brilliance. In addition the nobles used feather ornaments, preferably made of the long green feathers of the quetzal bird. Most of these precious materials were imported through long-distance trade. The rulers lived in palaces; these were furnished with woven reed mats and cushions of jaguar and puma hides, and surrounded by beautiful gardens. A roof decorated with stone mosaics, especially a frieze with discs or circles, distinguishes the palace both in pictorial representations and in reality—a beautiful example of such a building is the Casa de la Cacica in Yucu Ndaa (Tepozcolula). It is both an iconic representation of the rulers' homes and a symbolic representation of their lineage.

Theirs was a complex society of warlords, warriors, merchants, ambassadors, counsellors, priests, teachers, healers and, of course, peasants. The latter group served the nobles with tributes, working special lands, weaving cloth, serving in the palace, bringing wood and water, etc. Between the tributary farmers and the central authority, there was an important intermediate group of lower nobility. The ruler used to consult them on major decisions.

The dynastic historiography kept track of the genealogical sequence and of the family relationships and marital alliances of the rulers. Monogamy was the dominant rule, although there were a few cases in which a king married more than one wife. The inheritance was split among the children. Consequently marriages among close relatives occurred with the aim of reuniting the goods, privileges, land rights, and tributes that had belonged to earlier generations. Such strong political and economic motivations dictated that there were no forbidden grades of affinity, so we find marriages between uncle and niece and even between brother and sister.

From the codices it becomes quite clear that native historiography defined as its subject the royal couple: man and woman were equally important in the lineage and in creating legitimate offspring. The genealogical record follows most often (though not exclusively) the male line of descent, which remained in the town and carried on the lineage in a sequential, vertical sense. At the same time, the women were the ones who married outside and so established a wide-ranging (horizontal) web of marital alliances.

These historical persons are presented by means of stylized drawings, largely in profile. Gender is expressed in the clothing and hairstyle: men wear a loincloth, sometimes a tunic, and generally their hair is cut short, while women wear long skirts in combination with poncho-like upper garments. Their hair is braided. Marriage is indicated by a couple, consisting of a man and a woman facing each other, seated on a mat, in a house, or on top of a place-sign. The figures that follow are the children.

Footsteps or umbilical cords may emphasize that they are born and descend from the married couple. Usually the inheriting child is shown first, on his or her own, followed by brothers and sisters with their marriage partners. Then the first child is repeated, now with his or her own marriage partner, generally followed by the names of the parents of that partner in an abbreviated form.

Actions of war and the priesthood are easily identified by the use of weapons (shield, spear, spear thrower, bow and arrow) or ritual implements (incense burners, tobacco powder). A special ideogram for 'war' is a chevron band (*yecu*, 'warpath'), often combined with wavy lines (*tnañu*, 'battle').

Like the Aztecs, the Ñuu Dzaui venerated a large number of deities, such as Lord Sun, Lord Rain, the Plumed Serpent, the Grandmother of the Steambath, the Death God, and many other spirits of nature. The divine power as an abstract quality was symbolized—or rather concentrated—in some sacred objects or relics, wrapped in woven cloth, tied with a knot. Its spiritual essence was painted as a small, stone-like being (or animated stone), generally coloured red, which was the sign for *Ñuhu,* 'Deity'. Such a Sacred Bundle was considered 'the heart of the community' and played an essential part in rituals such as accession to the throne. On such occasions the priest and the (future) rulers had to fast and perform blood-letting rites (or 'self-sacrifice'), perforating their ears and tongues wih pointed bones or maguey spines. Enemy leaders, taken captive in war, were ceremonially executed by cutting out their hearts and offering them to the gods. Thus human sacrifice was an integral part of military conflicts, but certainly not so omnipresent and permanent as claimed by the Spanish, who tried to justify their own conquest by portraying the native peoples as bloodthirsty barbarians.

Counting time

The main ordering principle in pictorial manuscripts is the Middle American calendar. As we already noted, the first name of each individual was the day on which they were born. The basic unit of the ancient calendar was a standard sequence of twenty day signs. The vigesimal system (counting in units of 20) is characteristic of the different Mesoamerican languages and comes from the corporal device of counting with fingers and toes. The following list gives the signs and their depictions, their place in the sequence being indicated by a roman numeral:

I Alligator: *a profile view of an alligator head, with its characteristic jaw and row of sharp teeth.*

II Wind: *the beaked head of the Wind God.*

III House: *a profile representation of a house, with a flat or a thatched roof.*

IV Lizard: *the full-figure representation, or the head of a lizard only.*

V Serpent: *the full-figure representation, or the head of a snake only.*

VI Death: *a skull.*

VII Deer: *the head of the deer, often but not always with antlers; generally the teeth in the lower jaw are shown.*

VIII Rabbit: *the head (often with teeth in the upper jaw) or the full figure of a rabbit.*

IX Water: *a cut-through profile of a container with blue liquid, often with foam or brilliant disks on the surface.*

X Dog: *the head of a dog, with a characteristically cut (bitten) ear.*

XI Monkey: *the head of the animal.*

XII Grass: *the lower jaw of a human skull in combination with green leaves (or feathers) and sometimes with an eye.*

XIII Reed: *a bamboo reed, often taking the shape of an arrow, decorated with small feathers.*

XIV Jaguar: *the head of the animal in profile, with its characteristic pointed ear.*

XV Eagle: *the head of the bird in profile, with white and black feathers falling back behind it.*

XVI Vulture: *the bald head of this bird, often decorated with an earring.*

XVII Movement: *an ideogram in the form of an X, also used for 'orbit' and 'earthquake'.*

XVIII Flint: *a pointed flint knife in red and white.*

XIX Rain: *the mask of the Rain God, with jade rings around the eyes and large teeth.*

XX Flower: *the profile of a stylized yellow flower.*

The day signs are mostly derived from nature. The first, Alligator, is a metaphor for the earth itself. The only sign that refers to a human artefact is House, but that seems to be a later introduction: its earlier form was Owl.

These twenty signs are combined with numbers from 1 to 13. The combination of number (1–13) and sign (I–XX) results in a basic cycle of 260 days (13 x 20). The first day is 1 Alligator (1 I), then follows 2 Wind (2 II), 3 House (3 III), etc. until 13 Reed (13 XIII), which ends the first thirteen-day period. The next thirteen-day period starts with 1 Jaguar (1 XIV) and continues to 13 Death (13 VI), and so on, until the twentieth period of thirteen days, which brings us to the last day of the count: 13 Flower (13 XX).

The origin of the 260-day count is probably related to divinatory purposes. Traditional day-keepers, interviewed in recent times, have explained that the 260 days represent the period of human pregnancy. In it, the basic sequence of 20 signs is repeated 13 times. This produces an ideal symbolic equivalence between the moment of conception and the moment of birth. The number 20 is diagnostic for the human being (ten fingers and ten toes). The fact that this unit of 20 (the human being) has

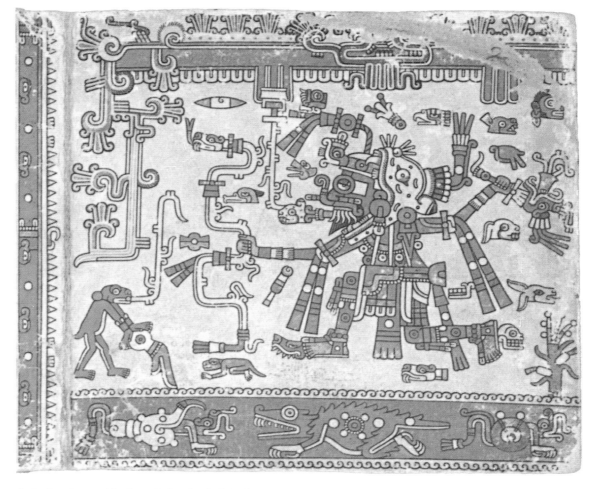

Codex Laud, p. 23: The Rain God as Lord of the Days.

to be counted (in pregnancy) 13 times before the conceived child is born qualifies 13 as a number of completeness. This becomes the point of departure for more symbolic associations. By using the axes produced by the sun's movement, the earth's plane is divided into four parts with a centre (yielding 4 + 1 = 5). The same quadripartite division is applied to the Underworld, resulting in a total number of 9 (= 4 + 4 + 1), which indeed is the symbolic number of death. Adding the four parts of heaven (4 + 4 + 4 + 1), we arrive at 13 as the sum of cosmic divisions.

Each sign, and each combination of sign and number, has its symbolic associations and divinatory value for actions undertaken and those born on the day in question. Persons are identified by their day of birth, which accompanies them through life and expresses their connection to the symbolic order of time, space, and divine power. The calendar name contains esoteric information about the possibilities, the character, and the destiny of the individual. Each day is guarded and guided by a series of different Patron Deities: the God of the Day Sign (cycle of 20), the God of the Night (cycle of 9), the God of the Number (cycle of 13), as well as the gods that governed certain periods such as the units of thirteen days. To the educated readers (priests) these associations provide a symbolic dimension, which may invite specific reflections or emotions.

Codex Laud (page 23), preserved in the Bodleian Library (MS. Laud Misc. 678), is a religious manuscript from ancient Mexico, dealing with divinatory and ritual aspects of the native calendar. On this page (p. 2) we see the Rain God (called *Tlaloc* by the Aztecs, *Dzaui* by the Mixtecs) as Lord of Time: he is surrounded by the twenty day signs. His large teeth and the jade rings around his eyes are his distinguishing attributes. Here he also wears a jaguar helmet, probably a symbolic reference to his power. Jewels and feathers indicate that he is a bringer of prosperity. In one hand he holds a flaming serpent, in the other a smoking axe—both are symbols of lightning. He is walking over the waters and

under the clouds. His assistant, the frog, is pouring water, and the corn plant grows. In the big ocean under his feet floats the precious alligator, symbol of earth, amid conches *(Strombus)* and red bivalve shells (which represent *Spondylus*).

The ancient calendar is also used to date historical events. The days are given in the basic structure of 260 different combinations of thirteen numbers and twenty day signs, in fixed order (running from 1 Alligator to 13 Flower). But the ancient calendar also had a count of 'solar years' of 365 days each. For agriculture—and later for the keeping of historical accounts—these periods of 365 days were delineated within the continuum of 260-day cycles. Each solar year is named after a specific day, the 'year-bearer'. It was marked by a special sign, which resembles a bound or chained ray of the sun, but historically seems to stem from a diadem-like headdress. This 'A-O sign' as it is often called in the literature, is a characteristic feature of manuscripts from the Ñuu Dzaui area. In Dzaha Dzaui it is read *cuiya*, 'year'. The A-O sign may be accompanied by an eye. In Dzaha Dzaui 'eye' *(nuu)* is a homonym of the preposition 'in' *(nuu),* so we may read this combination as *nuu cuiya*, 'in the year…'.

As year-bearers are 365 days apart, mathematics dictates that only four of the twenty day signs could occupy this position. These were: Reed (XIII), Flint (XVIII), House (III) and Rabbit (VIII), in this sequence. Similarly, the number associated with the year-bearer sign

progresses one unit per year, resulting in the year-bearer sequence: 1 Reed, 2 Flint, 3 House, 4 Rabbit, 5 Reed, 6 Flint, and so on, until 13 Rabbit. After such a cycle had been completed, the first year (1 Reed) returns and a new year cycle begins. As each of the four year-bearer signs appears in combination with each of the 13 numbers, the cycle consists of 52 years. Thanks to equivalences given in the early colonial documents, it is possible to correlate the ancient Mexican years with the Christian chronology. It should be mentioned that, although all Middle American peoples had the same calendrical system, there were many regional variations. Due to the fact that the beginning of the year was celebrated on different days, the Aztec year count differed from the one used in the Ñuu Dzaui village-states by one digit: the Ñuu Dzaui year 1 Reed corresponded to an Aztec year 2 Reed, etc., so 13 August 1521, when the Aztec capital Mexico-Tenochtitlan fell into the hands of the Spanish conquistadors, was the day 1 Serpent in the year 3 House in the Aztec calendar, but the year 2 House according to the Ñuu Dzaui count.

Full dates in the codices are made up of a day from the 260-day cycle and a year-bearer. Thus, events are dated in cycles of 52 years. Often the sequence is clear, as the birth, marriage, and death of an individual obviously have to occur in that order; but if the record is incomplete, it can become a problem to correlate dates in the cyclical Ñuu Dzaui historiography with the linear year-count of the Christian calendar.

Rosetta Stones

1) Codex Mendoza

Alphabetic texts in Spanish or native languages were added to several pictorial manuscripts of the early colonial period in order to elucidate their contents. These were generally based on authentic information provided by the indigenous experts (priests, painters, or historians). Nowadays they constitute the key to decipher the pictograms. From their identifications of particular scenes and signs a 'pictographic dictionary' may be derived. This becomes the foundation for our interpretations of the codices in precolonial style and of other images and inscriptions in the archaeological record.

An illustrative example of such an bilingual-bicultural source is Codex Mendoza (also preserved in the Bodleian Library MS. Arch. Selden. A. 1), an early colonial version of an Aztec tribute list, with additional information about rulers, customs, and scenes from daily life. It was painted on European paper, the pages measuring approximately 32.0 by 21.5 centimetres. Originally intended to provide information for the Spanish authorities (it is named after the first viceroy, Don Antonio de Mendoza), it was taken from a Spanish ship by French pirates and came into the hands of the French cosmographer André Thévet (1502–90). This author sold it to Richard Haykluyt (1552?–1616), chaplain to the English Ambassador in Paris and collector of travel reports. Samuel Purchas (±1575–1626) inherited Haykluyt's papers and published engravings of this early colonial Mexican manuscript in a book entitled *Purchas' His Pilgrimes* (London, 1625). After Purchas's death, the manuscript came into the hands of the humanist scholar John Selden (1584–1654), who left his collection of books and manuscripts to the Bodleian Library. Because of its straightforward and clear explanations of the pictorial elements, and because of its early publication, the Codex Mendoza has become one of the most important foundations for interpretative studies of ancient Mexican writing and visual art.

a) The marriage

One example is the convention for marriage. In Codex Bodley we regularly find married couples seated on mats. This sign refers to the Dzaha Dzaui expression for marriage: 'feast of the mat' *(huico yuvui)*. Codex Mendoza, fol. 61ʳ, provides a telling illustration of the Aztec marriage ceremony. The upper part of the page shows, as the Spanish commentary phrases it, how: 'a father, having a son of fifteen, handed him over for instruction, according as the lad himself was inclined, either to the master of youths, or to the chief priest, who are seated before their respective quarters'. The age of fifteen years is indicated by the fifteen blue dots in the centre of the page. The lower scene depicts the marriage ceremony. The reading starts at the bottom of the page and moves upwards, following the trail of footsteps. A group of women, clearly identified as such by their hairstyles and clothing, approach and enter a house, with torches in their hands. One of them carries a young woman on her back: the bride. This custom of carrying the bride to the house of the groom as part of the marriage festivities is still well known in present-day traditional communities in Mexico. Within the house a bowl with food has been prepared with a basket full of tortillas, together with a jar of pulque, the alcoholic drink made from the juice of the maguey, and a small cup in

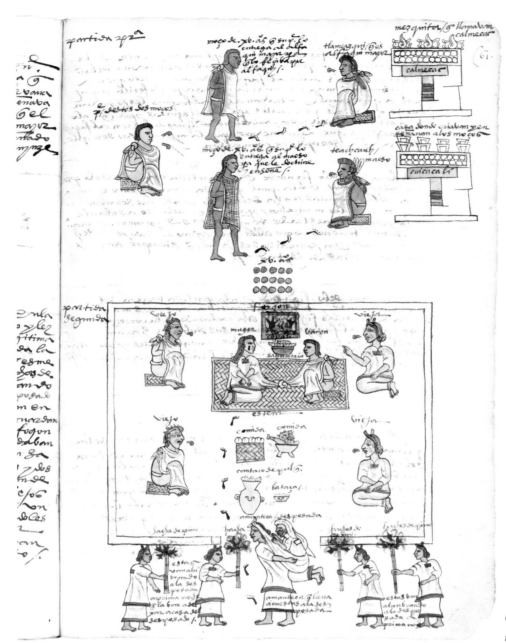

Codex Mendoza, fol. 61ʳ:
the Aztec marriage ritual.

which to serve it. The couple is seated on a mat in front of the hearth—the young woman in the characteristic female pose on her flexed legs. Their clothes are knotted together as sign of the marriage bond. Behind the couple, elders give them advice.

All elements are identified by glosses in Spanish. Moreover, a Spanish commentary on the opposite page gives a full explanation of the scene: 'The ceremony began when the bride left her home by night, and was carried, on the back of an *amanteca,* the matchmaker, accompanied by four companions bearing pine torches, to the house of the bridegroom. On arrival, the bride was met by his parents, who conducted her inside to the bridegroom, who was seated on a mat near the hearth, and, setting her down beside him, knotted their clothes together, the one to the other. Two old men and two old women, who were present as witnesses, then offered up incense to their gods, and laid food before the newly

wedded couple, at the same time addressing homilies to them on the subject of their future behaviour, exhorting them to perform all the obligations they had contracted, in order to live in peace' (James Cooper Clark , *Codex Mendoza,* vol. 1, p. 92).

b) Priestly duties

Codex Mendoza, fol. 63ʳ, illustrates the tasks of priesthood, which clarify the scene in Codex Bodley, p. 13-i. In both cases we see a man with a spoon-shaped incense burner in his hand and a man playing the two-toned drum. Codex Mendoza adds a third activity: the observation of the night sky (painted as a dark sphere, lightened by eyes, which represent the stars).

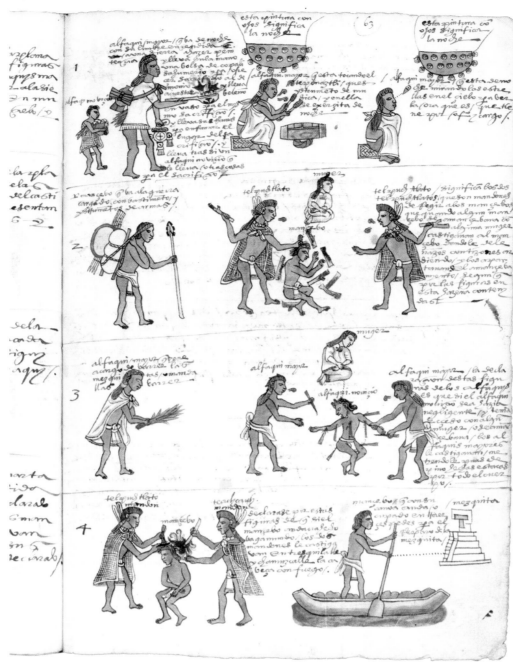

Codex Mendoza, fol. 63ʳ:
duties of the Aztec priests.

The Spanish commentary (on the opposite page) labels this scene: 'the various occupations of senior priests during the night-time; some go to the mountain to offer sacrifice to their gods, some are occupied with music, some are watchmen taking their time from the stars…' (James Cooper Clark , *Codex Mendoza*, vol. 1, p. 93).

c) Tributes and toponyms

Codex Mendoza, fol. 43ʳ, lists the toponymic signs of towns in the Mixtec Highlands that had to pay tribute to the Aztec ruler. The quantities are specified by numbers in the vigesimal system: 20 is represented

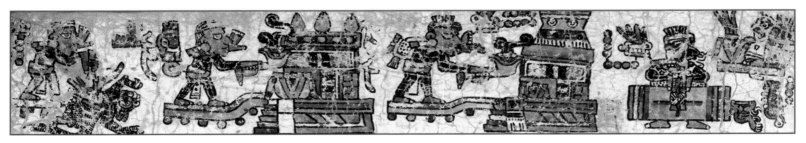

Codex Bodley, p. 13-i: activities of Mixtec priests.

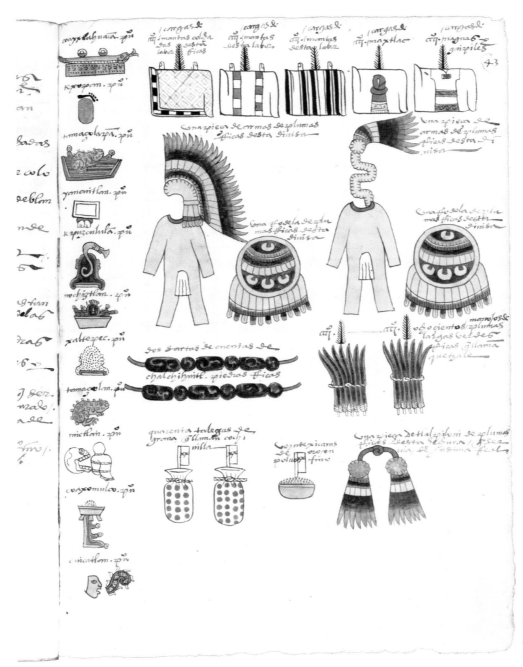

Codex Mendoza, fol. 43ʳ: tributes of Mixtec towns to the Aztec ruler.

by a banner, 400 by the sign for hair, and 8,000 by a bag. The tribute on this page consisted of 1) woven cloth for 400 rich quilted mantles, 400 striped red and white mantles, 400 striped black and white mantles, 400 loincloths, and 400 women's dresses, 2) two shields and warriors' dresses, with quetzal-bird feathers for the high ranks, 3) precious items: two jade necklaces, 2 x 400 handfuls of quetzal feathers, 2 x 20 bags of red paint (cochineal), 20 gourd bowls of gold dust, and a badge of rich feathers. These drawings help us to identify the dress of the Ñuu Dzaui princes and princesses. Lord 8 Deer uses a shield with the same motif as that in Codex Mendoza, for example, in Codex Bodley, fol. 33-v.

The place-signs are formed by the combination of a geographical category (mountain, river, rock, etc.) with a specifying adjective (e.g. a colour) or second noun. Most nouns in place names are rendered iconically (stylized drawings, mostly in profile). In order to understand the etymol-

ogy of a toponym and its relationship with the place-sign, we need to have at least a basic knowledge of the relevant Middle American languages. The signs in Codex Mendoza are designed on the basis of Nahuatl. The representations of toponyms in other languages follow the same system. Generally a word is painted iconically: a stylized depiction of the object to which the word refers. Where words could not be rendered this way, special conventions or signs of an arbitrary nature ('ideograms') had to be invented. Sometimes the painters chose to depict a homonym. Such cases are classified as 'phonetic writing': only the phonetic value of the sign is used, not its semantic value. There are also cases in which a sign is added just to indicate the semantic category of 'place'.

The toponyms on this page illustrate these different techniques.

1) The first sign from above is that of Coixtlahuaca, 'Valley of the Ser-

pents'. It consists of an iconic rendering of a serpent *(coatl)* on top of a rectangle filled with dots and hooks, which is a conventional sign for earth *(tlalli)*, a field *(milli)*, or a plain *(ixtlahuacan)*. Eyes *(ixtli)* are added to the rectangle as a phonetic complement to guarantee the reading *ixtlahuacan*.

2) Texupan, 'the Blue Place', is rendered by a blue spot *(texotl)* with a foot, which maybe read as the verb *panoa,* 'to pass', but which is used here as a phonetic writing of the place suffix *–pan*.

3) The 'Toad River', Tamazul-apan, is represented in a straightforward way as the cross-section of a river *(apan)*, with a toad *(tamazolli)* in it.

4) Yanhuitlan, 'New Place', is painted in the form of a white blanket, a convention to indicate the quality 'new' *(yancuic)*, in combination with a tooth *(tlan-tli)*, a near homonym for the place name suffix *-tlan,* which in itself is difficult to depict.

5) Tepozcolula probably means 'Place *(-lan)* of the Copper *(tepoz-tli)*-coloured Terraces *(colol-li)'*, but is analysed as 'Place *(-lan)* of the Curved *(coltic)* Axe (tepoz-tli)'. Consequently an axe with a curved helve is drawn on top of a mountain, which functions here as a semantic determinative. The addition of a mountain or house for the general notion 'place' is an example of how there are cases in which only the semantic value counts, without reference to the phonetics.

6) A bowl with a cactus and red liquid represents the name of Nochixtlan, the 'Place of Cochineal' as 'Place *(-tlan)* of the Blood *(ez-tli)* of the Cactus *(noch-tli)'*.

7) Xal-tepe-c means 'On the Mountain of Sand'. A bell-shaped form is the schematic rendering of a mountain *(tepetl* in Nahuatl). A filling of black dots on a white background represents 'sand' *(xalli)*.

8) The toad *(tamazolli)* stands for Tamazollan, 'Place of Toads'. The place suffix -lan is not indicated.

9) In order to represent Mic-tlan, 'the Place of Death', two references to death *(miquiztli)* are used: a skull and a mummy bundle, both depicted iconically in profile. Again the place suffix -tlan is simply not specified.

10) Water (a-tl), painted as a corner *(xomul-li)*, represents the place name Axomulco, "In the corner of the water". The locative suffix –co is not painted. The tripod bowl with food is either a phonetic writing for the first part of Coaxomulco or a reference to another town.

11) Cuicatlan means 'Place *(-tlan)* of Songs *(cuicatl)'*. It is represented by a person's face with an elaborate speech scroll.

d) Ñuu Dzaui place-signs

The analysis of the place-signs, identified with their Nahuatl names in Codex Mendoza, is the point of departure for studying the conventions in the representation of toponyms in other areas. Glosses in a number of early colonial manuscripts from the Ñuu Dzaui region produce a pictographic dictionary of much smaller dimensions, but essentially similar to the one that has been elaborated on the basis of Nahuatl manuscripts. It is enough, however, to demonstrate that Ñuu Dzaui pictography operates in the same way as that of the Mexica, although the specific words and names are, of course, different.

Students of these codices are continually confronted with two languages: (1) Dzaha Dzaui or Mixtec, the native language of the region, and (2) Nahuatl, the language of the Aztecs, who had an enormous influence in the whole of Middle America. Most of the ancient towns in Ñuu Dzaui teritory were registered by the colonial administration with their names in Nahuatl, and were put as such on the Mexican maps; but the signs in the Ñuu Dzaui codices refer to the original toponyms in Dzaha Dzaui. The structuring principles of the signs are identical, but the character of both languages is quite different. Where Nahuatl is polysynthetic, Dzaha Dzaui is a tonal language, which means that words pronounced with different tones have radically distinct meanings. For example, in Sahin Sau, the modern dialect of the area of Ñuu Ndeya (Chalcatongo), with which we are most familiar, *yukù* (with mid-low tones) means 'herb', but *yuku* (mid-mid) is 'mountain', and *ñuhù* (mid-low) means 'fire', but *ñuhu* (mid-mid) is 'earth, land'. The Ñuu Dzaui painters were quite creative in designing pictorial representations for the toponyms, often using tonal puns or word-plays with homonyms.

A rectangular frieze with stepped fret motifs is to be read as ñuu, 'town'. Coloured black *(tnoo),* it forms the sign of Ñuu Tnoo, 'Black Town'. Its neighbour A-ñute, 'Place of Sand', was painted as a mountain with a mouth (read as a-, the locative prefix) spitting sand *(ñute)*.

The place where the Ñuu Tnoo dynasty originated was Yuta Tnoho, 'River That Pulls Out [weeds]', which is painted as the cross section of a river *(yuta)* with a hand that is plucking *(tnoho)* feathers. Actually a play on words is involved: the feathers of the quetzal bird refer to the title *toho,* 'noblemen', and to a possible interpretation of the toponym as 'River of the [first] Lords'. In metaphoric terms, the founders of the different dynasties were 'pulled out' from the Sacred Mother Tree on the bank of this river. Therefore the town's name was also understood as Yuta Tnuhu,

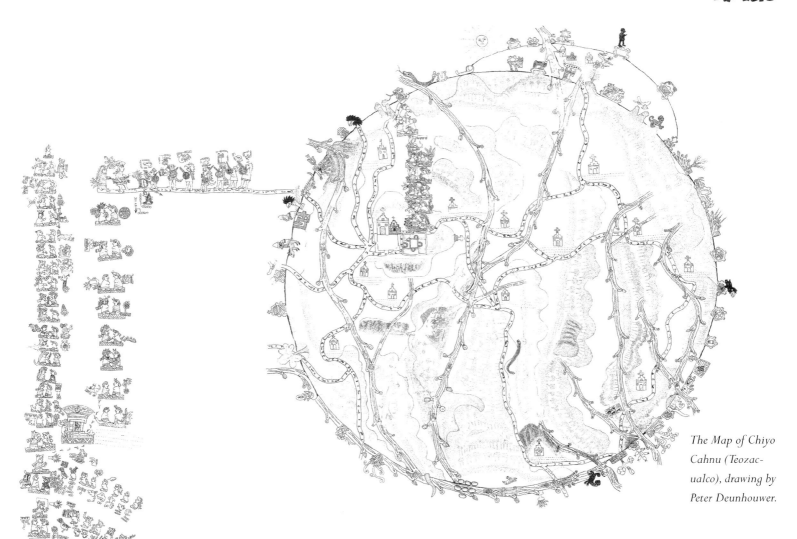

The Map of Chiyo Cahnu (Teozac- ualco), drawing by Peter Deunhouwer.

'River of History', which was then translated in the Aztec language as Apoala, from *a-* ('water'), *poa* ('to tell a story') and *-lan* (locative suffix).

Another important village-state, Chiyo Yuhu, probably means 'Altar *[chiyo]* That Is Hidden *[yuhu]*'. The latter quality is difficult to paint, so the painters recurred to the similar sounding strawberry tree *(yuhndu).* In the same way the adjective 'big, large' *(cahnu)* in other toponyms is painted as 'bent' or 'broken' *(cahnu).* Thus a curved or bent mountain *(yucu)* may be read as Yucu Cahnu, 'Big Mountain'.

Ndisi Nuu (Tlaxiaco) actually means 'Good View', but is represented as 'to cross beams or legs' *(ndisi)* in combination with a 'face' or 'eyes' *(nuu).* The Aztec name Tlaxiaco comes from tla-chia-co, 'place of seeing something', and was painted by the Aztec scribes as a ballcourt *(tlach-co)* with falling raindrops *(quiauh-).*

2) The Map of Chiyo Cahnu (Teozacualco)

The obverse of Codex Bodley contains the genealogical history of the rulers of Ñuu Tnoo (Tilantongo). This topic has been clarified by another

document in which the pictorial contents are identified by Spanish comments: an early colonial map added to a 1580 report, known as the *Relación Geográfica* of Chiyo Cahnu (Teozacualco), a southern neighbour of Ñuu Tnoo. It is a polychrome painting on European paper of 176 by 138 centimetres, preserved in the library of the Institute of Latin American Studies at the University of Texas in Austin. Its composition suggests that it was a copy of a *lienzo* (see p. 12). We will discuss it here in some detail, as it also provides us with a historical context in which Codex Bodley may have functioned, especially during the early colonial period.

Teozacualco is a Nahuatl toponym, like so many in Mexico, due to the Aztec expansion and to the spread of Nahuatl as a *lingua franca* in the contact between the Spaniards and the indigenous peoples in the six-teenth century. The original name of the town in Dzaha Dzaui is Chiyo Cahnu, 'Large Altar or Pyramid'. Its map contains a geographical and a historical section. The first is a round map, which gives the spatial exten-sion and the boundaries of the *cacicazgo* in a mixed Ñuu Dzaui-European style, registering rivers, mountain ridges, and roads, as well as place-signs for the names of the boundary points. The historical part consists of 'columns' of successive ruling couples, one representing the dynasty of Ñuu Tnoo and another that of Chiyo Cahnu. The personages are painted in a schematic way according to the conventions of Mesoamerican pic-tography, and identified through signs that represent their given names.

A short text or gloss in Spanish explains that they belonged to the dynasty that originally ruled Ñuu Tnoo; from there a prince departed to govern Chiyo Cahnu and so founded the second lineage (column).

> These are the nobles and lords that in ancient times came from the town of Tilantongo to this (town) of Teozacualco and those who descended from them and are alive today: Don Felipe de Santiago and Don Francisco de Mendoza, his son.

Don Felipe de Santiago, also known as Don Felipe de Austria, then, was the ruling lord in the second half of the sixteenth century under whose supervision the map was painted. Another text identifies his palace in the centre of the main town, next to the church, painted as a building of four rooms around a patio. The genealogical columns represent his background. The present-day association between church and municipal palace is prefigured here: each column starts with a temple and a place-sign. The sovereign community, the temple and the dynasty appear as a unit, expressing the same ideological message as the real temple that dominates the civic-ceremonial centre and usually contains the tomb of the deified Founding Ancestor.

The place associated with the first column (along the left-hand border of the map) is Black Frieze. The rectangular frieze with a step-fret motif is to be read as *ñuu*, 'town, place, people'. In combination with the black colour *(tnoo)* of the step fret motif it represents Ñuu Tnoo, 'Black Town', the Dzaha Dzaui name of the place called Tilantongo in Nahuatl. On top of this place-sign we see a temple *(huahi)* decorated with eyes on a blue background, representing the heavens *(andevui)*. A report of 1580 from this town, the *Relación Geográfica* of Ñuu Tnoo (Tilantongo), gives as the complete name of the hill on which the town, or rather the ceremonial centre, was situated: Ñuu Tnoo Huahi Andevui, 'Black Town, Temple of Heaven'. The second lineage, derived from that of Ñuu Tnoo in early times, is connected with a frieze bent by a small man. This sign represents the Dzaha Dzaui toponym Chiyo Cahnu, 'Big Altar, Big Pyramid'. As the abstract notion of 'big' is difficult to represent pictorially, the painter used a homonym with another tone: *cahnu*, 'to bend, to break'. The anonymous small man, painted black, is just an actor who represents the verb.

It was the Mexican archaeologist Alfonso Caso who made a first analysis of this crucial document in an article published in 1949. He observed that the seated men and women in the two columns are the same as those mentioned in a whole group of screenfold books, in which they are identified not only by the hieroglyphs of their given names but also by their calendar names. The map therefore demonstrates that this group of codices comes from the Mixtec Highlands and that it is historical in contents. Consequently Caso could use this document as a Rosetta Stone to decipher the Ñuu Dzaui codices.

The main part of the map is a stylized representation of the geographical dimension of the *cacicazgo*, with rivers, mountains, settlements, and a borderline, marked with place-signs. A detailed comparison with the actual situation, as well as with local archival documents and modern maps, made it possible to identify enough names of boundary marks to reconstruct the kingdom's territorial extension. In reality it does not have the form of a circle. Drawing a map with the contour line of 2,000 metres altitude, one sees immediately that the *cacicazgo* occupies the basin or drainage system of several adjoining rivers (Río Hondo, Río de Nochixtlan, Río Peñoles or Río Minas, and Río Grande). The historical identification of the precise spatial extension of the Chiyo Cahnu kingdom, in combination with the description of the area given by its *Relación Geográfica*, makes it possible to analyse its catchment area, i.e. the environmental base of its economy. Different roads connect the conceptual central place, Chiyo Cahnu, with its dependencies and with neighbouring Ñuu Dzaui towns. Interestingly no road is shown crossing the border with the region of the Beni Zaa (Zapotecs).

At the top of the map we see the rising sun, which may have a double meaning. In the geographical context, it provides the orientation of the map, marking the East—a convention shared by European maps and Mesoamerican iconography. On the level of sacred history the sunrise marks the beginning of human time and defines the ruling lineages as living 'after the first sunrise', i.e. in history as we know it.

An anomalous and therefore special feature is the presence of two frontier lines in the upper right-hand corner. The main place-sign in the middle of the two frontiers is Rock of the Maize Cob, identified by a gloss as Elotepec (Yucu Ndedzi in Dzaha Dzaui). The gloss further states that this place was originally a subject town of Chiyo Cahnu, but its name does not figure among the estancias of Chiyo Cahnu mentioned in a list of the main towns in New Spain from around the middle of the sixteenth century (the *'Suma de Visitas'*). A document in the municipal archive of Chiyo Cahnu (Teozacualco) explains that the frontier in this area was changed in 1574. The map documents both the old and the new frontier between Chiyo Cahnu and Yucu Ndedzi (Elotepec), i.e. not the

actual independence of the latter town but its taking control of an extension of lands (including the estancia Exotepec), which, at least according to this map, originally belonged to Chiyo Cahnu.

By comparing the representation of the lineage in the map to other codices, it becomes clear that the given name of Lord 4 Deer, the last precolonial ruler of Ñuu Tnoo, both in the map and in Codex Bodley, was represented as 'Eagle-Crossed Beams-Eye'. In Dzaha Dzaui the combination of the crossed beams (*ndisi,* 'to put crosswise') and the eye *(nuu)* reads: *ndisi nuu,* an expression that means 'good view' or 'clear sight'. This is also the Dzaha Dzaui name of the town of Tlaxiaco, locally pronounced as Ndijin Nuu. The given name of Lord 4 Deer, therefore, was Yaha Ndisi Nuu, which means both 'Sharp-eyed Eagle' and 'Eagle of Tlaxiaco'.

In the Map of Chiyo Cahnu we find him seated in the third to last couple of the Ñuu Tnoo dynastic column. His successor was his oldest son, who, according to the *Relación Geográfica* of Ñuu Tnoo (Tilantongo), was baptized as Don Juan de Mendoza. A document in Mexico's *General Archive of the Nation* tells us that this Don Juan de Mendoza married Doña María de Estrada *(Archivo General de la Nación, Ramo de Tierras 24, expediente 6).* In the Map of Chiyo Cahnu, the original Dzaha Dzaui names of this couple are given as Lord 'Faces of the Rain God' and Lady 'White Quechquemitl'. In baptism the indigenous rulers had to adopt Christian, i.e. Spanish, names. Generally they chose those of the Spanish officials or nobles of their own rank, like the viceroy or the local Spanish landowners *(encomenderos).* This also happened here. Mendoza is, of course, the family name of the Spanish viceroy Antonio de Mendoza, who ruled New Spain from 1535 till 1550. The name Estrada probably comes from Alonso de Estrada, the Spanish *encomendero* of Ñuu Tnoo.

Following the Map of Chiyo Cahnu, we see that Lord 'Faces of the Rain God' and Lady 'White Quechquemitl' had a son, 'Jaguar with Torch' (probably 'Jaguar That Lightens the War'), who married an unnamed lady. This couple, in turn, had an unnamed daughter, shown seated on the mat in Ñuu Tnoo. At the same level as this couple we see a Lord 'Coyote with Staff', going away in the direction of Chiyo Cahnu. We find him back in the Chiyo Cahnu dynastic column, as the man in the last ruling couple, who produced an unnamed son. Thinking of the map gloss, cited above, about the contemporary rulers of Chiyo Cahnu, we identify Lord 'Coyote with Staff' as Don Felipe de Santiago, and his son as Don Francisco de Mendoza. It is important to notice that Don Felipe the Santiago went to rule in Chiyo Cahnu, but originally belonged to the Ñuu Tnoo dynasty.

This representation corresponds to the political situation described in archival sources: a Don Francisco de Mendoza, whom we will call 'the Elder', had been ruler in Ñuu Tnoo and was succeeded by his daughter, Doña Francisca de Mendoza, who died without having children. Therefore Don Felipe de Santiago, the younger brother of Don Francisco de Mendoza, demanded to be recognized as the legitimate *cacique* (native ruler) of Ñuu Tnoo in 1576.

It follows that 'Jaguar with Torch' on the Map of Chiyo Cahnu is Don Francisco de Mendoza 'the Elder', Don Juan de Mendoza's successor. The boy 'Coyote with Staff' departing for Chiyo Cahnu is Don Francisco's younger brother, Don Felipe de Santiago. The son of Don Felipe de Santiago was also named Don Francisco de Mendoza; we will call him 'the Younger' to distinguish him from his paternal uncle.

In the Map of Chiyo Cahnu, the last person in the Ñuu Tnoo column is Don Francisco's daughter: Doña Francisca de Mendoza. As she died without having children, her father's brother, Don Felipe de Santiago, became her successor as *cacique* of Ñuu Tnoo in 1576. However, this had not yet happened at the time the map was painted, otherwise Don Felipe 'Coyote with Staff' would certainly have been shown as ruler of Ñuu Tnoo, which he was in 1580, when the *Relación Geográfica* was written. On the other hand, the map was clearly composed after the boundary correction with Yucu Ndedzi (Elotepec), which took place in 1574. This narrows down the date for the making of the Chiyo Cahnu map between 1574 and 1576. So it was not painted as an appendix to the *Relación Geográfica* (1580), but several years earlier, for another occasion. When the questionnaire for the *Relación Geográfica* arrived, the map was already present in the town; it would just have been handed over as a convenient illustration or copied for that purpose.

Looking again at its contents, we see that its most peculiar feature is precisely the boundary correction. We therefore suppose that the map was originally drawn to document the agreement about the new frontier with the neighbouring village. We also understand that it represents the viewpoint of the ruler, Don Felipe de Santiago. In 1574 he redefined his 'mat and throne' as an idealized unit, to be inherited by his son. He also indicated that he himself originally came from Ñuu Tnoo and that, on several earlier occasions, the Lord of Chiyo Cahnu also had come from there: Ñuu Tnoo is presented as the 'mother dynasty'.

Don Felipe de Santiago is also known as Don Felipe de Austria. The Dominican chronicler Friar Francisco de Burgoa tells us how, when baptized, he consciously chose to take the name of the Spanish king, his equal.

The first king of Tilantongo to be baptized, asked, before receiving the sacrament, what the name was of the king, our lord, to whom he was pledging obedience. And the *conquistadores* told him that our lord king was named Don Felipe de Austria. Then he said: 'Well that same name and lineage I choose, and I want to be called that same way'. Thus he received his name; and his eldest son and heir he called Don Francisco Pimentel, the second Don Juan de Aguilar, to whom he entrusted the land of Tezoatlan…

The original Felipe de Austria, better known as Philip II, was the king of Spain, who had acceded to the throne in 1555. The referred baptism must have taken place after that year. Our Don Felipe was not the first Ñuu Tnoo ruler to undergo this ritual of becoming Christian, as Burgoa suggests. His father, Don Juan de Mendoza, had already been baptized— his choice of family name indicates that it had happened during Viceroy Mendoza's reign.

As we have seen, Don Felipe de Austria/Santiago was a prince of the house of Ñuu Tnoo, but became ruler of Chiyo Cahnu after the previous *cacique* of that town, Lord 'Coyote That Came Down from Heaven', died without offspring. Colonial documents inform us that in 1542 there had not been a *cacique* in Chiyo Cahnu for three years. Don Felipe de Austria/Santiago may have been installed as *cacique* in Chiyo Cahnu because of the prestige of the Ñuu Tnoo dynasty, which moreover was related to the ruling family of Chiyo Cahnu by frequent intermarriage.

From colonial documents we know that Don Felipe de Austria/Santiago was married to a lady baptized as Doña Inés de Zárate, daughter of the indigenous *caciques* of Yucu Ndaa (Tepozcolula), who had been baptized as Don Pedro Osorio and Doña María de Zárate. In 1563, therefore, Don Felipe was declared *cacique* of Yucu Ndaa, but at the same time he remained in control of Chiyo Cahnu. In 1566 Doña Catalina de Peralta challenged his authority over Yucu Ndaa, claiming descent,

through her mother (Doña María) from the precolonial rulers Lord Flint (Tecpateuctli) and Lady Monkey (Ozumasuchitl).

In several lawsuits Don Felipe claimed that Ñuu Tnoo had an ancient right to appoint rulers in places where the local dynasty had died out. Don Felipe lost the case. In 1569 Doña Catalina and her husband, Don Diego de Mendoza, *cacique* of Tequevui (Tamazulapan), took possession of the *cacicazgo* of Yucu Ndaa and established themselves in the palace *(aniñe),* still known locally as the Casa de la Cacica, 'House of the Queen'. Recently, after a long period of neglect, excavations have brought to light some of its ancient splendour.

During the following years (1572–74), Don Felipe de Austria tried to gain control of the *cacicazgo* of Ñuu Ndaa (Tejupan), with similar claims and with a similarly frustrating outcome. But, finally, he did succeed in expanding his realm, by becoming *cacique* of Ñuu Tnoo in 1576. Another case in which, at last, the ideological claim of Don Felipe de Austria seems to have worked, was that of his younger son, Don Juan de Aguilar, whom he was able to appoint *cacique* of Tezoatlan when the ruler of that town died without children.

The eldest son of Don Felipe de Austria was Don Francisco de Mendoza, 'the Younger' (not to be confused with Don Felipe's older brother). We saw that he appears in the Chiyo Cahnu Map as the son of 'Coyote with Staff'. In 1574 he was still an unmarried boy. This Don Francisco de Mendoza 'the Younger', called Don Francisco de Pimentel by Burgoa, married Doña Inés de Guzmán, the daughter of Don Gabriel de Guzmán, *cacique* of Yodzo Cahi (Yanhuitlan), who ruled from 1558 till 1591, and Doña Isabel de Rojas, who in turn was a daughter of the *caciques* of Ñuu Ndecu (Achiutla) and Ndisi Nuu (Tlaxiaco). Doña Inés de Guzmán was the richest and most powerful woman in the region at that time. The wedding was one of the major society events in Ñuu Dzaui early colonial history, bringing together more than 2,000 nobles from the whole region for a huge gala of banquets and dances, a display of wealth and elegance, and a show of power.

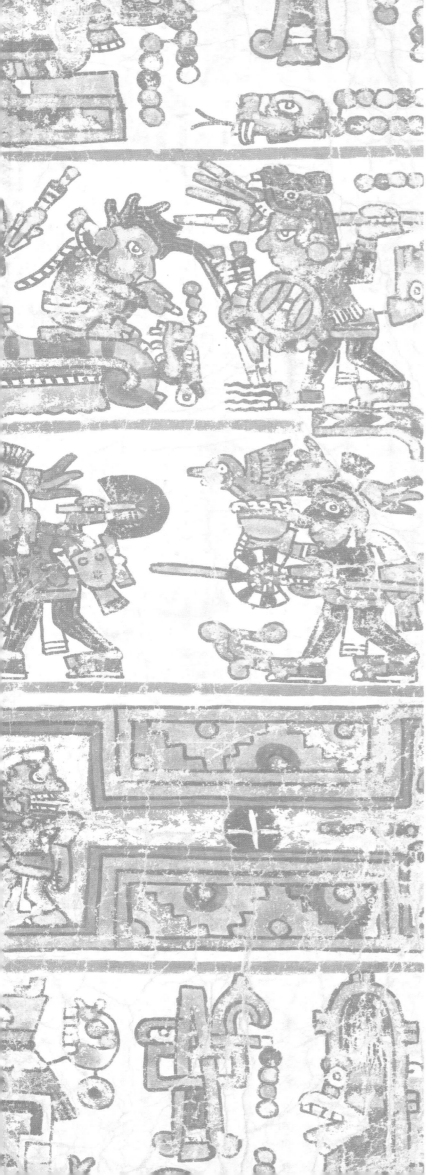

Codex Bodley

The ancient Ñuu Dzaui book published here is preserved in the Bodleian Library, Oxford as MS. Mex. d. 1. This designation dates from the end of the nineteenth century when the Librarian, Edward Nicholson, introduced new shelfmarks according to the provenance and language of the documents. An earlier number is 2858, used in the 1697 Catalogue of Edward Bernard *(Catalogi Librorum Manuscriptorum Angliae et Hiberniae),* which included this codex as *'Hieroglyphica Mexicana'* following the heading of 'Books from China' *(Libri Sinenses).* Still earlier is the reference to the 'Arch[ivum] A[ustrale]' (south cupboard in Duke Humphrey's Library): Arch. Bodl. A. 75. Probably the earliest reference to its existence in the library is the entry in the 1605 Catalogue (p. 349): 'manuscript book in the Mexican language, quarto format (medium size), in the cupboard' *(Liber lingua mexicana scriptus. Q. in Arch.).* Because of its identification as 'Mexican', it appears under the heading Libri Artium, M. 2 (i.e. bookcase M, shelf 2). Its position is between the volumes 2 and 3 on the list, marked by a ¶ sign, which probably indicates that it was not kept on the shelf but in the cupboard. In the scholarly literature it has become known as *Codex Bodley 2858,* shortened among students of Middle American civilization to 'Bodley'. It was first published as a set of coloured drawings in the first volume of the monumental work *Antiquities of Mexico,* edited by Lord Kingsborough (London 1830–48). The drawings were made by the Italian painter Agustino Aglio (1777–1857) and give an interesting image of the state of preservation nearly two centuries ago. Aglio clearly differentiated between colours such as green and yellow, which now have faded into a less differentiated ocre or brown. It is difficult to tell whether those colours were much brighter in his time, or if Aglio was able to reconstruct them on the basis of his expert knowledge of these manuscripts.

In 1960 the Mexican archaeologist Alfonso Caso published a photographic facsimile together with a detailed commentary, which is still a classic in the study of Ñuu Dzaui precolonial history.

Form and composition

Codex Bodley is a screenfold book consisting of strips of deerskin, glued together, covered with stucco, and folded into twenty-three pages approximately 25 centimetres high by 28 centimetres wide. The closed document is approximately 3 centimetres thick. Twenty of these pages are painted on both sides, resulting in a pictorial text of forty numbered

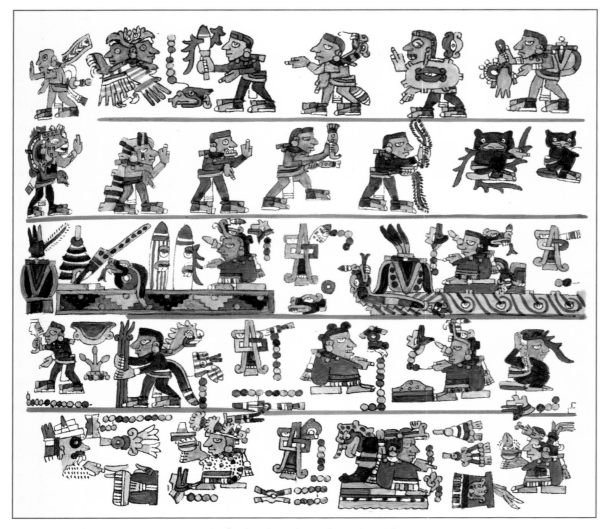

The drawing of Codex Bodley, p. 31, by Aglio for the edition by Lord Kingsborough.

In some spots we can still see some traces of the preparation of the deer hide: small holes were covered with pieces of leather and painted over (p. 16-i/ii, p. 17-v). After the polychrome painting was finished, the text seems to have been corrected: in a few places emendations and additions in black paint have been added. An example is the name of Lady 6 Monkey on p. 35-ii: the layer of chalk has been scraped away and the name has been corrected with a black line drawing. Seeing the original, one becomes painfully aware of its fragile condition. Although the overall impression is that of a clear set of beautifully coloured paintings, at several places the thin stucco layer has come off and parts of the overlapping segments of deerskin that were glued together have loosened.

pages (twenty on the obverse, and twenty on the reverse side of the codex). Caso's reproduction is significantly larger than the original (28 centimetres height by 31 centimetres width) and has a somewhat darker, brownish aspect that contrasts with the original's beautiful bright and lively colours on a white background.

The pages are subdivided into four or five horizontal bands by red guidelines, in a boustrophedon reading pattern. For reference purposes, these bands are designated with Roman numerals top down, so the upper band is i and the lower band is either iv or v. The paintings on both sides are distributed in such a way that they have the same top and bottom. The pages have been numbered with Arabic numerals on both sides from left to right, following the European convention. In reality, however, the overall sequence of the pages is only from left to right on the obverse (pp. 1–20), but goes from right to left on the reverse (pp. 40–21). The codex has a blank front cover (the verso side of p. 40), after which begin the two story lines on p. 1 (obverse) and p. 40 (reverse) respectively. On both sides the painted pages are followed by two blank pages (after p. 20 and after p. 21 respectively) prepared to continue the story—the ones on the reverse were already subdivided by red guidelines. After these follows the blank back cover.

History of the document

The obverse side describes the development of the royal lineage of Ñuu Tnoo (Tilantongo) from the early tenth century AD onwards until the last precolonial king. In a parallel way the reverse side focuses on the related dynasty of the village-state Ndisi Nuu (Tlaxiaco to the Aztecs). The style has much in common with other pictorial manuscripts from the Ñuu Tnoo area, for example with that of the Codex Selden, also in the Bodleian Library (MS. Arch. Selden. A. 2), which originally comes from the town of Añute (Jaltepec), a neighbour of Ñuu Tnoo. Probably, therefore, Codex Bodley was painted in Ñuu Tnoo (Tilantongo), the main village-state in the Mixtec Highlands, shortly before the Spanish conquest (1521). How it left the 'royal library' in that town and ended up in England is a matter of conjecture.

As we have seen, an early colonial descendant of the ancient rulers of Ñuu Tnoo accepted Catholic baptism, changing his name to that of the Spanish king, Don Felipe de Austria. In order to keep and augment his

The 1605 Catalogue of the Bodleian Library.

privileges and territorial rights, he initiated numerous lawsuits and may have presented this manuscript to the Spanish authorities as a demonstration of the historical predominance of the Ñuu Tnoo dynasty. Filed with the acts of the process, it must then have been sent to Europe, possibly to Seville, where the administrative documents of the colonies arrived and were kept in what later became the General Archive of the Indies *(Archivo General de Indias).*

Eventually it surfaced in the library re-founded at Oxford by Sir Thomas Bodley, who was an active collector of books and manuscripts. Having studied in Oxford himself and being proficient in Italian, French, and Spanish, Bodley had travelled through Europe on diplomatic missions for Queen Elizabeth. In 1597 he retired from the court. Having married a rich widow, Ann Ball, he was well-to-do. The couple had no children, and Bodley now dedicated himself fully to his project, to restore and expand the earlier public library in Oxford at his own costs and to furnish it with books, stimulating others to make donations (Myers, *The Bodleian Library,* p. 9).

Selecting all kinds of valuable items personally, Bodley spent his money buying books in London, and sent agents around Europe and as far as Syria. Moreover the library received numerous donations and, in 1602, when 2,000 books had been brought together, it was opened to the public. The first catalogue was printed in 1605. At that time, the codex was already part of this library. The lack of documentation about an earlier owner may indicate that it came from Bodley's personal collection. The circumstances of its acquisition are unclear, and leave much room for speculation. The famous British Mayanist Sir Eric Thompson, for example, has suggested that Bodley received it in 1600 from his friend the Earl of Essex, who had sacked the library of Bishop Mascarenhas of Faro in 1596. If that were the case, however, one would expect to find a more precise reference.

There is another possibility. The fact that the 1605 Catalogue identifies it as 'Mexican' is in sharp contrast with the attribution of another ancient pictorial manuscript from ancient Mexico that was donated somewhat later to the same library, the Codex Laud, which was at first described as an Egyptian manuscript *(Liber Hieroglyphicorum Aegyptorum MS).* The fact that the provenance of Codex Bodley was still known at the time of acquisition points to a relatively short pedigree of the document in Europe, and speaks against the theory of it being obtained during a raid. Sir Thomas Bodley got many of his books through specific agents. One of these was the London bookseller John Bill, who in 1604 travelled to Spain, where he even visited Seville, the entrance port for goods and documents from the 'New World':

… in the years 1600 to 1605 Bodley received in all about £1,700 from benefactors, and with this backing was able to employ two of the leading London booksellers, John Norton and John Bill. He seems to have relied largely on Norton's stock and advice, and on his twice-yearly importations from the Frankfurt Book Fair, while Bill acted more frequently as his travelling agent. In the summer of 1602 Bill was buying for Bodley in Paris, and then on Bodley's behalf visited Rome and Venice and nine other towns in Northern Italy. By June 1603 Bodley was able to declare that Bill 'hath gotten every where, what the place would affourd: for his commission was large, his leisure very good, and his paiment sure at home', which sounds like a perfect recipe for what we now know as blanket book-buying. In the following year (1604) Bill paid a short visit to Spain, intending to make a tour of book-trade centres as he had done in Italy, but he got no further than Seville and then had to return home because the 'peoples usage towards all of our nation is so cruel and malicious'. Despite this hostility, which could have been no great surprise, Bill was able to arrange for a considerable consignment of Spanish books to be sent over… (Philip, *The Bodleian Library,* p. 9; based on letters of Bodley to James on 23 June 1603 and 14 November 1604).

Bill came back with a considerable number of Spanish books, and he just may have bought this codex there, too, as a curious example of an unknown writing system.

How to read Book One

The obverse of Codex Bodley presents the dynasty of Ñuu Tnoo (Tilantongo), from the Founder, Lady 1 Death, born from a Sacred Tree in the Valley of Yuta Tnoho (Apoala), to the last precolonial ruler, Lord 4 Deer. Its time span is from the tenth to the end of the fifteenth century. The pages have been numbered with arabic numerals from left to right, following European convention. This works fine for the obverse side. The narrative is straightforward and follows a relatively uncomplicated linear pattern, ordered in bands that are to be read in a boustrophedon fashion in units of two pages at a time. A band in which the reading order is from right to left is followed by a band that is to be read from left to right, and vice versa. In this way the story advances in horizontal bands distributed in an upward or downward sequence over two successive pages. For reference purposes, these bands have been designated with roman numerals from the top down, so the upper band is i and the lower band is v. Due to the boustrophedon pattern, these numbers do not represent the reading sequence. For example: the account of the codex begins on the lowest band of the first page (p. 1-v), reading from left to right, continuing on the adjacent lowest band of the second page (p. 2-v), then moves up on the second page to the fourth band (p. 2-iv), reading from right to left and continuing on the fourth band of the first page (p. 1-iv), and so on.

The genealogical story has direct parallels in the Map of Chiyo Cahnu (Teozacualco), the reverse side of Codex Yuta Tnoho (Vindobonensis), and in parts of Codex Tonindeye (Nuttall). It is clear that by the time of the conquest this subject matter had been quite well codified. The painter of the obverse side of Codex Bodley probably had several other manuscripts at his disposal, the layout of which he could follow and copy.

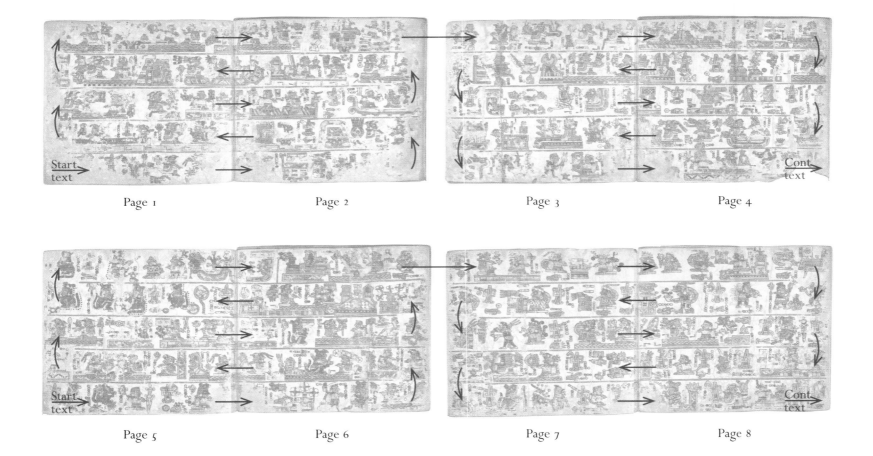

Page 1 Page 2 Page 3 Page 4

Page 5 Page 6 Page 7 Page 8

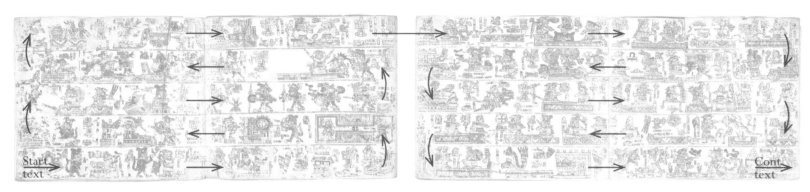

Page 9 Page 10 Page 11 Page 12

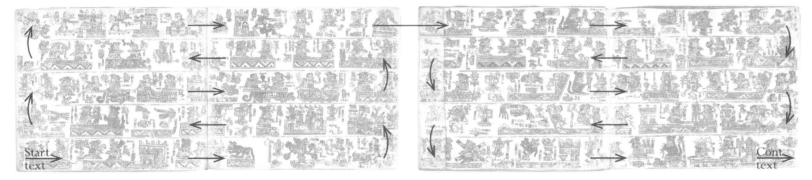

Page 13 Page 14 Page 15 Page 16

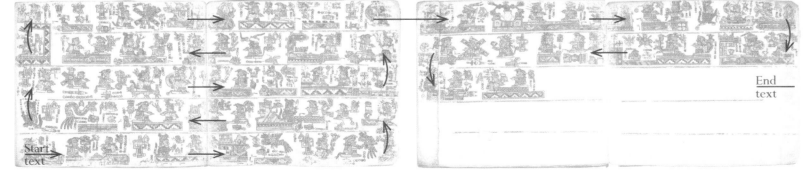

Page 17 Page 18 Page 19 Page 20

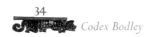

How to read Book Two

The reverse of Codex Bodley presents the dynasty of Ndisi Nuu (Tlaxi-aco). Apparently this noble house had been founded at a relatively late date, somewhere at the end of the twelfth century. Therefore it had to annex an earlier history from other sources, in order to connect to the primordial personages associated with the sacred origin of the Ñuu Dzaui dynasties in Yuta Tnoho (Apoala). Doing so, the reverse starts in the ninth century AD and continues right up to the rule of Lord 8 Grass of Ndisi Nuu, who was born in 1435. Apparently the painter composed this manuscript on the basis of several other originals (all of which are now lost). The integration of these different texts caused a lot of problems, which were solved in ingenious ways, creating 'footnotes', capricious manipulation of the boustrophedon pattern, and, towards the

end, the simultaneous presentation of no less than three distinct narra-tive lines. The pages are numbered from 21 to 40, but this sequence is in reverse order. The story starts on p. 40, and the overall sequence of the pages is from right to left. There is an irregular boustrophedon pattern of horizontal bands. Sometimes the upper bands are to be read sepa-rately, as they give specific information that complements the main text and continues in a linear way over several pages. There may be four or five bands, which are numbered with Roman numerals from the top (i) to the bottom (iv or v). As on the obverse, a band in which the reading order is from right to left is followed by a band that is to be read from left to right, and vice versa. The reader will find that sometimes this se-quence is broken up and two 'staircase patterns' are created on one page.

Please start at page 40 and work from right to left.

⟶ main text ⟶ parallel text 1

⟶ notes on the text ⟶ parallel text 2

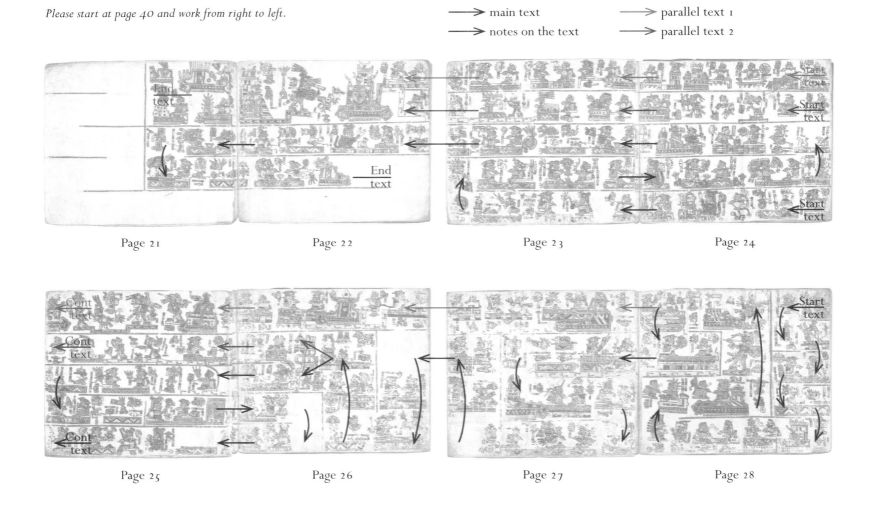

Page 21 Page 22 Page 23 Page 24

Page 25 Page 26 Page 27 Page 28

Page 29 Page 30 Page 31 Page 32

Page 33 Page 34 Page 35 Page 36

Page 37 Page 38 Page 39 Page 40

The narrative of Codex Bodley

A crucial statement for the interpretation of Codex Bodley exists in the *Relación Geográfica* of Ñuu Tnoo (Tilantongo), made in 1580: in the early sixteenth century this village-state was ruled by a lord *(iya)*, known as Qhcuaa, '4 Deer'. As this Lord 4 Deer died shortly after the conquest, at least before the Dominicans started their missionary efforts around 1530, he was not baptized. This lord descended in a direct line from the first ruler, named Iya Qhquehui Yaha Nene, Lord 4 Alligator 'Blood Eagle', who had been born from the earth itself, on the mountain where Ñuu Tnoo is situated.

> They said that the first ruler that they had known, was named Iya Qh Quehui Yaha Nene, which in Nahuatl corresponds to Nahui Cipactli and in Spanish means 'Lord 4 Alligator Eagle of Blood'. This lord, they say, was born from a mountain called Tilantongo. They say that he was born from the earth itself. A direct descendant of his ruled the place when Cortés came to conquer New Spain: his name was Iya Qh Cuaa, which corresponds to Nahui Mazatzin in Nahuatl and which means 'Lord 4 Deer' in Spanish. This Lord was not baptized as he died shortly after the conquest.

In Codex Bodley we find the founder, Lord 4 Alligator 'Blood Eagle', on page 1-iv, and his descendant, Lord 4 Deer, at the very end of the lineage, on p. 19-iii. In a parallel way it is possible to identify the last individual on the reverse side, Lord 8 Grass, as the Malinaltzin ('Lord Grass'), who is mentioned in colonial chronicles as the ruler of Ndisi Nuu (Tlaxiaco) who defended his lands against the invading Aztecs and was sacrificed by them ten years before the Spanish conquest.

Codex Bodley gives the impression of being a finished document, but at the same time it leaves ample open space at the ends of both sides to continue the historical register (presumably that of the descendants of Lord 4 Deer and Lord 8 Grass respectively), thereby presenting the ruling couples of Ñuu Tnoo and Ndisi Nuu not as 'the end of history', but as having a—still undefined—future, as links in the chain of time. The emphasis on genealogy in its contents suggests that this codex was intended as a compendium to be consulted whenever disputes over succession and tribute rights might arise. The logical moment to paint such a book would be a dynastic marriage or the official appointment of an heir. The particular combination of the two lineage histories seems to have

been redacted for the earlier marriage between Lord 8 Grass with an aunt of Lord 4 Deer, Lady 9 Deer. It is possible that there was an earlier codex, which ended with that marriage and which some years later was copied and brought up to date for the marriage of Lord 4 Deer. The given name of Lord 4 Deer is painted as an eagle with the sign 'Crossed Legs and Eyes'. This combination is to be read as *Yaha Ndisi Nuu*, which means both 'Sharp-eyed Eagle' and 'Eagle of Ndisi Nuu (Tlaxiaco)'. It suggests a particular relationship between Lord 4 Deer and the Ndisi Nuu dynasty.

Both royal families trace their history back to the sacred valley of Yuta Tnoho, 'in the beginning of time'. The obverse (p. 1 / 2-v) starts with the thorny ceiba tree from which the First Mother, Lady 1 Death, was born and depicts a Place of Heaven, while the reverse mentions the place-sign River with the Hand That Is Plucking Feathers. These elements appear also in the early colonial chronicles.

The Dominican Friar Antonio de los Reyes states in the beginning of his Mixtec grammar (1593):

> The general opinion among these Mixtecs was that the origin and beginnings of their Gods and Lords had been in Apoala, a village here in the Mixteca, which in their language is called Yuta tnoho, 'River from which the Lords came forward', because they say that they were plucked from some trees that grew out of that river...

Another Dominican chronicler, Friar Gregorio García, summarizes the ancient Mixtec story of creation in his book, *Origin of the Indians (1607):*

> In the year and on the day of darkness and obscurity before there were days or years, when the world was in great darkness and everything was chaos and confusion, the earth was covered with water: there was only slime and mud on the face of the earth.
>
> In that time … appeared visibly a God whose name was 1 Deer and whose given name was Puma Serpent, and a very pretty and beautiful Goddess whose name was 1 Deer and whose given name was Jaguar Serpent….
>
> With their omnipotence and wisdom they made and founded a huge rock, on top of which they constructed some palaces, very sumptuous and made with great skill, which were their seat and dwelling on earth ….

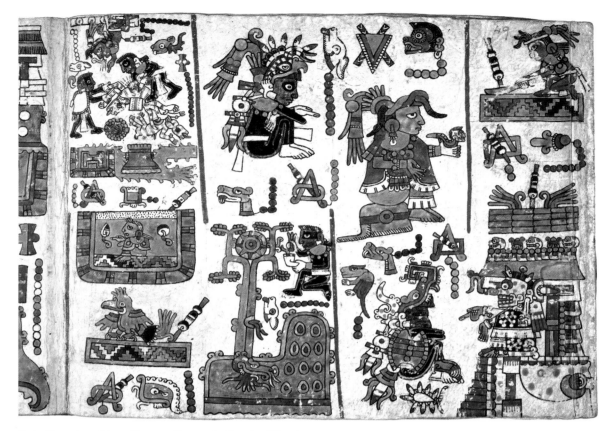

Codex Tonindeye (Nuttall), p. 44:Visit to the Temple of Death.

This rock with the places of the Gods was on a very high mountain, close to the village of Apoala, which is in the province of the Mixteca Alta. This rock … was called *Place where the Heaven was.*

This memory of a new creation corresponds to the archaeologically observable restructuring of the native society around 900 AD. There was a break then between the so-called 'Classic Period' (dominated by the influences from huge sites such as Teotihuacan in Central Mexico and Monte Albán in the central valley of Oaxaca) and the 'Postclassic Period'. Differences in style and in the preferred location of sites suggest a dramatic social change. The noble houses of the Postclassic Period saw it as 'a new sunrise'.

Although both the obverse and the reverse of Codex Bodley start with references to Yuta Tnoho, each side focuses on specific personages associated with that town and their different lineages. The information is brought together in the marriage of three princesses from Monte Albán with, respectively, a prince from Ñuu Tnoo (Tilantongo) in the Mixteca Alta, and two princes from Town of the Red and White Bundle, probably located in the Valley of Oaxaca. These weddings took place toward the end of the tenth century AD. The obverse follows the first couple (p. 3-i and p. 4-v), which ruled Ñuu Tnoo, while the reverse focuses on the descendants of the third couple, associated with Town of the Red and White Bundle (p. 4-i/ii and p. 36-iv). Information from Codex Añute (Selden) and Codex Tonindeye (Nuttall) helps to reconstruct what happened.

Several decades after the triple marriage, the first dynasty of Ñuu Tnoo fell victim to a troubled time of conflict. The king of Chiyo Yuhu (Suchixtlan), Lord 8 Wind, seems to have gained political supremacy in most of the Valley of Yanhuitlan and Nochixtlan, and to have taken control over the rulers of Ñuu Tnoo (Codex Bodley, pp. 5/6). Power in Ñuu Tnoo came into the hands of the High Priest, Lord 5 Alligator 'Rain Sun', who became the president of the Council of Four that ruled the village-state (Codex Bodley, pp. 7/8). He had two wives and several children.

The first-born son of his second marriage was Lord 8 Deer 'Jaguar Claw' (1063–1115), who grew up as a successful warrior. After his father's death, Lord 8 Deer started out on a daring adventure (pp. 9/10). It should be remembered that he did not belong to the royal dynasty of Ñuu Tnoo. Probably the legitimate ruler of Ñuu Tnoo, Lord 12 Lizard, had died by then, and his direct descendant, the infant Lord 2 Rain 'Twenty Jaguars' was in the custody of Lord 8 Wind of Chiyo Yuhu. Leaving a cave in which he had retired, either as an escape during an armed conflict or for religious purposes, young Lord 8 Deer turned to Lady 4 Rabbit 'Precious Quetzal' (p. 9-v). She was an important political personality, being sister to both Lord 12 Lizard (ruler of Ñuu Tnoo) and Lord 10 Eagle (ruler of Añute). In fact she was next in the royal bloodline of Ñuu Tnoo. Moreover she was married to the ruler of Dark Specked Mountain, probably Acuchi (Sosola), an important fortress in the northeast of the Mixtec Highlands. There Lord 8 Deer carried out several ritual acts on the day 5 Flower, a day of games and dances but also dedicated to the spirits of the warriors who died in battle or sacrifice (p. 10-v). We see him seated in front of a sanctuary of the Sacred Bundle and in front of a temple dedicated to 1 Death—the appropriate day for offerings to the Sun God and to the Great Mother of the Dynasty, Lady 1 Death. The Sun God is generally represented in full and associated with a precious temple; the Bundle suggests an ancestral cult. So it is plausible that Lord 8 Deer is venerating the great-great-grandmother of Lady 4 Rabbit. But at the same time he seems to have made vows to the Sun God, in preparation for activities that follow.

After all this, Lord 8 Deer challenged the Sun God (Lord 1 Death) and the Venus God (Lord 1 Movement), probably represented by human impersonators, to a ball game. In the typical Middle American version of this game, two individuals or small teams play a massive rubber ball by hitting it with the elbows and hips or, in the Mixtec variant, also with the hand, which is protected by a hard glove. The field had the form of a double T—such ballcourts can be seen in many archaeological sites. In this case, the day chosen for the occasion was 6 Serpent: it had a special significance for Lord 8 Deer as it functioned as the eve of his name day and was dedicated to a 'birthday' ritual (apparently the intermediate 7 Death was not considered a good day for ritual celebrations).

The story does not tell us what Lord 8 Deer had bet on this game, but certainly the stakes must have been high, probably involving his life. But he won and thereby gained the support of these deities, with which he 'conquered', i.e. obtained with great difficulty, a stone that contained the precious power of the West, the River of the Ashes (p. 10-iv). The Goddess of the West, also known as the Grandmother of the River, the old Lady 1 Grass, is associated with fertility and procreation. The River of Ashes is her realm and can be identified as the Nejapa River, the western border of the Mixtec region, but as this 'conquest' took place on the same day as the ball game (6 Serpent), certainly no journey to that area is implied. The action probably has a symbolic significance.

Lord 8 Deer's next act was to shoot a coyote on the Mountain of the Temple of Heaven. It was certainly not a normal hunting party, but another way to obtain power and to prepare for the following scene, which is represented in several ancient manuscripts of Ñuu Dzaui: the visit of Lord 8 Deer 'Jaguar Claw' to Lady 9 Grass in the Temple of Death. The place was the important funerary cave, Mountain of the Small Deer (Cerro de los Cervatillos), in the ancient kingdom of Ñuu Ndaya (Chalcatongo). It was the sanctuary where the ancient rulers of the Ñuu Dzaui village-states were buried together, a place full of the special powers of death. As such it was one of the caves that are known today as Vehe Kihin, scary places of doom, where daring people may go to ask Mephistophelean demons for luck, glory, and riches but, not unlike Faust, have to give up their soul in exchange. Modern Mixtec readers will sense that a fatal drama is set in motion here, a story of greatness and rapid success that will end in bloodshed and tragedy. The fact that the scene occurs in all the important codices of Ñuu Dzaui suggests that it was widely known as the turning point of a saga, recalled, told, and performed during court rituals.

Because of the different representations, we know that Lord 8 Deer did not go alone to the Vehe Kihin cave. He went there together with a young princess of Añute (Jaltepec), Lady 6 Monkey 'Garment (i.e. Virtue or Power) of the Plumed Serpent', who was related to the dynasty of Ñuu Tnoo. Her story is told with much more detail in Codex Añute (Selden), where she is shown visiting the Vehe Kihin on her own. The boustrophedon reading of Codex Tonindeye (Nuttall), p. 44, starts at the upper right hand corner: after Lord 8 Deer's conquests we see the Temple of Death, the Vehe Kihin, with its Patron or Spiritual Guardian, elsewhere named Lady 9 Grass. A man, Lord 3 Lizard, painted black, his eyes closed, i.e. as a priest in trance, transformed into a Fire Serpent (i.e. flying as a ball of lightning through the air), has guided Lady 6 Monkey of royal descent (seated on a jaguar throne), and Lord 8 Deer in priestly function, to this place. It was the day 6 Serpent of the year 6 Reed (1083).

The reading order of the scene in Codex Añute is from the bottom upward, in a boustrophedon fashion, starting at the lower left-hand corner.

p. 5-iv/6-i: Lady 9 Wind 'Power of Flint', 'Jewel of the Deceased Lord 8 Wind (her father)' sat down as ruler on the mat and the throne of Añute and married Lord 10 Eagle 'Stone Jaguar' (son of Lord 10 Flower and Lady 2 Serpent) from Ñuu Tnoo on the day 10 Deer of the Year 3 House (1041). Their three sons carry white banners indicating that they were killed in human sacrifice. That happened during a war ritual for the Flayed God on the day 8 Vulture, year 9 House (1073). They were buried in the Temple of Death (Ñuu Ndaya). Their younger sister, Lady 6 Monkey 'Power of the Plumed Serpent' escaped the ordeal because she was put under the protection of an elder priest, Lord 10 Lizard 'Jade Axe'.

p. 6-ii: In the year 4 House (1081 AD), on the day 4 Wind, Lady 6 Monkey's father, Lord 10 Eagle 'Stone Jaguar', had to defend his kingdom, Añute (Jaltepec), against the attack of Lord 3 Serpent 'Jeweled Hair' (a son of Lord 8 Wind of Chiyo Yuhu). Lord 10 Eagle won the battle, grabbed his opponent by the hair and stabbed him with his spear. Lord 3 Lizard was crying. Because of this conflict, Lord 2 Rain 'Twenty Jaguars' (the infant prince of Ñuu Tnoo) went to consult the oracle of the 'Precious Heart of the People of the Rain God' (a sacred Bundle) in a cave above a river (located near Ñuu Ndecu, Achiutla).

p. 6-iii: Similarly Lady 6 Monkey and her tutor Lord 10 Lizard 'Jade Axe', who had now also gained the titles 'Eagle Down', 'Arrow', and 'Flaming Mirror', went on a journey to win divine support. They invoked a divine being (Ñuhu), called Lord 6 Vulture, whose given name

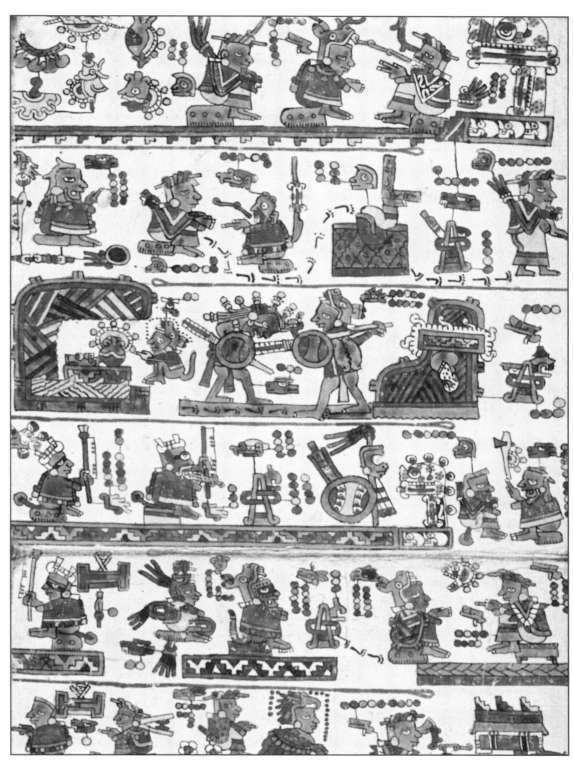

Codex Anūte (Selden), pp. 5–6: The story of Lady 6 Monkey.

is painted as a digging stick *(yata)* with a bone *(yeque)* and may be translated as 'Ancient Bone' or 'Bone from the Past' *(YequeYata)*. This spirit, apparently conjured from an old bone, gave Lady 6 Monkey permission to enter a subterranean passage, which brought her to the Temple of Death, the Vehe Kihin of Ñuu Ndaya. It was the day 6 Serpent of the year 5 Reed, which should be corrected to 6 Reed (1083).

p. 6-iv. The Patron of the Vehe Kihin, Lady 9 Grass, spoke to Lady 6 Monkey about Lord 11 Wind 'Blood Jaguar' (here erroneously 10 Wind), who was to be her husband. In gratitude the princess offered a set of precious objects.

Codex Tonindeye (Nuttall) and Codex Nacuaa (Colombino-Becker) tell us that Lady 6 Monkey and young warrior Lord 8 Deer sat side by side in the cave, invoking its awe-inspiring Patron, Lady 9 Grass, a skeletal and macabre figure with bloodshot eyes. Their close combination in this act suggests that both youngsters may have planned to marry each other, but the spirit of the cave decided otherwise. Lady 9 Grass arranged for Lady 6 Monkey to wed a quite different person: Lord 11 Wind 'Blood Jaguar' from Town of the Red and White Bundle, an older man, who had been married before to Lord 8 Deer's half-sister. This union is also documented on the reverse side of Codex Bodley (pp. 36/35).

Meanwhile, Lord 8 Deer was ordered by Lady 9 Grass to leave the Mixtec Highlands. He went to the Pacific Coast, where, thanks to his great ability in warfare, he founded his own kingdom in Yucu Dzaa (Tututepec). It was there that he was contacted by ambassadors of a great king in Central Mexico: Lord 4 Jaguar, ruler of the Toltec empire, whom Aztec chronicles refer to as Nacxitl Topiltzin Quetzalcoatl. Lord 4 Jaguar proposed a political and military alliance to Lord 8 Deer, and invited him to his capital Tollan-Chollollan (present-day Cholula) to receive the distinction with the turquoise nose-plug, a symbol of Toltec rulership (Codex Bodley, p. 9-ii).

For Lord 8 Deer this alliance came at exactly the right moment. The infant prince of his home town, Lord 2 Rain 'Twenty Jaguars', last direct descendant of the founders of the first dynasty of Ñuu Tnoo, had arrived

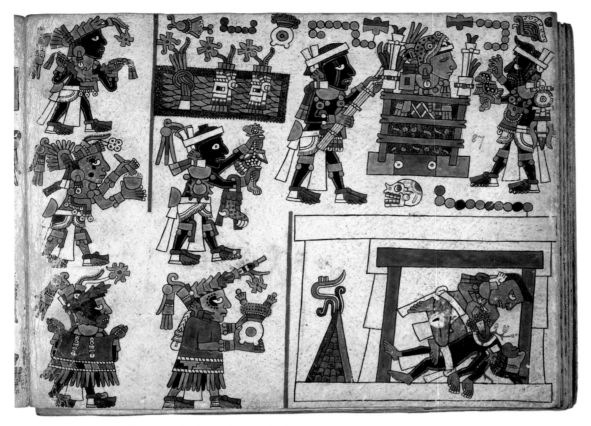

Codex Tonindeye (Nuttall), p. 81: Murder in the steambath.

sacrifice, but it is quite straightforward to anyone familiar with the sweatbath, still in use today. The bath is a type of sauna. Normally one person, generally a healer, or in other ways an expert in this ritual activity, will add to the invigorating effect on the bather by hitting him with branches. On this occasion, a major sacrilege took place. The healer—a mercenary not identified by name—had hidden a knife between the leaves and, amid the vapours and darkness of the bath, killed Lord 12 Movement with it.

at the age of 21 and started consultations and rituals to reclaim his ancestral throne and to obtain effective rulership. Codex Bodley, p. 5-i, shows that the outcome was quite different, however. We see the calendar name 2 Rain connected to a 'road of knife and star' that leads to heaven. After that, a red line marks the end of this chapter. Such a celestial road with knives and stars is a metaphor for shamanic trance. The fact that it ends Lord 2 Rain's career makes us understand that he went out on an ecstatic voyage but did not return: he died in the trance, leaving the kingdom of Ñuu Tnoo without a legitimate successor.

In this moment of crisis, the support of the Toltec king enabled Lord 8 Deer to take over power in Ñuu Tnoo. From all over the Ñuu Dzaui lands, and even from farther away, nobles and kings came to acclaim his accession to the throne. Codex Tonindeye (Nuttall), pp. 54-68, counts 112 participants in the ceremony. Afterwards Lord 8 Deer accompanied Lord 4 Jaguar on a military campaign to the faraway Maya region, where tradition has it that they entered the Realm of the Dead Ancestors and Sacrificed Warriors, finally arriving at the Precious Temple of the East (probably located at Chichen Itza), where they spoke to the Sun God himself.

Codex Bodley only refers in passing to these events, and is silent about the dark period that followed. Returning to Ñuu Tnoo, Lord 8 Deer seems to have had a hand in the killing of his elder half-brother: Lord 12 Movement, son of his father's first marriage, was murdered while taking a steambath. The scene in Codex Tonindeye (Nuttall), p. 81, describes the murder. The scene has often been interpreted as a human

The reading order is boustrophedon, starting at the lower right-hand corner: Lord 12 Movement is killed in a steambath. Afterward his body is dried above a fire and made into a bundle. Priests and nobles come, bringing offerings and paying their respects.

Lord 8 Deer, although the first one to benefit from the death of his older half-brother, blamed this political murder on two sons of his older half-sister, i.e. the lady who had been the first wife of Lord 11 Wind of Town of the Red and White Bundle, now married to Lady 6 Monkey. In 1101 AD, exactly 365 days after Lord 12 Movement was killed in the steambath, Lord 8 Deer attacked Town of the Red and White Bundle and took the whole royal family prisoner (Codex Bodley, p. 34-v). The queen, Lady 6 Monkey, his former companion in visiting the Vehe Kihin, was killed, and so were the male descendants of the first marriage of her husband. Lord 8 Deer then married the only female descendant, Lady 13 Serpent, in order to appropriate their estate and heritage. Lady 6 Monkey's own son, Lord 4 Wind, escaped by hiding in a cave.

In the following years Lord 8 Deer married four other wives in a row (Codex Bodley, pp. 11/12). Years went by, but Lady 13 Serpent, probably traumatized by these violent events, did not become pregnant. When his second wife gave birth to a son, a dynastic problem arose. In response, Lord 8 Deer took Lady 13 Serpent to a temple, where both encountered a huge vision serpent. In other words they had a visionary experience in the sanctuary that helped the young woman to overcome her trauma. Nine months later she gave birth to a son.

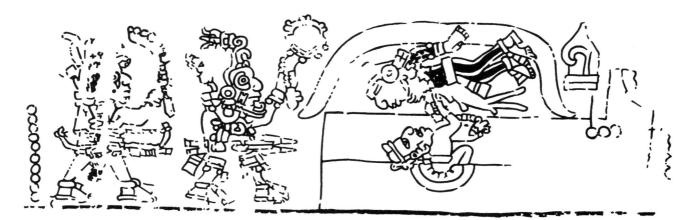

Codex Iya Nacuaa I (Colombino), p. 16: Lord 4 Wind and his companion looking at Lord 8 Deer being murdered in his sleep.

The different wives with their children must have caused a lot of discussion and intrigues at the court about securing privileges and obtaining power. It was in this tense atmosphere that Lord 8 Deer went hunting in the land of his second wife. There he was ambushed by Lady 6 Monkey's son, Lord 4 Wind. Codex Nacuaa I (Colombino), p. 16, shows how Lord 8 Deer was sleeping under a blanket when a man rose up from the earth and stabbed him with a knife. Lord 4 Wind was standing nearby and raised a stick and a stone, the symbol of punishment. It was the night of 12 House, that followed the day 11 Wind, the birthday of Lord 4 Wind's father, an appropriate day for such vengeance.

Codex Bodley obverse, p. 14-v, shows the killing of Lord 8 Deer too and adds that he was buried with the insignia of a great king, a Toltec ruler, in the dark sanctuary, i.e. in the large funerary cave, at Ñuu Ndaya (Chalcatongo), where, after him, all Mixtec kings would be buried. The reverse side of Codex Bodley tells us about what happened then. First Lord 8 Deer's Toltec ally, Lord 4 Jaguar, persecuted Lord 4 Wind, but in the end he decided that it was more practical to accept the new reality and to form a new alliance with the new 'strong man' in the region. So Lord 4 Jaguar and Lord 4 Wind were reconciled by the Sun God. This was the beginning of Lord 4 Wind's long reign. He chose a new capital, Ñuu Yuchi, 'Town of Flint', the remnants of which—several mounds around plazas—are now known as the archaeological site Mogote del Cacique in the hamlet San José Tres Lagunas, near Ñuu Tnoo.

In order to obtain legitimacy in the eyes of all who admired Lord 8 Deer and were loyal to him, Lord 4 Wind wed the daughter of Lord 8 Deer and Lady 13 Serpent (who was Lord 4 Wind's own half-sister): Lady 10 Flower 'Spiderweb of the Rain God' (Codex Bodley, p. 29-iv). It was probably at their court that the saga of Lord 8 Deer obtained its literary form. The author, in all likelihood a great storyteller and dramatic performer, created a fascinating and unusually profound, even 'Faustian', vision of the protagonist: not a simple, triumphalist story of a local hero, but a moving, tragic account of human ambition and the dark forces of the Underworld. This epic of destiny and doom may have been composed this way in the context of commemorative rituals, in which both the killer and the daughter of Lord 8 Deer participated as king and queen.

It was in the early days of Lord 4 Wind's reign that we find the first mention of Ndisi Nuu (Tlaxiaco), as a temple visited by Lord 4 Wind (Codex Bodley, p. 32-iv). This association was enough reason for the painter to include this whole story as antecedent of the Ndisi Nuu dynasty, which occupies the rest of Codex Bodley reverse.

After Lord 4 Wind's death in 1164 AD, the Supreme Council of Ñuu Yuchi approached his two direct descendants as possible successors, but as small children they were no match for a third person on the political scene: Lord 7 Water 'Red Eagle' of Chiyo Cahnu (Teozacualco). Probably he was first invited to be a protector of the infants, but he seems rapidly to have taken matters into his own hands. Shortly afterwards, in 1175, his son, Lord 13 Eagle 'Sacred Rain', attacked the temple of Ndisi Nuu (Tlaxiaco).

The armed conflict may indicate that, after the death of the great ruler Lord 4 Wind, the different regions and noble houses claimed their autonomy. The Ndisi Nuu area was under the control of Lord 8 Jaguar 'Blood Coyote', who may have been a governor appointed by Lord 4 Wind. He took advantage of the power vacuum to convert Ndisi Nuu into a mat and throne of his own (Codex Bodley, p. 28-i). His descendants reinforced their legitimacy by intermarrying with another new dynasty, that of Ñuu Ndecu (Achiutla), also a major religious centre that now developed from an important sanctuary into the capital of an independent village-state.

The genealogical accounts that follow on both the obverse and the reverse side of Codex Bodley show the intricate relationships between the Ñuu Dzaui polities. Political autonomy of the communities, each having its own royal house, was complemented by a network of marital alliances. On several occasions the dynasties of obverse and reverse connected, for example when Lady 1 Monkey of Ñuu Tnoo married Lord 12 Rain of Ndisi Nuu (p. 15-ii and p. 26-iv right side), when the widow queen of Ñuu Tnoo, Lady 6 Water married Lord 4 Death from Ndisi Nuu (p. 15-v and p. 25-v), and when Lady 9 Deer of Ñuu Tnoo married the famous Lord 8 Grass of Ndisi Nuu (p. 20-ii and p. 21-iii). In this way the genealogical histories of the different lineages were interwoven and a common history of Ñuu Dzaui emerged.

The sociopolitical system

The historiography of the village-states shows both individualizing and group-oriented tendencies, which probably correspond to the reality of the underlying structures and dynamics of the Ñuu Dzaui world. The formation of social boundaries is manifest in the marking of the rulers' body with nice clothing, jade earspools, turquoise necklaces, golden jewels, and quetzal feathers; in the distinction of the rulers' palace-structures with fine stonework, mosaics, and relief carvings; and in the ornamentation of the rulers' tombs with paintings and funerary offerings. On the other hand, lineage history does not focus on the human individual as such, but on kinship structures. All those kings and queens, though identified by name, are painted in the same generalizing manner, as incidental players of permanent roles in a communitarian ethos.

The main segment of the pictorial chronicles deals with the genealogical connections between the noble houses, as a chart for identifying prospective marriage partners and the implications of kinship policies in terms of heritage rights (tributes and other privileges). The marital alliances both connected the rulers as members of a large, supralocal family, and stimulated social and economic interaction between communities. The codices present the beginnings of this 'grand dynasty' as a creation story, shrouded in sacred mystery and metaphors: the First Rulers were children of Dawn, born from Earth or from the Sacred Mother Tree. Then follows the epic tale of Lord 8 Deer and Lady 6 Monkey, which served also as a mechanism to create a narrative identity and to integrate the communities. Moreover, by marrying various wives Lord 8 Deer became the founder of several new lineages, among which were those of Ñuu Tnoo and Chiyo Cahnu. Their intensive interactions among each other and with other polities formed the genealogical-chronological framework for Ñuu Dzaui history in the four centuries that followed.

The choices of marital alliances reflect the geographical horizon of the sovereign communities, and at the same time their historical dynamics. In the earliest epoch, the centre of outside validation was Monte Albán. In the period of Lord 8 Deer it shifted to Cholula in Central Mexico. Where the centralist historiography of that region only refers to the Toltec ruler Nacxitl Topiltzin Quetzalcoatl as a divine hero, the Ñuu Dzaui codices focus on the agency of their own local leaders, such as Lord 8 Deer. The demise of the Toltec empire —the collapse of the 'core'—coincided with the end of the period of Lord 8 Deer and Lord 4 Wind. During the next century, the Ñuu Dzaui polities looked inward

and seem to have had few, if any, long-range contacts. Meanwhile new independent village-states were founded, such as Chiyo Cahnu (Teozacualco), Ñuu Ndecu (Achiutla), and Ndisi Nuu (Tlaxiaco). Probably this was not a fission of existing polities, but the rise of new royal lineages, accompanied by a relocation of their capitals.

At the end of the thirteenth century, this tendency changes with the marital alliance between Chiyo Cahnu and Zaachila, which led to regional interaction on a much larger scale. In the second half of the fifteenth century we see a counterpart phenomenon: the struggle against the invading Aztecs, followed by the Spanish conquest (1521) and the incorporation of both the Aztec realm and the Ñuu Dzaui village-states in the Spanish colonial empire.

Nowadays it is common to analyse ancient rulership in terms of control of strategic resources and trade routes, combined with the coercion of people (mainly through military force and warfare); in turn, ideological indoctrination and manipulation provide legitimation. Ñuu Dzaui historiography, however, stressed other, less materialist, aspects of power. Land was not seen as a commodity but as the living space of a deity (Ñuhu). The fundamental social-religious covenant was that those who venerated the divine Patron or true Owner of the place were allowed to use the land to plant and to harvest. In this context the ruler becomes an intermediary, or rather a connection, between society (ñuu) and the sacred (ii). This makes the royal couple a pivot in the diverse domains of social and religious life. Consequently the stories about creation and the common origin of dynasties, as well as those about the dramatic destinies of Lord 8 Deer and Lady 6 Monkey, have moral and ritual implications. Power was derived from the Divine Forces of Nature, and demanded devotion, care, and respect for the Ancestors, the Gods, and the Sacred Places in the landscape that surrounded the community.

In addition, the genealogical register suggests that, in the village-state culture, influence was exercised more through alliances than through military means and (the threat of) war. Delicate diplomacy and respect for important elders and neighbours were key elements for success. Reciprocity, generally ritualized, was the cornerstone of the system, the underlying moral principle of tributary obligations, of gift-giving, and even of honest bartering in the market.

This behaviour found its logic not only in kinship relations but also in the landscape. From very early times the Ñuu Dzaui economy must have been determined by the differentiation in production according to an altitude, which naturally promoted an interdependency and symbiosis

between the cold mountainous areas of the Highlands and the tropical zones of the deep river gorges and the coastal lowlands. Specific resources such as salt or obsidian, as well as local specializations in craft production (ceramics, basketry, weaving, etc.) certainly gave additional impulses to the exchange networks. Getting precious materials (jade, feathers, gold, shell, turquoise) and artefacts from far away was crucial for expressing high status, but by definition a limited affair. At the same time the community shaped its own cultural landscape locally, by constructing impressive and perennial ceremonial centres, where social bonds and corporate identity could be ritually reaffirmed.

Pictorial writing—and its public performance—probably played a major role in the process of local and interregional communication and network-forming. The recitation of such texts was an essential part of community rituals, and therefore of the construction of corporate identity, both on the local level and in a wider network of contacts: such impressive ceremonies must have drawn pilgrims and other people from far away. At the same time the codices themselves are easy to transport: they would have permitted the communication of narratives and ideas beyond the constraints of specific languages.

Dynastic marriages are to be considered true alliances between sovereign communities, with important consequences for commitment to loyalty and mutual support. Other forms of contact and interaction must have complemented these alliances. The bride or groom who left his or her own 'house' to live in another polity was probably accompanied by personal attendants and counsellors, and must have gone back regularly to his or her home-town to participate in rituals and important family events. At the same time he or she received part of the inheritance of his or her parents, which led to a continuous connection with the tribute-paying vassals of the original estate. These personal relationships functioned against the background of cycles of supralocally important rituals, pilgrimages, markets, and long-distance trade, which brought about a religious-economic integration on a regional level. Cultivating such interactions and relationships was a crucial part of the village-state culture.

The genealogical history of these manuscripts introduces a time-depth of many generations, which permits a long chronological perspective. There is no dramatic emotion here, but a calculated framework for the politics of the noble houses. Generally lineage-historiography followed the line through the first-born son, but the intricate web of marital alliances also made it possible and necessary to follow the other lines. By including parentage statements for the wives, the codices register not only the male line of descent but also, in a more implicit way, the female line. Thus the record obtains the intertwined structure of a woven mat. Indeed, this is the central symbol of both marriage and rulership.

In general this type of historiography must have imbued the members of the royal family with a sense of belonging and commitment. The choice of a partner was determined by the parents and confirmed by those who acted as the marriage ambassadors, the wise elders of the community, the prefigurations of the present-day godparents. According to Ñuu Dzaui custom, the parents of the prospective groom took the initiative, and those of the bride held the key to the outcome. Therefore in the negotiation both parties, that of the man and that of the woman, were equally important. Although on first sight it was the father of the crown-prince who appeared as the great planner of the alliance, present-day practice makes us suspect that in reality it was the mother of the future queen who decided.

While the stories of the great kings and queens were recited and performed in the plazas of the ceremonial centres, dynastic policies with their alliances and marriages were discussed and planned around the central fireplace of the royal residences. This realm of the hearth was probably the sphere of female action and decision-making. We should not idealize this situation, however. The assembly that came together for the offering of royalty was an exclusively male affair, indicating that men controlled the public aspect of power. Moreover, the fact that princesses were often very young at the time of contracting marriage indicates that there was no real concern for their personal will or opinion, much less a concept of individual development. Arranged and forced marriages seem to have been the rule. Just as in other early state societies, the young couple had to subject personal considerations and feelings of love to dynastic politics, the age-old paradigmatic structure of relationships between the noble families. Only in this way could the rights and privileges of the mat—symbol of marriage and of power—be obtained. Self-realization was achieved through self-sacrifice. A similar message was contained in the rituals that each generation had to perform: the invariable sequence of penitence and visionary experiences was the spiritual backbone of royalty, mediating between the community and the Forces of Nature in their age-old covenant.

The position of the rulers, then, was to a large extent based on the way in which they succeeded in investing in their relationships with others, both inside their realm and abroad, through family ties, ritual kinship, gifts, and reciprocity. The same holds for the village-states them-

selves, which did not derive their prestige and influence from coercive force, but from being a node in a complex interactive system. We now understand that the genealogical accounts are much more than a family history. On an ideological level they document the kinship-based world-view of the village-state culture: this was a landscape of autonomous units, all governed by their own dynasty, but at the same time all ideally connected through bonds of brother- and sisterhood.

List of the main identified places in Codex Bodley

First the Dzaha Dzaui name is given, followed by a translation and, in brackets, the modern name, generally derived from Nahuatl followed by a description of the pictorial representation.

Yaa Yuta, 'River of Ashes' (Río Nejapa), emblem of the West: *cross section of a river with black dots representing ashes.*

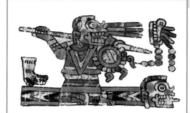

Huahi Cahi (Vehe Kihin), 'Funerary Cave' (on the Mountain of Deer, near Chalcatongo), emblem of the South: *temple of skull and bones.*

General

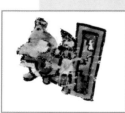

Ñuu Dzaui, 'Land/People of the Rain God' (La Mixteca): *frieze with head of the Rain Deity (identified by large teeth and goggled eyes).*

Cavua Caa Andevui, 'Rock That Rises into Heaven' (near Apoala), emblem of the East: *mountain with a blue band filled with eyes that represent stars.*

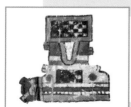

Yucu Naa, 'Dark Mountain' (near Tepeji), emblem of the North: *mountain with a checkerboard motif, combined with split mountain.*

Mixtec Highlands

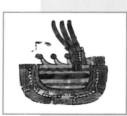

Yuta Tnoho, 'River That Pulls Out [weeds]' (Apoala): *cross section of a river with a hand that is plucking feathers.*

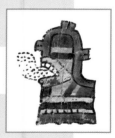

A-ñute, 'Place of Sand' (Jaltepec): *mountain with a mouth that spits black dots representing sand.*

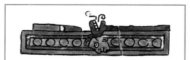

Adzeque, 'Place of Head' (San Miguel Adeques) and Ñuu Naha, 'Ancient Town' (San Pedro Cántaros): *frieze with a head, mouth, and words.*

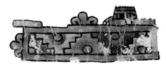

**Sachio, 'At the Foot of the Altar'
(Sachio near Jaltepec):** *altar with feet.*

Acuchi, 'Place of Gravel' (Sosola): *mountain
with mouth and dark specked material.*

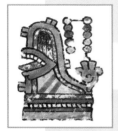

**Yucu Ndeque, 'Mountain of the Horn' (Huau-
clilla):** *frieze with pointed objects.*

**Yucu Ita, 'Mountain of Flowers'
(Yucu Ita, near Nochixtlan):** *mountain
with flowers.*

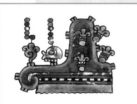

**Chiyo Yuhu, 'Hidden Altar'
(Suchixtlan):** *basement with strawberry
tree (yuhndu).*

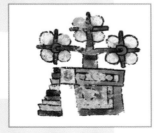

**Andua, 'Place of Spiderwebs'
or 'Place of Arrows' (Andua
in the Valley of Yanhuitlan):**
frieze with spider's web.

**Yodzo Cahi, 'Large Plain'
(Yanhuitlan):** *plain with mouth
and bird with arrow beak.*

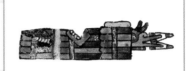

**Ñuu Tnoo, 'Black Town'
(Tilantongo):** *frieze with
black step-fret motif.*

**Yute Coo, 'River of the
Serpent' (running southward
from Tilantongo):** *cross section of
a river with a serpent on it.*

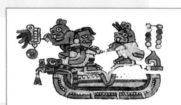

**Ñuu Yuchi, 'Place of Flint'
(Mogote del Cacique, near
Tilantongo):** *frieze with flints.*

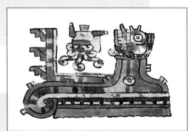

**Dzandaya, 'Place of Death'
(Mitlatongo):** *skull mountain.*

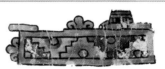

**Ñuu Ndecu, 'Burning Town'
(Achiutla):** *frieze with flame.*

**Chiyo Cahnu, 'Big Altar'
(Teozacualco):** *frieze that is
broken or frieze with flower.*

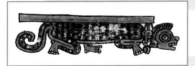

Ticodzo, 'Monkey Place' (Teita): *frieze with monkey.*

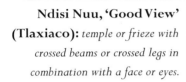

Ndisi Nuu, 'Good View' (Tlaxiaco): *temple or frieze with crossed beams or crossed legs in combination with a face or eyes.*

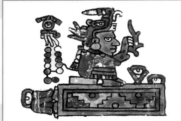

Ñuu Ndaya, 'Death Town' (Chalcatongo): *frieze with skull.*

Yuu Usa, 'Stone Seven' (Yuxia, near Chalcatongo): *mountain with seven stones.*

Yucu Cahnu, 'Big Mountain' (Monte Albán): *mountain that is opened or torn, place of altars and vessels, mountain of the moon or reed, slope of the fly.*

Tocuisi, 'White Lords' (Zaachila): *town or plain with carrying frame.*

Pacific Coast

Ñuu Sitoho, 'Town of the Lords' (Juquila): *frieze with a hand plucking feathers.*

Yucu Dzaa, 'Mountain of the Birds' (Tututepec): *stone with bird.*

Valley of Oaxaca

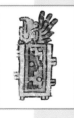

Ñuu Ndodzo, 'Town of the Quetzal' (Huitzo): *frieze with quetzal bird.*

Ñuu Nduchi, 'Town of Beans' (Etla): *frieze with black beans.*

Mixtec Lowlands

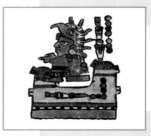

Ñuu Huiyo 'Town of Young Maize', analysed as '(Place of the calendar name) 6 Reed' (Tuctla): *mountain with the calendrical sign 6 Reed.*

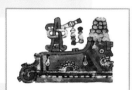

Nuu Siya, 'Place of (Pearls of) the Lord' (Tezoatlan): *mountain of pearls with face.*

Ñuu Niñe, 'Place of Heat' (Tonalá): *red sweatbath.*

Ñuu Ñaña, 'Place of Jaguars/Coyotes' (Cuyotepeji): *frieze with jaguar.*

Centre of Mexico

Ñuu Cohyo, 'Town of Reeds' (Tollan, i.e. Cholula; later: Mexico City): *frieze with cattail reeds.*

The House of Ñuu Tnoo (Tilantongo)

The genealogy of Codex Bodley can at times seem complex. The following is a list of the main protagonists in each of the lineages. Within a dynasty, each new generation represents the child of the foregoing couple. This is only a summary presentation: the + sign is used to indicate marriage (the number 2 between brackets indicates that the mentioned partner represents a second marriage), while b. stands for 'birth' and d. for 'death'.

First dynasty

Lady 1 Death 'Sun Fan' + Lord 4 Alligator 'Blood Eagle', married 940.

Lady 1 Vulture 'Cloud Jewel' + Lord 4 Rabbit 'Jaguar, Who Carries 1 Alligator in His Breast'.

Lady 5 Reed 'Rain Power' + Lord 9 Wind 'Stone Skull' (the descendant of a local dynasty associated with River of the Serpent, b. 942), married in 990.

Lord 10 Flower 'Jaguar with Burnt Face' (b. 992) + Lady 2 Serpent 'Plumed Serpent' (daughter of Lord 8 Wind, Chiyo Yuhu), married in 1013.

Lord 12 Lizard 'Arrow Feet' + his nieces Lady 4 Flint 'Quetzal Feather Face' and Lady 4 Alligator 'Jewel Face'.

Lord 5 Movement 'Smoke of Heaven' + (2) Lady 2 Grass 'Precious Quetzal', married in 1073.

Lord 2 Rain 'Ocoñaña' (b. 1075, d. 1096).

Second dynasty

Lord 5 Alligator 'Rain Sun' (priest since 1025) + (2) Lady 11 Water 'Blue Parrot', married in 1061.

Lord 8 Deer 'Jaguar Claw' (b. 1063, d. 1115) + Lady 6 Eagle from Ñuu Ndaya (Chalcatongo), married in 1105.

Lord 6 House 'Jaguar That Came Down from Heaven' (b. 1109) + Lady 9 Movement 'Jade Heart', married in 1138.

Lord 5 Water 'Stone Jaguar' + Lady 10 Reed 'Quetzal Jewel'.

Lord 8 Reed 'Pheasant' (b. 1162) + his sister Lady 5 Rabbit 'Jewel'.

Lord 2 Movement 'Serpent with Markings' + his niece Lady 4 Eagle 'Blood Garment' (from Teita).

Lord 1 Lizard 'Blood Jaguar' + Lady 6 Reed 'Jewel'.

Lord 12 Reed 'Coyote Sun' + his sister Lady 3 Jaguar 'Precious Butterfly Sun'.

Lord 5 Rain 'Sun Movement' + his niece Lady 13 Lizard 'Truly Precious Butterfly'.

Lord 13 Wind 'Fire Serpent' + his father's cousin Lady 1 Eagle 'Jade Fan', married in 1277.

Lord 9 Serpent 'Jaguar That Lightens the War' + Lady 8 Flint and Lady 7 Flower.

Lord 4 Water 'Blood Eagle' (b. 1301, d. 1341) + his niece Lady 6 Water 'Quetzal, Jewel of the Flower War' (daughter of his sister Lady 6 Reed 'Plumed Serpent' and Lord 2 Dog of Chiyo Cahnu).

Third dynasty

Lady 6 Water 'Quetzal, Jewel of the Flower War', widow of Lord 4 Water + Lord 4 Death 'War Venus of Ndisi Nuu', married in 1343.

Lady 3 Rabbit 'Divine Spiderweb' (b. 1345) + her maternal uncle Lord 9 House 'Jaguar That Burns the Nahuas' (son of Lady 6 Reed and Lord 2 Dog of Chiyo Cahnu b. 1323), married in 1353 or 1355.

Lord 2 Water 'Fire Serpent That Burns the Nahuas' (b. 1357) + Lady 2 Vulture 'Flower Jewel' (Teita).

Lady 12 Flower 'Split Mountain Butterfly' + Lord 13 Eagle 'Blood Jaguar' (Chiyo Yuhu).

Lord 6 Deer, 'Sacred Rain' (b. 1393) + Lady 13 Wind 'Seed of Split Hill'.

Lord 4 Flower 'Pheasant' (b. 1409) + Lady 7 Vulture 'Quetzal Fan'.

Lord 10 Rain 'Rain Sun'(b. 1438) + his cousin Lady 5 Wind 'Cacao Flower'.

Lord 4 Deer 'Eagle of Ndisi Nuu' (b. 1476).

The House of Ndisi Nuu (Tlaxiaco)

Antecedents

Lord 1 Flower 'Quetzal' and Lady 13 Flower 'Quetzal'(Yuta Tnoho).

Lady 9 Alligator 'Rain, Plumed Serpent' + Lord 5 Wind 'Rain Who Came Down from Heaven' (from Ñuu Niñe).

Lord 5 Reed 'Arrows in the Back' + Lady 3 Serpent 'Flower of the Rising Deity (the East)'.

Lady 13 Eagle 'Bird with Precious Tail' + Lord 5 Alligator 'Rain' (from Nuu Siya?).

Lady 6 Eagle 'Jewel Flower' + Lord 2 Rain 'Jaguar-Sun'.

Lord 7 Movement 'Earth Face' (b. 940) + Lady 12 Serpent 'Blood Knife', rulers of Town of the Red and White Bundle.

Lord 9 Deer 'Jade Bone, Flute' + Lady 10 Alligator 'War Jewel'.

Lord 11 Wind 'Blood Jaguar' + (2) Lady 6 Monkey 'Garment (Virtue, Power) of the Plumed Serpent' (Añute), married in 1090.

Lord 4 Wind 'Fire Serpent' (b. 1092) makes offerings to Lady 9 Reed in the Temple of Ndisi Nuu (1123).

First dynasty

Lord 8 Jaguar 'Blood Coyote' + Lady 2 Vulture 'Jewel Fan' .

Lord 2 Wind 'Blood Rain' + Lady 4 Death 'Fan of Flames' (Ñuu Ndecu).

Second dynasty

Lord 1 Deer 'Eagle of Ndisi Nuu' (great-grandson of Lord 8 Jaguar) + Lady 10 Grass 'Precious Butterfly'.

Lord 12 Rain 'Blood Jaguar' (d. 1305) + Lady 1 Monkey 'Beauty of Jade' (daughter of Lord 12 Reed and Lady 3 Jaguar, Ñuu Tnoo).

Lady 8 Serpent 'Sun Spiderweb' + Lord 3 Dog 'Venus Sun' (descendant of Lord 8 Jaguar).

Lord 12 Deer 'Fire Serpent That Lightens the War' + his niece Lady 11 Lizard, 'Jewel of Flames' (Ñuu Ndecu).

Third dynasty

Lady 11 Rabbit 'Jewel of the Rising Deity (the East)' (Ñuu Ndecu) + Lord 10 Rabbit 'Blood Jaguar' (1330s).

Lord 9 Rain 'Blood Jaguar' + Lady 7 Flint 'Quetzal-Fan' (daughter of Lady 6 Reed and Lord 2 Dog, Chiyo Cahno).

Lord 11 Wind 'Smoking Claw' + Lady 4 Grass, 'Flower Jewel' (Ñuu Ndecu).

Lord 1 Monkey 'Rain-Sun' + Lady 5 Flint 'Heavenly Fan' (descendant of Lord 10 Rabbit and Lady 11 Rabbit).

Lord 13 Eagle 'Eagle of Ndisi Nuu' + his cousin, Lady 8 Jaguar 'Jaguar Power' (Ñuu Ndecu).

Lady 5 Flower 'Quetzal Sun' + Lord 5 Rain 'Eagle That Came Down from Heaven' (b. 1402, son of Lord 2 Water of Ñuu Tnoo and Lady 3 Alligator of Zaachila).

The generation of Lady 8 Deer 'Quetzal Spiderweb', Lord 8 Deer 'Fire Serpent', Lord 3 Serpent 'Venus Sun' and Lord 8 Grass 'Rain Sun'(b. 1435).

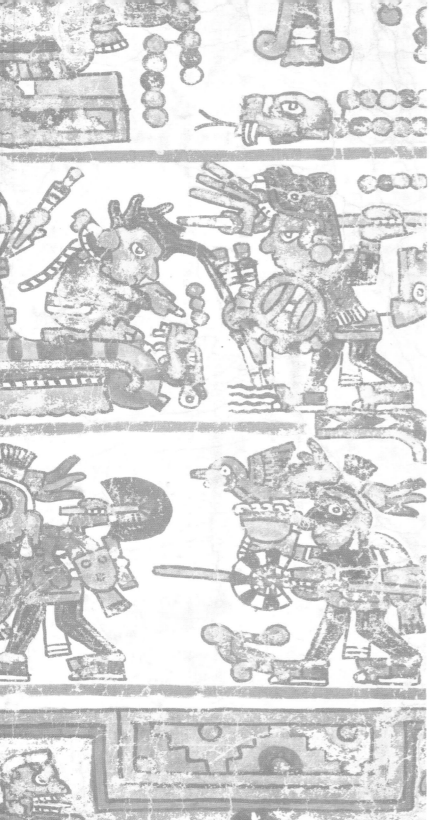

Further Reading

General works on Middle American civilization

Robert M. Carmack, Janine Gasco, & Garry H. Gossen, *The legacy of Mesoamerica. History and Culture of a Native American Civilization* (Upper Saddle River, N.J.: Prentice Hall, 1996).

Oxford Encyclopedia of Mesoamerican Cultures, ed. David Carrasco (Oxford: Oxford University Press, 2001).

Susan T. Evans, *Ancient Mexico and Central America. Archaeology and Culture History* (New York: Thames & Hudson, 2004).

The Postclassic Mesoamerican World, ed. Michael E. Smith & Frances Berdan (Salt Lake City: University of Utah Press, 2003).

Archaeology of the region

Richard E. Blanton et al., *Ancient Oaxaca. The Monte Albán State* (Cambridge: Cambridge University Press, 1999).

The Cloud People: Divergent Evolution of the Zapotec and Mixtec Civilizations, ed. Kent Flannery & Joyce Marcus (New York: Academic Press, 1983).

Estructuras Políticas en el Oaxaca Antiguo. Memoria de la Tercera Mesa Redonda de Monte Albán, ed. Nelly M. Robles García (Mexico: CONACULTA-INAH, 2004).

Introductions to Mexican pictography

Ferdinand Anders & Maarten Jansen, *Schrift und Buch im alten Mexiko* (Graz: Akademische Druck- und Verlagsanstalt, 1988).

Elizabeth Hill Boone, *Stories in Red and Black. Pictorial histories of the Aztecs and Mixtecs* (Austin: University of Texas Press, 2000).

Gordon Brotherston, *Painted Books from Mexico* (London: British Museum Press, 1995).

Joyce Marcus, *Mesoamerican Writing Systems: propaganda, myth and history in four ancient civilizations* (Princeton: Princeton University Press, 1992).

Karl Anton Nowotny, *Tlacuilolli, die mexikanischen Bilderhandschriften, Stil und Inhalt, mit einem Katalog der Codex Borgia Gruppe* (Berlin: Monumenta Americana. Gebr. Mann, 1961).

Editions and interpretations of codices

Ferdinand Anders & Maarten Jansen, *Pintura de la Muerte y de los Destinos. Libro explicativo del llamado Códice Laud* (Mexico: Fondo de Cultura Económica, 1994).

Ferdinand Anders, Maarten Jansen, & G. Aurora Pérez Jiménez, *Origen e Historia de los Reyes Mixtecos. Libro explicativo del llamado Códice Vindobonensis* (Mexico: Fondo de Cultura Económica, 1992).

Ferdinand Anders, Maarten Jansen, & G. Aurora Pérez Jiménez, *Crónica Mixteca: El rey 8 Venado, Garra de Jaguar, y la dinastía de Teozacualco-Zaachila. Libro explicativo del llamado Códice Zouche-Nuttall* (Mexico: Fondo de Cultura Económica, 1992).

Codex Mendoza ed. Frances Berdan & Patricia R. Anawalt, 4 vols. (Berkeley: University of California Press, 1992).

Alfonso Caso, *Interpretación del Códice Bodley 2528* (Mexico: Sociedad Mexicana de Antropología, 1960).

Alfonso Caso, *Interpretación del Códice Selden 3135* (Mexico: Sociedad Mexicana de Antropología, 1964).

Alfonso Caso, *Interpretación del Códice Colombino* (with Mary Elizabeth Smith: *Las Glosas del Códice Colombino*) (Mexico: Sociedad Mexicana de Antropología, 1966).

James Cooper Clark, *Codex Mendoza,* 3 vols. (Oxford & London: Waterlow & Sons, 1938).

Maarten Jansen, *La Gran Familia de los Reyes Mixtecos. Libro explicativo de los llamados Códices Egerton y Becker II* (Mexico: Fondo de Cultura Económica, 1994).

Maarten Jansen & G. Aurora Pérez Jiménez, *La Dinastía de Añute. Historia, literatura e ideología de un reino mixteco* (Leiden: CNWS Research School of Asian, African and Amerindian Studies, 2000).

Manuel A. Hermann Lejarazu, *Códice Muro. Un documento mixteco colonial* (Oaxaca: Gobierno del Estado de Oaxaca/Secretaría de Asuntos Indígenas/Biblioteca Nacional de Antropología e Historia/ CONACULTA-INAH, 2003).

Miguel León-Portilla, *Códice Alfonso Caso. La vida de 8-Venado, Gara de Tigre (Colombino-Becker I)* (Mexico: Patronato Indígena, 1996).

María Teresa Sepúlveda y Herrera, *Códice de Yanhuitlan* (Mexico: Instituto Nacional de Antropología e Historia & Benemérita Universidad de Puebla, 1994).

Specific studies of the Ñuu Dzaui codices

Bruce E. Byland & John M.D. Pohl, *In the Realm of 8 Deer* (Norman & London: University of Oklahoma Press, 1994).

Alfonso Caso, *El Mapa de Teozacoalco, Cuadernos Americanos* 8. 5 (1949), 145–181.

Alfonso Caso, *Reyes y Reinos de la Mixteca* (I, II) (Mexico: Fondo de Cultura Económica, 1977/1979).

Philip Dark, *Mixtec Ethnohistory. A method of analysis of the codical art* (New York: Oxford University Press, 1958).

Maarten Jansen, Peter Kröfges, & Michel Oudijk, *The Shadow of Monte Albán. Politics and Historiography in Postclassic Oaxaca, Mexico* (Leiden: CNWS Research School of Asian, African, and Amerindian Studies, 1998).

Maarten Jansen, 'Archaeology and Indigenous Peoples: Attitudes towards Power in Ancient Oaxaca', in *A Companion to Archaeology,* ed. John Bintliff (Oxford: Blackwell Publishing, 2004), 235–252.

Maarten Jansen & G. Aurora Pérez Jiménez, 'Renaming the Mexican Codices', in *Ancient Mesoamerica,* 15 (2004), 267–271.

Mauricio Maldonado Alvarado & Benjamín Maldonado Alvarado, *La Sabiduría de las Pieles. De las técnicas de curtición de los códices a la curtiduría tradicional actual en Oaxaca* (Oaxaca: Instituto de Investigaciones en Humanidades de la Universidad Autónoma Benito Juárez de Oaxaca/Secretaría de Asuntos Indígenas del Gobierno del Estado/Centro INAH, 2004).

Emily Rabin, 'Toward a Unified Chronology of the Historical Codices and Pictorial Manuscripts of the Mixteca Alta, Costa and Baja: an Overview', in *Homenaje a John Paddock,* ed. Patricia Plunket (Puebla: Universidad de las Américas, 2004), 101–136.

Mary Elizabeth Smith, *Picture Writing from Ancient Southern Mexico, Mixtec Place Signs and Maps* (Norman: University of Oklahoma Press, 1973).

Mary Elizabeth Smith, 'The Relationship between Mixtec Manuscript Painting and the Mixtec Language', in *Meso-american Writing Systems,* ed. Elizabeth P. Benson (Washington: Dumbarton Oaks, 1973), 47–98.

Mary Elizabeth Smith & Ross Parmenter, *The Codex Tulane* (Graz & New Orleans: Akademische Druck- und Verlagsanstalt & Middle American Research Institute, Tulane University, 1991).

Mary Elizabeth Smith, *The Codex López Ruiz. A lost Mixtec pictorial manuscript* (Nashville: Vanderbilt University Publications in Anthropology 51, 1998).

Nancy Troike, 'Preliminary Notes on Stylistic Patterns in the Codex Bodley', in *Actes du XLII Congrès International des Américanistes,* vol. 7, (Paris, 1979), 183–192.

Nancy Troike, 'The Identification of Individuals in the Codex Colombino-Becker', in *Tlalocan* 8 (1980), 397–418.

Nancy Troike, 'Studying Style in the Mixtec Codices: an Analysis of Variations in the Codex Colombino-Becker', in *Pre-Columbian Art History,* ed. Alana Cordy-Collins (Palo Alto: Peek Publications, 1982), 119–151.

Nancy Troike, 'The Interpretation of Postures and Gestures in the Mixtec Codices', in *The Art and Iconography of Late Post-Classic Central Mexico,* ed. Elizabeth H. Boone (Washington: Dumbarton Oaks, 1982), 175–206.

Analysis of the political structure

Richard A. Blanton et al., 'A Dual-Processual Theory for the Evolution of Mesoamerican Civilization', *Current Anthropology* 37.1 (1996), 1–14.

John K. Chance, 'The Noble House in Colonial Puebla, Mexico: Descent, Inheritance, and the Nahua Tradition', *American Anthropologist* 102.3 (2000), 485–502.

Chiefdoms: power, economy, and ideology, ed. Timothy Earle (Cambridge: Cambridge University Press, 1991).

Michael Lind, 'Mixtec City-States and Mixtec City-State Culture', in: *A comparative study of thirty city-state cultures,* ed. Mogens Herman Hansen (Copenhagen: C.A. Reitzels Forlag, 2000), 567–80.

Caciques and their people. A volume in honor of Ronald Spores, ed. Joyce Marcus & Judith Francis Zeitlin, Anthropological Paper 89 (Michigan: Museum of Anthropology, University of Michigan, Ann Arbor, 1994).

Elsa M. Redmond, *Chiefdoms and Chieftaincy in the Americas* (University Press of Florida, 1998).

History of the Bodleian Library

J.N.L. Myers et al., *The Bodleian Library in the Seventeenth Century. Guide to an Exhibition held during the Festival of Britain 1951* (Oxford: Bodleian Library, 1951).

Ian Philip, *The Bodleian Library in the Seventeenth and Eighteenth Centuries* (Oxford: Clarendon Press, 1984).

Colonial Ñuu Dzaui sources

Relaciones Geográficas del siglo XVI: Antequera, 2 vols., ed. René Acuña. (Mexico: Universidad Nacional Autónoma de México, 1984).

Fray Francisco de Burgoa, *Geográfica Descripción,* 2 vols. (Mexico: Editorial Porrúa, 1989).

Fray Gregorio García, *Origen de los Indios del Nuevo Mundo* (Mexico: Fondo de Cultura Económica, 1981).

Antonio de Herrera, *Historia General de los Hechos de los Castellanos en las Islas y Tierra firme del Mar Océano* (Madrid, 1947).

María de la Cruz Paillés Hernández, *Documentos del archivo del doctor Alfonso Caso para el estudio de la Mixteca (Ramo Tierras)* (Mexico: Instituto Nacional de Antropología e Historia, 1993).

María de la Cruz Paillés Hernández, *Documentos del archivo del doctor Alfonso Caso para el estudio de la Mixteca (Ramo Civil)* (Mexico: Instituto Nacional de Antropología e Historia, 1993).

'Suma de Visitas', ed. Francisco del Paso y Troncoso, in *Papeles de Nueva España,* vol. 1 (Madrid, 1905).

María Teresa Sepúlveda y Herrera, *Procesos por idolatría al cacique, gobernadores y sacerdotes de Yanhuitlan, 1544–1546* (Mexico: Instituto Nacional de Antropología e Historia, 1999).

Colección de documentos del Archivo General de la Nación para la etnohistoria de la Mixteca de Oaxaca en el siblo XVI, comp. Ronald Spores (Nashville: Vanderbilt University Publications in Anthropology 41, 1992).

The colonial world

Peter Gerhard, *A Guide to the Historical Geography of New Spain* (Cambridge: Cambridge University Press, 1972).

Robert Himmerich y Valencia, *The Encomenderos of New Spain, 1521–1555* (Austin: University of Texas Press, 1991).

Barbara E. Mundy, *The Mapping of New Spain. Indigenous cartography and the maps of the Relaciones Geográficas* (Chicago & London: University of Chicago Press, 1996).

Ma. de los Angeles Romero Frizzi, *El sol y la cruz. Los pueblos indios de Oaxaca colonial* (Mexico: Centro de Investigaciones y Estudios Superiores de Antropología Social & Instituto Nacional Indigenista, 1996).

Ronald Spores, *The Mixtec Kings and their People* (Norman: University of Oklahoma Press, 1967).

Kevin Terraciano, *The Mixtecs of Colonial Oaxaca. Ñudzavui History Sixteenth through Eighteenth Centuries* (Stanford: Stanford University Press, 2001).

Contemporaneous society

Miguel A. Bartolomé, *Gente de costumbre y gente de razón. Las identidades étnicas en México* (Mexico: Siglo XXI & Instituto Nacional Indigenista, 1997).

Véronique Flanet, *Viviré si Dios quiere. Un estudio de la violencia en la Mixteca de la Costa* (Mexico: Instituto Nacional Indigenista, 1977).

Juan Julián Caballero, *Educación y cultura. Formación comunitaria en Tlazoyaltepec y Huitepec, Oaxaca* (Mexico: Centro de Investigaciones y Estudios Superiores en Antropología Social, 2002).

Indigenous Mexican Migrants in the United States, ed. Jonathan Fox & Gaspar Rivera Salgado (San Diego: University of California, 2004).

John Monaghan, *The Covenants with Earth and Rain. Exchange, sacrifice, and revelation in Mixtec sociality* (Norman: University of Oklahoma Press, 1995).

The language: Dzaha Dzaui

Ruth Mary Alexander, *Gramática Mixteca, mixteco de Atatlahuca* (Mexico: Instituto Lingüístico de Verano, 1980).

Francisco de Alvarado, *Vocabulario en Lengua Mixteca* (Mexico: Instituto Nacional de Antropología e Historia & Instituto Nacional Indigenista, 1962).

Studies in the Syntax of Mixtecan Languages, vols. 1–4, ed. C. Henry Bradley & Barbara E. Hollenbach, Summer Institute of Linguistics, publications 83, 90, 105, 111 (Arlington: University of Texas, 1988–92).

Ann Dyk & Betty Stoudt, *Vocabulario mixteco de San Miguel el Grande* (Mexico: Instituto Lingüístico de Verano, 1973).

Maarten Jansen & G. Aurora Pérez Jiménez, *El Vocabulario del Dzaha Dzavui (Mixteco Antiguo), hecho por los padres de la Orden de Predicadores y acabado por Fray Francisco de Alvarado (1593). Edición Analítica.* Online publication <www.archeologie.leidenuniv.nl: research> (Native American Religion and Society, 2003).

Monica Macaulay, A *Grammar of Chalcatongo Mixtec* (Berkeley, Los Angeles & London: University of California Press, 1996).

Antonio de los Reyes, *Arte en Lengua Mixteca* (Nashville: Vanderbilt University Publications in Anthropology 14, 1976).

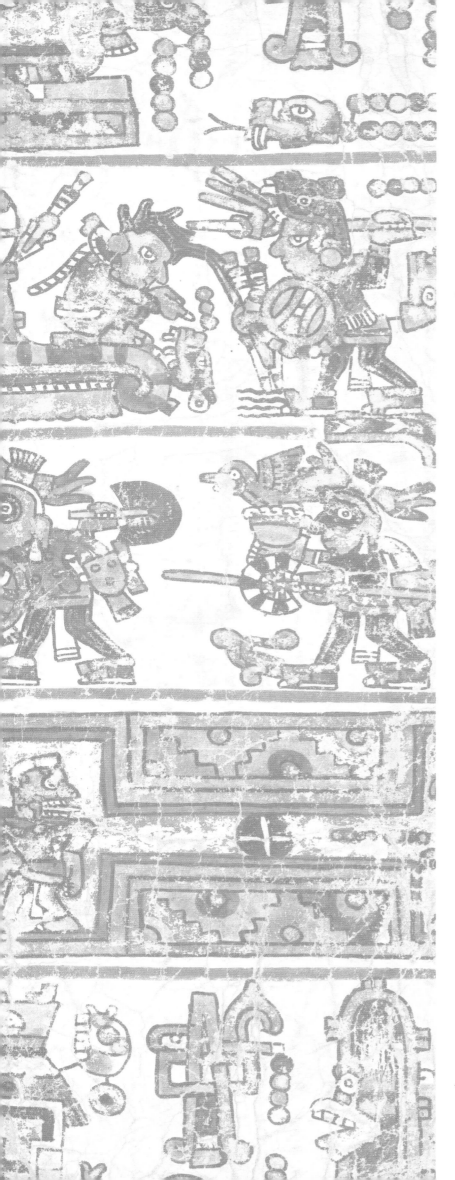

Book One

The Dynasty of Ñuu Tnoo (Tilantongo)

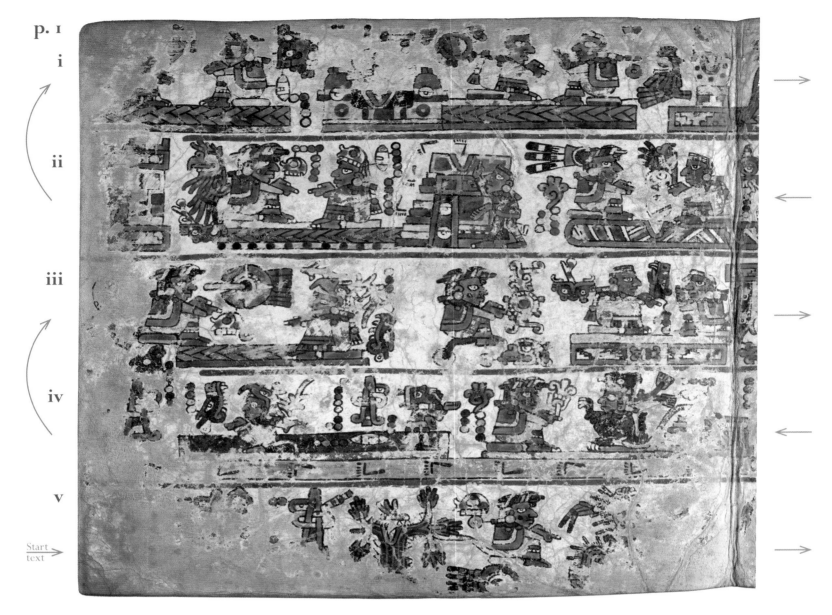

p. 1 i

ii

iii

iv

v

Start text →

p. 1/2–v Three dates, too damaged to reconstruct with certainty, refer to the sacred time of origin. The following scene contains a pochote, or thorny ceiba tree, clearly identified by its spines, while flames (ñuhu) painted above it express its sacredness (ñuhu). From this tree was born Lady 1 Death 'Sun Fan'. She was protected by two powerful spirits, Lord 4 Alligator 'Coyote Serpent' and Lord 11 Alligator 'Jaguar Serpent'. All went to an important shrine on the Mountain of Heaven, near the village of Yuta Tnoho (Apoala). The axe (caa) next to the sign for heaven helps to identify the place as Cavua ('rock') Caa ('which rises into' or 'where is stretched out') Andevui ('heaven'), a dominant peak east of the village. Here was the foundation of heaven and earth, symbolized by a column. Here two houses or families were to be united in an everlasting marital alliance. Lord 4 Alligator 'Coyote Serpent' and Lord 11 Alligator 'Jaguar Serpent' offered precious gifts to a priest of Lord 4 Serpent—7 Serpent, the Patron Deity of Ñuu Tnoo, who in turn spoke to them and gave them tobacco, a priest's tunic, jade, and quetzal feathers.

p. 2/1–iv As a result of this interaction, in the year 5 Reed (939), on the day 6 Alligator, both lords instructed Lady 1 Death to leave the Place of Heaven. Before we hear where she went, a new lineage is introduced, associated with the sacred date year 5 Flint day 7 Flower, 'when the first day was born from earth', i.e. at the dawn of time. The date actually consists of a combination of calendar names of the founding couple: Lord 5 Flint 'Jaguar from the Tree' and Lady 7 Flower 'White Flower', ruling at Temple of Pearls, the Temple of Earthquakes. Their son was Lord 4 Alligator 'Blood Eagle', born in the Land of the Rain God, Ñuu Dzaui.

p. 1/2–iii It was with him that Lady 1 Death contracted matrimony on the day 6 Jaguar, eve of the ritually important day 7 Eagle, of the year 6 Flint (940). They had one daughter: Lady 1 Vulture 'Cloud Jewel'. Then the nine other leading couples of the region came together to found the village-state of Ñuu Tnoo. 1) Lord 5 Serpent 'Performer of Self-Sacrifice for the Earth' and Lady 8 Flower, 'Blood of the Town of Darkness', ruled the Place of Ceremonies in Ñuu Tnoo. 2) Lord 10

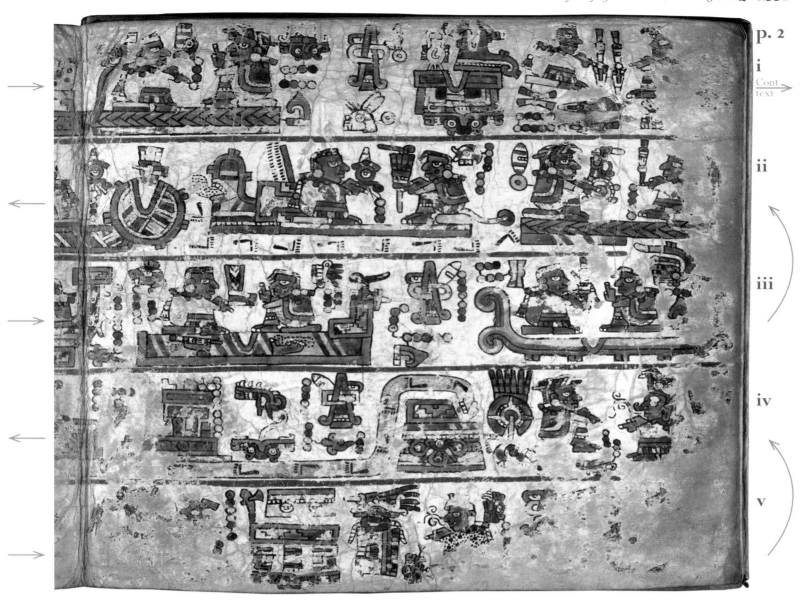

p. 2

i

Cont → text

ii

iii

iv

v

Dog 'War Foot' and Lady 8 Grass 'Cloud of Ñuu Dzaui' ruled the Place Where the Sacred Arrow Is Kept. 3) Lord 6 Movement 'Arrow' and Lady 9 House 'Sacred Seed of the Cave' were seated in the Cave of Clouds or the Cave of the Spring and the Tree. Its sacred date was year 7 Flint, day 9 House.

p. 2/1–ii 4) The son of Lord 6 Movement and Lady 9 House, Lord 5 Reed 'Born in War', married Lady 1 Flint 'Fire Serpent Jewel', the daughter of Lord 4 Rain 'Down-ball Quetzal' and Lady 7 Flower 'Eagle Wing', who ruled Stone of the Red and White Bundle. 5) The daughter of Lord 5 Reed and Lady 1 Flint was Lady 7 Death 'Fire Fan'. She married Lord 3 Rain 'Staff of Marks in the Ballcourt', ruler of Añute (Jaltepec). 6) Lord 10 Flint 'Skull' from the ancient Dark Altar married Lady 8 Death 'Quetzal, Performing Self-Sacrifice for the Earth'.

p. 1/2–i 7) In Temple of the Plant ruled Lord 7 Flower 'Jaguar, Mountain Bird' and Lady 5 Flint 'Cave Lady'. 8) Lord 10 Movement 'Flower Shield' and Lady 1

Movement 'Quetzal' ruled Valley of Mud. 9) Lord 4 Lizard 'Serpent That Carries the Sky' and Lady 8 House 'Visible on Earth' ruled Town of the Drum. Apparently Lord 4 Alligator had succeeded in bringing their lineages together and so integrated the power base of what was to become the kingdom of Ñuu Tnoo. Another important political factor was the ancient Zapotec capital of Monte Albán, the ruins of which are situated on a huge mountain near the city of Oaxaca—today a major tourist attraction. Its main sign, the 'mountain that is opened or torn', is to be read as Yucu Cahnu, 'Big Mountain'. It was a place of altars and vessels, a place of origin. Here ruled Lord 10 Movement 'Arrow' and Lady 1 Rabbit 'Shield'. Its sacred date was year 1 Rabbit day 1 Rabbit.

Elsewhere this composite place-sign includes a mountain *(yucu)* with a moon or a field of reeds (both: *yoo*) and a mountain with an insect, either a fly or a louse (both: *tiyuqh*). These signs appear in a painting of Monte Albán on the colonial *Map of Xoxocotlan,* where they identify two major slopes of the site: Yucu Yoo (Acatepec in Nahuatl) and Tiyuqh (Sayultepec in Nahuatl).

p. 3

i

Start text →

ii

iii

iv

v

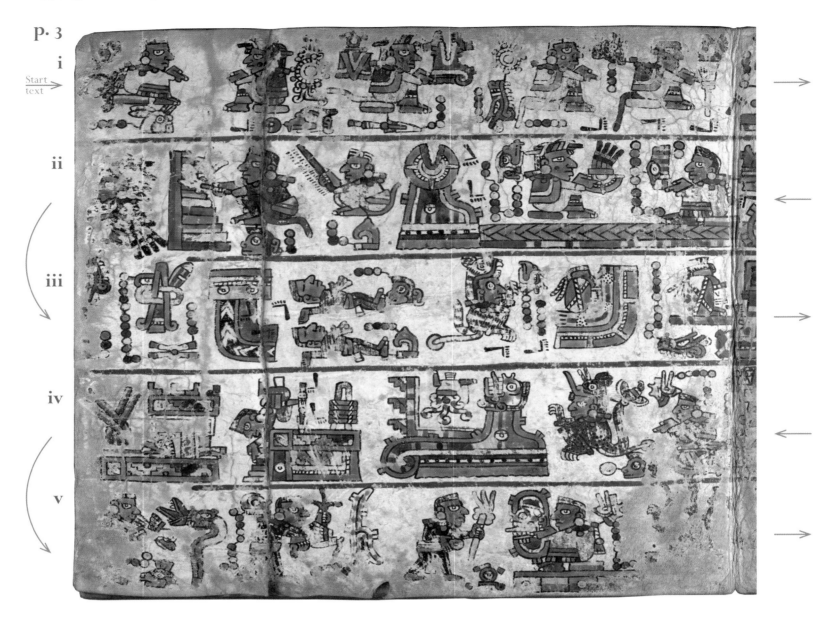

p. 3/4-i Their son, Lord 4 Rabbit 'Jaguar That Carries One Alligator in his Breast', married Lady 1 Vulture 'Cloud Jewel', the daughter of Lady 1 Death and Lord 4 Alligator, whose birth was mentioned on p. 1-iii. Three daughters were born to this couple: Lady 5 Reed 'Rain Garment from Monte Albán', Lady 10 Alligator, 'War Jewel', and Lady 5 (here 4) Jaguar 'Quetzal Fan'. The second daughter, Lady 10 Alligator was sent to the Mountain of Pearls, probably Nuu Siya (Tezoatlan), where she married Lord 9 Deer 'Jade Bone, Flute', the son of Lord 7 Movement 'Face of the Earth' and Lady 12 Serpent 'Blood Knife', the rulers of Town of the Red and White Bundle. They had a son: Lord 12 Lizard 'Arrow Feet'.

p. 4/3-ii He was to marry his aunt, Lady 5 Jaguar 'Quetzal Fan', the above-mentioned third daughter of Lord 4 Rabbit and Lady 1 Vulture of Monte Albán. This new marital alliance would take the place of the former governmental structure of Monte Albán, the dynasty associated with the sacred date year 1 Rabbit day 1 Rab-

bit. Before, the site had been the seat of a dual rulership: Lord 12 Lizard 'Standing Firm on Big Mountain' and Lord 12 Vulture 'Quetzal Feather from Sun Mountain'. They are represented here as a couple, as 'father and mother of the people', seated on the mat of marriage and rulership. They had four 'sons', i.e. they were assisted by four governors. These were called: Lord 4 House 'Staff of Strokes', Lord 3 Monkey 'Burner of the Pyramids', Lord 10 Alligator 'Eagle' and Lord 10 Eagle 'Coyote'.

p. 3/4-iii They all died in an armed conflict, described as 'the war that came from Heaven', which marked the end of the last remains of the realm of Monte Albán and the political structure of the so-called 'Classic Period' (approximately 200–900 AD). Year 12 Flint day 4 Movement, the day of the 'new sun' or 'new era', was the date of the official funerary solemnity. Lord 4 House and Lord 3 Monkey, who had both been slain in battle, were buried in the Place of Heaven, the mountain near Yuta Tnoho (Apoala), which symbolizes the East. The mummy bundle of Lord

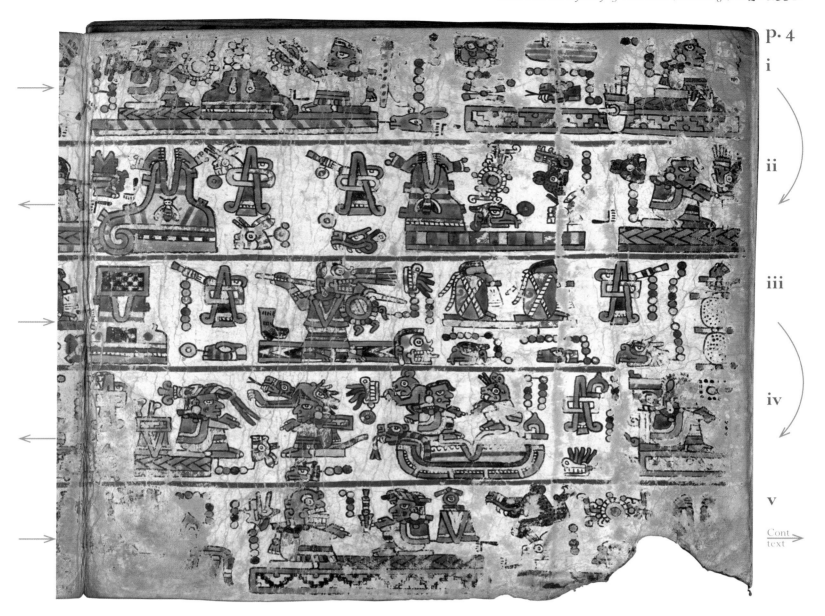

p. 4
i
ii
iii
iv
v
Cont
text

10 Eagle was deposited in the River of Ashes, Río Nejapa, the western boundary of Ñuu Dzaui. The mummy bundle of Lord 10 Alligator was put to rest in the Split Dark Mountain, near Tepeji, the emblematic site of the North. The remains of Lord 12 Lizard and Lord 12 Vulture themselves were buried in the Temple of Death, a large and important funerary cave in the Mountain of Small Deer, in the region of Ñuu Ndaya (Chalcatongo), which symbolizes the South and stands under the supervision of the Death Goddess Lady 9 Grass, a deity of war. Until the day 12 Eagle of the year 6 Reed, commemorative rituals were celebrated in this Temple of Death.

p. 4/3-iv Year 10 House day 1 Grass was the sacred date of Lord 10 House 'Jaguar' and Lady 1 Grass 'Puma', divine patrons of the Yute Coo, 'Serpent River', near Ñuu Tnoo. From this Primordial Couple descended Lord 3 Eagle 'Eagle from the Serpent Place'. He married Lady 4 Rabbit 'Garment (Virtue) of Death Town'. Her name suggests that she came from the nearby Town of Death, Dzandaya (Mitla-

tongo). Lord 3 Eagle and Lady 4 Rabbit had two sons: Lord 9 Wind 'Stone Skull' and Lord 1 Monkey. The latter became the founding father of the Dzandaya (Mitlatongo) dynasty. In front of him is the Skull Mountain, which appears to represent Dzandaya. Several other places follow.

p. 3/4-v Both brothers were recognized as local rulers: three priests—Lord 1 Rain, Lord 10 Death 'Cloud' and Lord 4 Dog 'Serpent-Maguey'—offered them fire, quails, and branches. Lord 9 Wind 'Stone Skull' then married Lady 5 Reed, one of the three princesses of Monte Albán, whose genealogical background is explained above (p. 3-i). Together they became rulers of Ñuu Tnoo. The year of the marriage was 4 Rabbit (990).

That date is given in Codex Yuta Tnoho (Vindobonensis) reverse, p. iii/iv-1, which also clarifies that Lord 9 Wind had been born in the year 8 Rabbit (940). The chronology of this early period has several problems, however.

p. 5

i

ii

iii

iv

v

Start
text

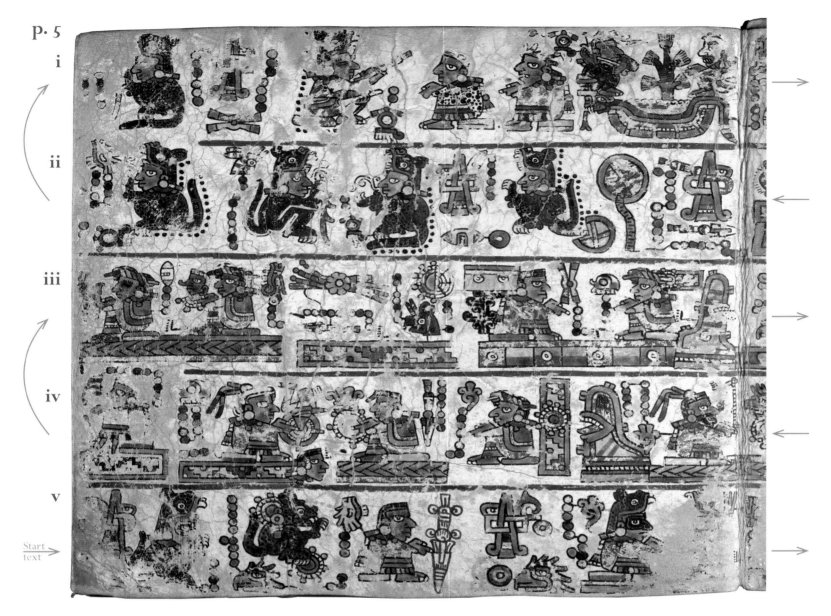

p. 5/6-v Lord 9 Wind and Lady 5 Reed had three sons. In the year 6 Flint (992) was born Lord 10 Flower, 'Jaguar with Burnt Face'. Later followed Lord 13 Eagle 'Precious Jaguar' and Lord 3 Water 'White Arrow'. Lord 9 Wind and Lady 5 Reed arranged a marriage for their first-born son, establishing an alliance with the ruling couple of Chiyo Yuhu, known today by its Aztec name as Suchixtlan, near the important centre of Yanhuitlan.

Thus in the year 1 House (1013), on the day 1 Eagle, Lord 10 Flower, the son of Lord 9 Wind 'Stone Skull' and Lady 5 Reed, at the age of twenty or twenty-one, was engaged to be married to Lady 2 Serpent 'Plumed Serpent'. She was a princess of Chiyo Yuhu, daughter of Lord 8 Wind 'Twenty Eagles' and Lady 10 Deer. From this marriage seven children were born: 1) Lord 12 Lizard 'Arrow Feet', 2) Lord 10 Eagle 'Stone Jaguar', who married Lady 9 Wind 'Flint Garment' from neighbouring Añute.

p. 6/5-iv 3) Lady 12 Jaguar 'Jewelled Spiderweb', who married Lord 10 Reed from the Yahua (Tamazola) dynasty, and ruler of Staff Town (probably Yucu Tatnu/Topiltepec), 4) Lady 6 Grass 'Transparent Butterfly', who married Lord 10 Reed 'Precious Jaguar' from Torch Mountain (possibly Yucu Quesi/Tataltepec), 5) Lady 4 Rabbit 'Precious Quetzal', who married Lord 10 Flower 'Bow Tail' from Dark Specked Mountain, 6) Lady 7 Flower 'Jewel of the Town', who apparently did not marry, 7) Lady 7 Reed 'Jewel Flower', who married Lord 13 Death 'Setting Sun' from Head Town.

p. 5/6-iii The first-born, Lord 12 Lizard 'Arrow Feet', married his nieces, Lady 4 Flint 'Quetzal Feather Face' and Lady 4 Alligator 'Jewel Face', both daughters of his sister, Lady 12 Jaguar 'Jewelled Spiderweb', and her husband Lord 10 Reed, rulers of Staff Town. This family marriage was probably motivated by the wish to bring the divided heritage back together. The first of Lord 12 Lizard's children was Lord 5 Movement 'Smoke of Heaven'. He married first a princess of Añute, Lady 4 Death 'Jewel of the People'. She belonged to the Ñuu Tnoo royal family through her father, Lord 10 Eagle, who was the younger brother of the Ñuu Tnoo ruler Lord 10 Flower, and consequently an uncle of Lord 12 Lizard.

Lord 5 Movement's brother and sisters were: 1) Lord 12 Water 'Sky Jaguar', 2) Lady 3 Movement 'Fan of the Earth', who married Lord 8 Serpent 'Serpent in Flames' from River, 3) Lady 1 Flint 'Jewel Face', who married Lord 6 Movement 'Precious Bone', a son of Lord 8 Wind of Chiyo Yuhu (Suchixtlan).

p. 6/5-ii Ñuu Tnoo's crown prince Lord 5 Movement 'Smoke of Heaven' remarried, this time to a princess from Lord 8 Wind's circle, Lady 2 Grass 'Precious Quetzal', who came from the community of Visible Stones, belonging to Chiyo Yuhu. Apparently he never ruled Ñuu Tnoo, but stood under the influence of the ruling family of Chiyo Yuhu. In the year 11 Reed (1075), Lady 2 Grass was close to giving birth to her first son. On the day 9 Reed a vision appeared in an obsidian mirror: a birth was announced, and an umbilical cord was seen, connected to 9 Reed.

p. 6

i

Cont →
text

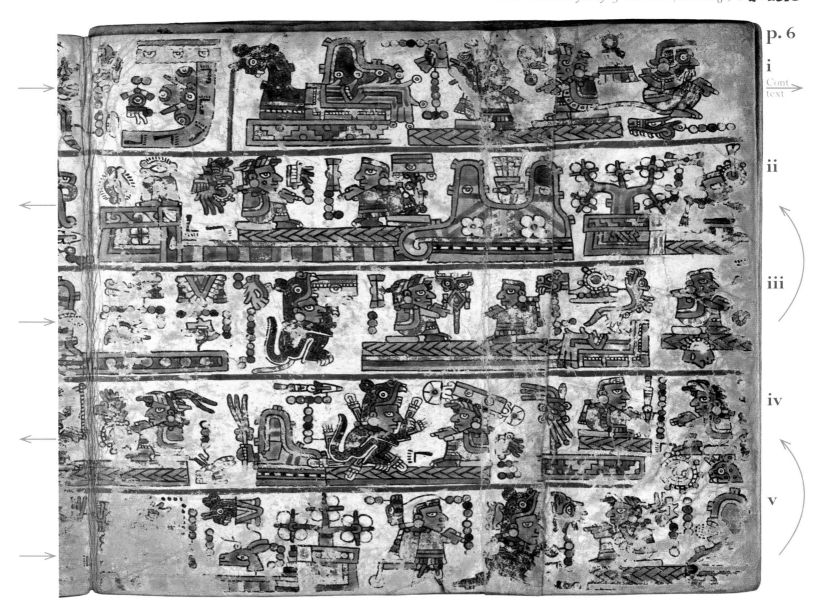

ii

iii

iv

v

This was the day of the Goddess who was the Power of the Arrowhead of Volcanic Glass (obsidian). The vision stated that the child was going to be dedicated to that goddess, to be under her spell and supervision. This was not a pleasant announcement, because the Goddess 9 Reed could bring destruction. Her very name indicated the combination of fatality (symbolized by 9, the number of death) and war or conquest ('reed' being an arrow). Six days later the child foreseen in the mirror was born: Lord 2 Rain 'Twenty Jaguars' (Ocoñaña). He was heir to the throne of Ñuu Tnoo, but another manuscript (Codex Tonindeye / Nuttall) shows that Lord 8 Wind of Chiyo Yuhu had him put under the watchful eyes of his warriors.

In the year 6 Flint (1096) Prince 2 Rain 'Twenty Jaguars' reached the age of twenty-one. On 1 Flint, the day before the day of his calendar name, he had an important conversation with Lord 10 Rabbit 'Blood Jaguar'. Other manuscripts show that this man was a grandson of the mighty Lord 8 Wind of Chiyo Yuhu (presumably deceased by now). As such he was a second cousin to Lord 2 Rain's father and would have been respected as an uncle by Lord 2 Rain himself. His relationship with Lord 2 Rain went back to 1076, when he had been present at the ceremony in which the young boy had been bestowed with the royal title (depicted in the map of Chiyo Cahnu / Teozacualco). The subject of the conversation between Lord 10 Rabbit and Lord 2 Rain is not made explicit, but in view of the age and family relationship of the two men, it is probable that the elder man gave counsel and instructions to the prince. They had a second conversation on the day 12 Water.

p. 5/6-i Then, on the day 7 Movement, the last day of the twenty-day period that had started on 1 Flint, Lord 2 Rain spoke with two priests: one in a white priestly tunic with black dots, the other an old man with a red tunic. The first was the priest in charge of the Sacred Arrow, and the second was the one with the title 'Smoke' or 'Cloud'. Both were members of the Supreme Council of Four that assisted the ruler of Ñuu Tnoo. Lord 2 Rain engaged in a ritual activity, probably aimed at claiming his rightful position as ruler of Ñuu Tnoo. His body is painted black with a hallucinogenic ointment and his eyes are closed; apparently he had entered the priestly trance. In one hand he holds a perforator for blood-letting; in the other he grasps an arrow, directing the point towards his chest. Probably this is the Sacred Arrow, the War-Spirit of Ñuu Tnoo. Still in a trance, the prince made a blood offering to the Divine Lord 7 Vulture in Serpent River, the place of a Sacred Tree. From here he went on a 'road of knife and star' to heaven, i.e. he died during his shamanic journey. This was the end of the first dynasty.

In order to understand the further political development, it is important to focus on another important person, necessitating a return in time. Lord 13 Dog 'White Eagle, Venus' and Lady 1 Vulture 'Rain Skirt' had founded a noble house at 'River, Black Mountain, Curved Jaguar Mountain', possibly nearby Ayuta, 'Place of the River'. Codex Tonindeye (Nuttall) reveals that Lady 1 Vulture belonged to the dynasty of another neighbouring settlement: Ñuu Ñañu, the old fortress of Yahua (Tamazola). This couple had one son: Lord 5 Alligator 'Rain Sun'.

p. 7

i

Start text →

ii

iii

iv

v

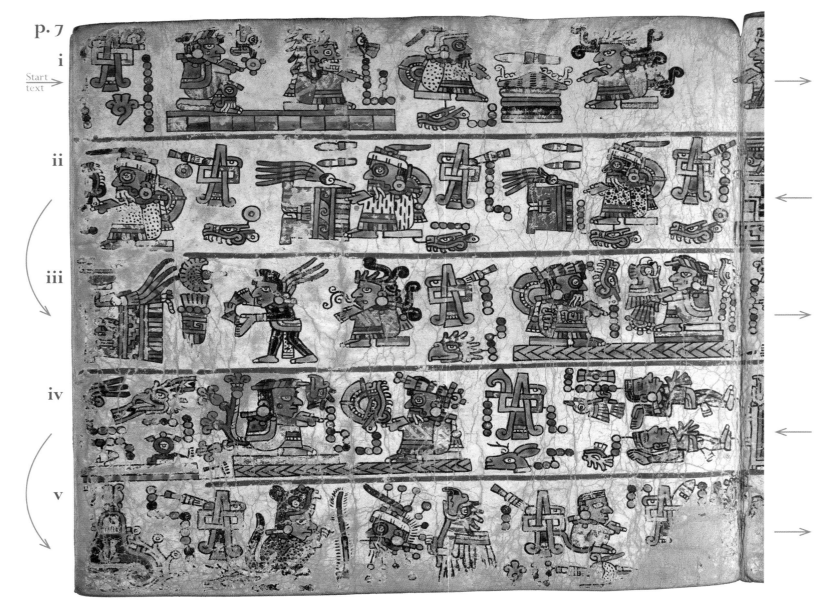

p. 7/8-i On the occasion of the day 10 Flower of the year 13 House, three priests of the supreme council of Ñuu Tnoo visited Lord 5 Alligator, seated with his parents behind him. They asked his parents' permission to take the boy to priestly duties in the temple, putting before him a sacrificial knife, together with tobacco and blankets. The first priest was named 'Smoke'; the last one was the Keeper of the Sacred Arrow. Day 10 Flower was the name-day of the prince of Ñuu Tnoo, who, born in the year 6 Flint (992), was now thirty-three years old. We suspect that this date is mentioned here because it was chosen for Lord 10 Flower's accession to the throne of Ñuu Tnoo—his father, Lord 9 Wind 'Stone Skull', would by 1025 be aged eighty-three, and would probably be dead. First, young Lord 5 Alligator went to Mountain of Plants and Flowers to offer a tunic as tribute to Lord 7 Movement, a Rain Spirit. After that, Lord 5 Alligator went to the River of the Serpent (Yute Coo), the ancestral place of the ruling dynasty of Ñuu Tnoo, where he offered another tunic.

p. 8/7-ii Continuing his journey, he was welcomed and ceremonially saluted by two priests: Lord 10 Flower 'Stone Man, born from the Earth' and Lord 7 Reed 'White Star', who offered him fire and blew the ceremonial conch. Lord 10 Flower was probably the ruler of Ñuu Tnoo at that time. Then, still on the day 7 Movement of the year 13 House (1025), Lord 5 Alligator burnt incense for the Sacred Bundle in the Temple of Heaven, the ceremonial centre of Ñuu Tnoo. He became a

priest there, and in following years passed through the successive ranks of priesthood, symbolized by different tunics and sacrificial knives that he received, the first in the year 6 Reed (1031), the second in the year 10 Reed (1035), the third in the year 1 Reed (1039). The ritual day to enter a new period of four years' service was, logically, 1 Alligator, the beginning of the count of 260 days. After a first period of six years (probably composed of two 'preparatory' years and a regular rank period of four years) and then three successive rank periods of four years each, i.e. after a total of eighteen years in the Temple of Heaven, Lord 5 Alligator had reached the highest level of priesthood.

p. 7/8-iii The elderly Smoke Priest sent a younger priest to him with a garland of flowers, indicating that he could leave the priesthood and marry. By then Lord 5 Alligator 'Rain-Sun' had become an extremely important figure with great charisma and political power. In the year 5 Reed (1043), on the day 7 Eagle, a sacred day for the Ñuu Tnoo dynasty, Lord 5 Alligator had his first wedding. Later he would marry a second time. Comparing Codex Bodley with other manuscripts, we conclude that this codex has inverted the sequence of the two wives. Here the first wife is Lady 11 Water 'Blue Parrot'. She had been married before to Lord 3 Wind 'Jaguar Warrior, Bird with Fish Tail', who came from Town of Stones, and was the son of Lady 10 House 'Garment of Stone' ('Virtue of Town of Stones'). With this man she had a son: Lord 8 Flower 'Flint-Hair'.

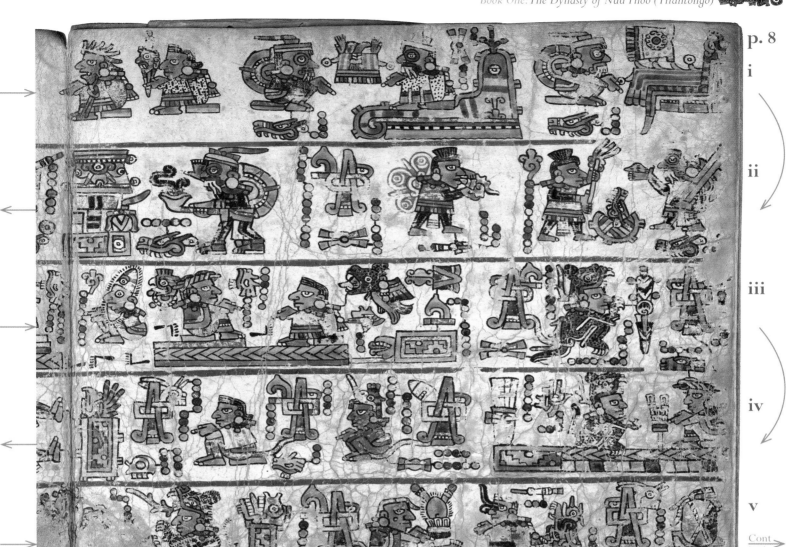

p. 8

i

ii

iii

iv

v

Cont text

Several children were born from the first marriage of Lord 5 Alligator: 1) In the year 7 House (1045) Lord 12 Movement 'Blood Jaguar', who was to become Keeper of the Sacred War Arrow.

p. 8/7-iv 2) In the year 9 Reed (1047) Lady 6 Lizard 'Jewel Fan', who later married Lord 11 Wind from the Town of the Red and White Bundle. 3) In the year 10 Flint (1048) Lord 9 Movement 'Hummingbird'. 4) In the year 10 House (1061) Lord 3 Water 'Heron'. The latter two would be slain in the year 9 Rabbit (1086), on the day 8 Death, in a place called Town of the Quetzal, probably Ñuu Ndodzo (today known as Huitzo), at the entrance of the Valley of Oaxaca. In the year 10 House (1061) on the day 6 Deer, Lord 5 Alligator 'Rain-Sun' married for the second time. The name of his wife is given as Lady 9 Eagle 'Cacao Flower'. She was the daughter of Lord 8 Rain 'War Eagle' and Lady 12 Flint 'Quetzal Feathers', rulers of Island of Stone.

p. 7/8-v The following children were born from the second marriage—in fact they were the children of Lady 11 Water: 1) Lord 8 Deer 'Jaguar Claw', born in the year 12 Reed (1063). His birth was marked by several symbolic occurrences, which announced his later importance. The first omen is represented as a long plumed grass. Perhaps this indicates simply that the grasses were extraordinarily high that season, or that there was a drought. But the grass is also a symbol of poverty and ob-

livion, and may indicate Lord 8 Deer's low birth. On the other hand, these grasses are used in sacrifices, and so might prophesy ritual bloodshed. The same symbol occurs in Codex Tonindeye (Nuttall) as the hieroglyph of the place where Lord 8 Deer starts his huge campaign of conquests. The second omen is represented as the head of the Rain God from which coloured dots emanate, perhaps suggesting an unexpectedly long period (twenty days?) of heavy rain, an appropriate sign for the birth of someone whose actions would affect the whole of Ñuu Dzaui, the People of the Rain, i.e. the Mixtecs. The third sign was an eagle, which could be an augury of bravery in war, but could also be understood as a warning that an eagle might snatch away the good luck.

2) The younger brother of Lord 8 Deer was Lord 9 Flower 'Sacred Arrow', born in the year 3 Reed (1067). 3) Their sister, Lady 9 Monkey 'Jewel Quetzal', was born in the year 13 Flint (1064). She married Lord 8 Alligator 'Blood Coyote', ruler of the great Death Town, i.e. Ñuu Ndaya. 4) A last child, Lady 12 Grass 'Hand with Jewel and Fur', was born in the year 4 House (1081) and married Lord 3 Reed, a visionary priest from Mountain of the Insect, possibly the slope Tiyuqh of Monte Albán.

On the day 9 Dog of the Year 5 Rabbit (1082) the great High Priest, Lord 5 Alligator, died.

The passing away of this spiritual and political leader must have had a great impact in the region. His ambitious son, Lord 8 Deer, had anticipated it by making himself a name through military conquests and ritual celebrations.

p. 9

i

ii

iii

iv

v

Start
text

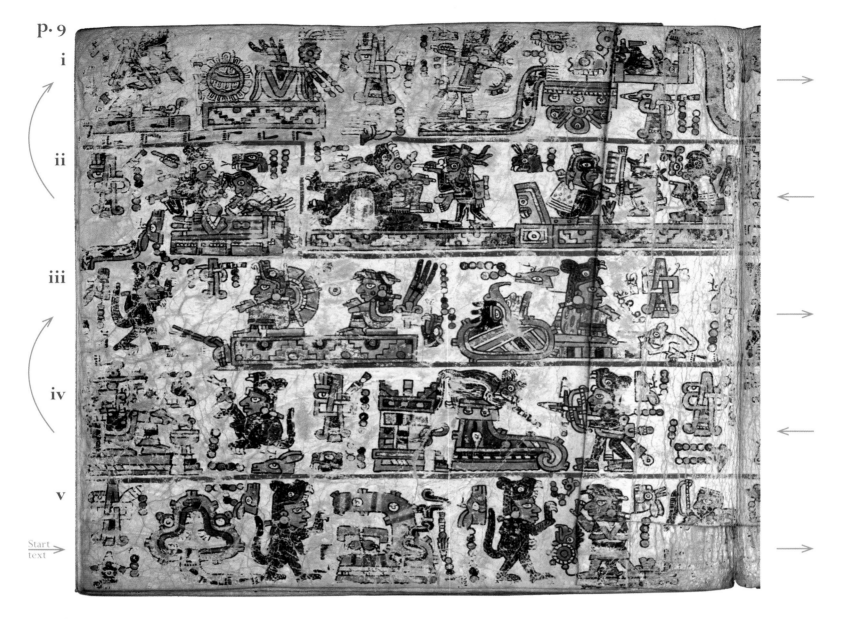

p. 9/10–v In the year 3 Flint (1080) on the day 4 Rain, Lord 8 Deer came out of a cave, where he may have been in retreat to fast and perform self-sacrifice. That day, going to another cave located at the foot of Curved (i.e. Big) Mountain, a place of visions, where dark vapours rose from the ground, he found a chest filled with jewels. It was in the land of Lord 3 Reed, who would later marry Lord 8 Deer's younger sister, 12 Grass (not born until 1081). Big Mountain was a name of Monte Albán; the treasure may well have been the valuable contents of a tomb among the ruins of that classic acropolis. The next day, 5 Flower, Lord 8 Deer visited Lady 4 Rabbit 'Precious Quetzal' and her husband Lord 10 Flower 'Bow Tail' in Dark Specked Mountain, possibly Acuchi, 'Place of Gravel', now known as San Jerónimo Sosola. On the same day, 5 Flower, Lord 8 Deer retired into yet another cave in order to venerate the Sacred Bundle. Afterwards, still on the day 5 Flower, Lord 8 Deer paid his respects to the Sacred Bundle in the Temple of Heaven of the nearby Town of the Pointed Objects, possibly Yucu Ndeque (Huauclilla). This temple was dedicated to 1 Death, the appropriate day for offerings to the Sun God and to the Great Mother of the Dynasty, Lady 1 Death. On the third day of the next year, the day 6 Serpent in the year 4 House (1081), Lord 8 Deer went to the River of Sacred Fish, in the territory of Dark Specked Mountain.

p. 10/9–iv There he played ball with the Sun God (Lord 1 Death) and the Venus God (Lord 1 Movement), probably represented by human impersonators. Ap-

parently he won, and in recompense his former opponents helped him to conquer the Jewel Stone of Ash River, i.e., a precious object associated with the West, the realm of the descending Sun and Venus. Through this victory, Lord 8 Deer made Sun and Venus, both Patrons of war, his allies. Probably the precious Stone of the West was an object of divine, magical power, the possession of which would guarantee good fortune.

On the day 13 Flower, the seventh day of the next year, 6 Reed (1083), Lord 8 Deer 'Jaguar Claw' went hunting on the Mountain of the Temple of Heaven, where offerings of knotted grass had been made in preparation for this act. With his arrows he shot a coyote. This was in preparation for going to the Temple of Death (Vehe Kihin), the sanctuary where the ancient rulers of the Ñuu Dzaui village-states were buried together, near Ñuu Ndaya (Chalcatongo). There he met with the Patron Goddess of that funerary cave, Lady 9 Grass.

p. 9/10–iii Following her orders, Lord 8 Deer descended to the tropical lowlands that border the Pacific Coast. There he presented himself to Lord 1 Death 'Sun Serpent' and Lady 11 Serpent 'Flower, Quetzal Feathers', the rulers of the village-state of Town of Hand Holding Feathers. This place has been identified as Ñuu Sitoho, 'Town of the Lords', i.e. Juquila, the main town of the Chatino people, which in those days controlled part of the coastal region. After consulting with these rulers, Lord 8 Deer conquered Water of the Rubber Ball, burnt the place, and took

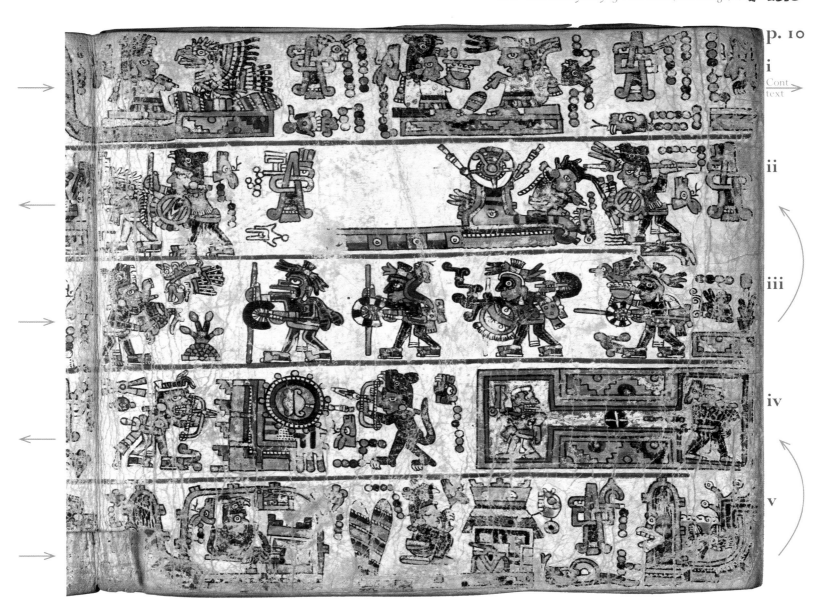

p. 10

i

Cont
text

ii

iii

iv

v

its ruler, Lord 9 Serpent, prisoner. Probably this conquest put him in control of the important Lagoon of Chacahua. Consequently he was able to establish himself as ruler of Stone of the Bird, i.e. Yucu Dzaa (Tututepec), which was to become the main Mixtec capital on the Pacific Coast. The date accompanying this scene is heavily damaged. It might be year 6 Flint (1096), day 9 Jaguar.

While Lord 8 Deer was seated as ruler in Yucu Dzaa, a red rodent approached him. Probably this animal helped him to gain power. Soon afterwards, Lord 8 Deer received a group of four Toltecs, distinguished by specific attributes and names: Lord Wind, who was the Carrier of the Bone Flute, Lord 'Serpent Ear-Ornament', Lord 'Smoking Shield', and Lord Hummingbird. All hold a staff and a fan, the characteristic attributes of travellers and ambassadors. They came to transmit the words of Lord 4 Jaguar, the ruler of Town of the Cattail Reeds, which is the sign of Tollan-Cholollan, present-day Cholula, in Central Mexico. Lord 8 Deer welcomed them with a ceremonial salute. An omen was seen: when Lord 8 Deer decapitated a quail as an offering to his visitors, an eagle came down from heaven and grasped the quail's head. The scene recalls the omen at the birth of Lord 8 Deer.

p. 10/9-ii The next year, Lord 8 Deer went on the warpath to conquer Mountain of the Moon Vessel, i.e. the Yucu Yoo (Acatepec) fortress on top of the northern cliffs of Monte Albán. He captured its ruler, Lord 3 Alligator, and took him to the Toltec king, Lord 4 Jaguar, in Cholula, to be sacrificed. On the day Wind of

the year 7 House (1097), Lord 8 Deer underwent the ceremony of Toltec rulership. We see him reclining on a jaguar throne; a Toltec nobleman perforated his septum and placed in his nose the turquoise ornament, symbol of royal status.

p. 9/10-i Lord 8 Deer returned to Ñuu Tnoo, where he deposited the Objects of Power: the Staff of Rulership, the Precious Shield, and the Sacred Bundle. The day 4 Wind of the year 8 Rabbit (1098) marked his elevation to the status of great king in this central town of the Mixtec Highlands. From here, he again went on the warpath, now to the Place of Heaven, the East, where the Founders of the Ñuu Tnoo dynasty, Lord 4 Alligator and Lady 1 Death, were venerated. In a sanctuary there he had a vision. Codices Iya Nacuaa (Colombino-Becker) and Tonindeye (Nuttall) explain that Lord 8 Deer undertook this campaign together with the Toltec ruler Lord 4 Jaguar (called Quetzalcoatl in Central Mexican sources and Kukulkan by the Mayas) and arrived at the Temple of the Sun God Lord 1 Death. Coming back in the year 9 Reed (1099) he visited Town of the Pointed Objects and the Eagle. Later, on the day 7 Flower of the year 12 Rabbit (1102), he returned here to celebrate a royal ritual, drinking pulque, the alcoholic drink made from maguey juice, and receiving the salute and recognition of Lord 13 Jaguar 'War Eagle'. Passing over dramatic events in Lord 8 Deer's personal and political life (alluded to on the reverse of Codex Bodley, p. 34-v), the narrative proceeds directly to the day 13 Serpent in the year 13 Reed (1103).

p. 11

i

Start
text →

ii

iii

iv

v

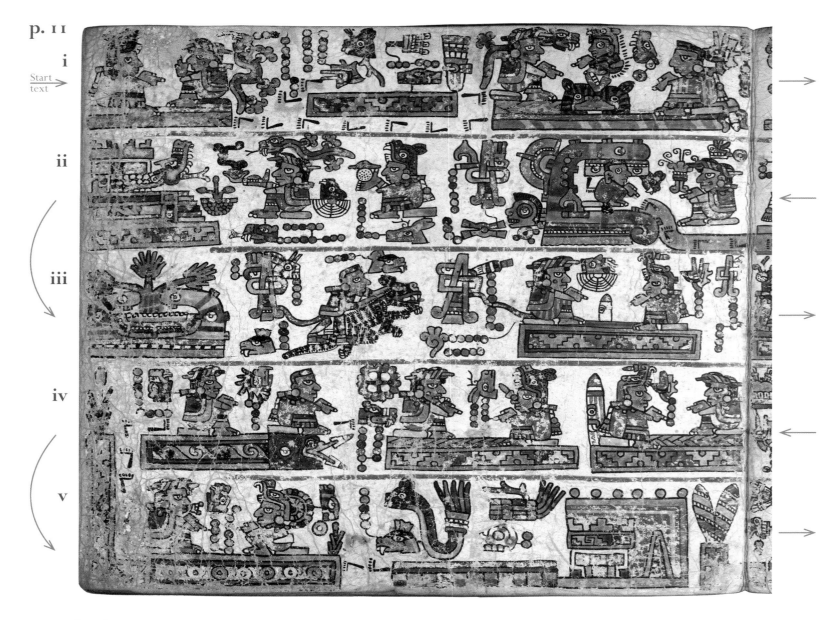

p. 11/12-i On this day Lord 8 Deer wed Lady 13 Serpent. She was his 'half-niece', the daughter of his half-sister, Lady 6 Lizard, who had married Lord 11 Wind of Town of the Red and White Bundle. Before, Lady 13 Serpent had been married to Lord 8 Wind of Owl Place, with whom she had a son, Lord 1 Alligator 'Puma with Markings' (i.e. with authority). Apparently this union was dissolved.

On the day 3 Deer of the year 2 House (1105), Lord 8 Deer wed his niece, Lady 6 Eagle 'Jaguar Spiderweb', the daughter of his sister, Lady 9 Monkey, who had married Lord 8 Alligator, the ruler of Ñuu Ndaya (Chalcatongo). Lady 6 Eagle had been married before: she was the wife of Lord 13 Dog 'Flower Jaguar', ruler of Mountain of the Seven Stones, Yuu Usa, present-day Santa Catarina Yuxia, a community belonging to Ñuu Ndaya.

p. 12/11-ii From Mountain of the Seven Stones, where her son, Lord 9 Flower 'Blood Shield', had been born, Lady 6 Eagle left to marry Lord 8 Deer. In the year 6 House (1109) their son was born: Lord 6 House 'Jaguar That Came Down from Heaven'. He was the first-born son of Lord 8 Deer, but his mother was the second wife of his father. This created a dynastic problem, so Lord 8 Deer resorted to a trick. He asked the couple Lady 1 Grass 'Flower' and Lord 9 Rabbit 'Plumed

Sun', assisted by the priest Lord 4 Water, to take care of the boy. Only eight days later, on 1 Monkey, they had hidden him safely in the Sun Cave, where Lady 1 Grass attended him as a mother. It was not until some years later that his birth would be made publicly known. In the meantime Lord 8 Deer tried to find a remedy for the sterility that had befallen his first wife. The ritually important day 4 Movement of the year 6 House was chosen for a pilgrimage: the ruler and Lady 13 Serpent went to a temple in Valley of the River with a Tree, to make offerings of copal and tobacco. There they had a vision: a huge dark serpent with an alligator head manifested itself to them.

p. 11/12-iii The vision cured Lady 13 Serpent: she became pregnant and 273 days later, in the year 7 Rabbit (1110), gave birth to a son: Lord 4 Dog 'Coyote Catcher'. In the following years four other children were born: 1) Lady 10 Flower 'Spiderweb of the Rain God' in the year 8 Reed (1111)—she would marry Lord 4 Wind of Flint Town, Ñuu Yuchi (the archaeological site Mogote del Cacique near Ñuu Tnoo). 2) Lord 4 Alligator 'Sacred Serpent' in the year 9 Flint (1112)—he would marry Lady 13 Flower 'Precious Bird' from Flint Town, Ñuu Yuchi (Mogote del Cacique). 3) Lady 6 Wind 'Quetzal Feather of Royal Blood'. 4) Lady 6 Flint

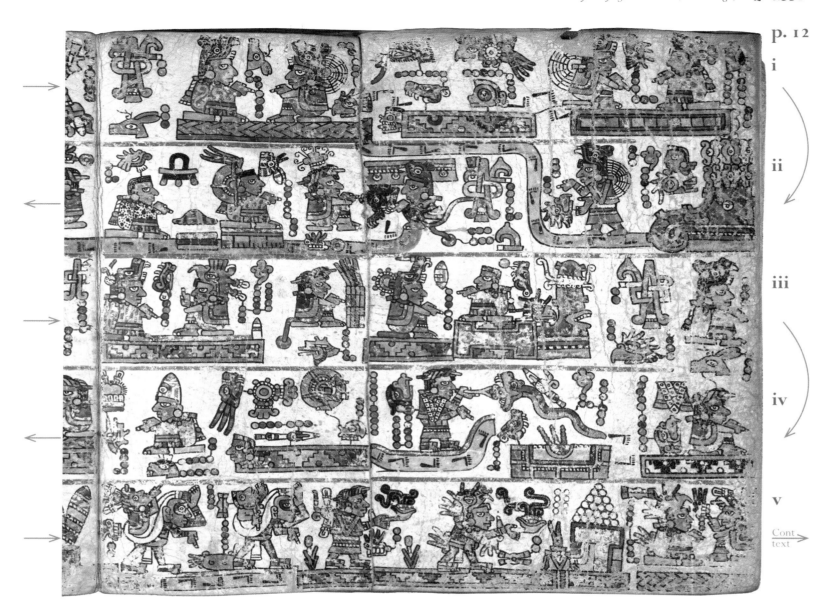

p. 12

i

ii

iii

iv

v

Cont
text

'Precious Fire Serpent'. Lady 6 Wind and Lady 6 Flint would marry Lord 1 Alligator 'Eagle of the Ballcourt', ruler of Añute.

p. 12/11–iv On the day 7 Eagle, in the year 2 House (1105), Lord 8 Deer married Lady 10 Vulture 'Brilliant Garment'. She was the daughter of Lady 7 Reed 'Flower, Jewel', the sister of Lord 12 Lizard of Ñuu Tnoo, who had married Lord 13 Death of Head Town. Because of this ancestry, Lady 10 Vulture by now was one of the few inheritors of the first dynasty of Ñuu Tnoo. Thirteen days earlier, on the day 6 Alligator, Lady 10 Vulture had come from the village-state of her parents to the River of Flames, probably the river of the ceremonial centre Ñuu Ndecu. There she had made a sacrifice and had received a vision. In that vision Lord 9 Flower 'Sacred Arrow', i.e. Lord 8 Deer's younger brother, manifested himself as a serpent. Speaking from the Other World, he instructed Lady 10 Vulture to marry his brother. The guidance of this vision, of course, strengthened the importance of this particular marital alliance, which now united Lord 8 Deer directly with the first dynasty of Ñuu Tnoo.

Lady 10 Vulture gave birth to a son, Lord 12 Dog 'Knife', and a daughter, Lady 5 Wind 'Ornament of Fur and Jade'. The latter, like her half-sister, Lady 10 Flower, would marry Lord 4 Wind, the ruler of Flint Town.

The fourth wife of Lord 8 Deer was Lady 11 Serpent 'White Flower, Teeth Inlaid with Turquoise'. She was from a Toltec noble house: her parents were Lord 5 Eagle and Lady 9 Serpent, rulers of Place of Bird with Arrow-Pointed Beak, probably Totomihuacan near Cholula.

p. 11/12–v This Lady 9 Serpent in turn was the daughter of a couple that had ruled in the great Tollan, i.e. Cholula, itself: Lady 11 Serpent 'Jewel Mouth' and Lord 1 Lizard 'Serpent, Decorated Shield'. The latter was the son of Lord 5 Dog 'Plumed Jaguar Serpent' and Lady 2 Death 'Quetzal Feather of Royal Blood', from Red Steambath, i.e. Ñuu Niñe (Tonalá) in the Mixteca Baja. Lord 8 Deer and Lady 11 Serpent had two children: Lord 10 Movement 'Quetzal Owl' and Lady 2 Grass 'Sacred Jade'. They were both taken to Cholula at an early age to become instructed in the temple cult. Toltec priests carried them on their backs. Arriving there at the Temple of Pearls the two made incense offerings to the Sacred Bundle and then married each other.

Clearly Lord 8 Deer tried to confirm his political alliance with the ruler of Cholula through marrying a Toltec noblewoman and having his children grow up in that important capital. A Toltec branch of the family was created.

p. 13

i

ii

iii

iv

v

Start text →

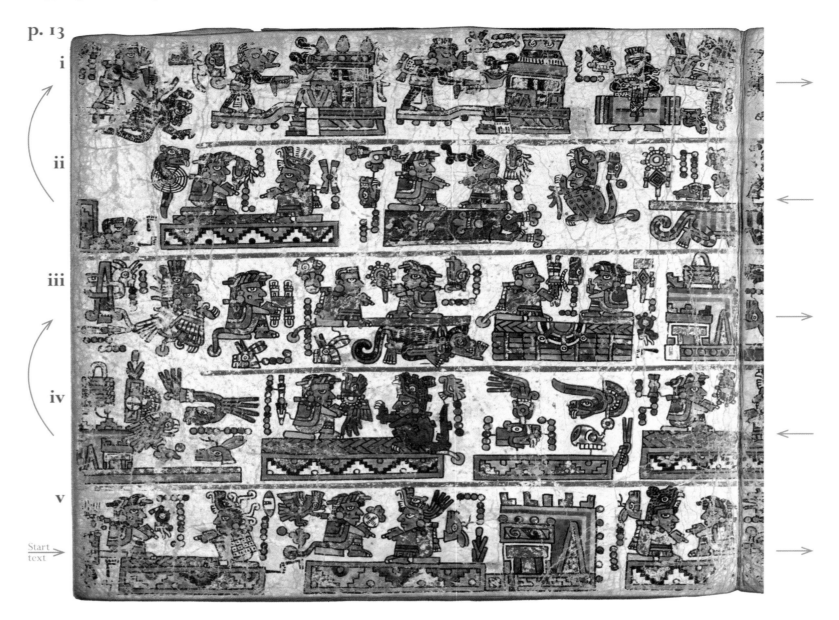

p. 13/14-v Brother and sister had two daughters together: Lady 13 Rain 'War Jewel of Tollan', who married Lord 7 Flint 'Cloud Serpent', and Lady 1 Flower 'Quetzal, Jewel of Tollan', who married a prince from Steambath, i.e. Ñuu Niñe (Tonalá), Lord 8 Deer 'Plumed Serpent'.

The fifth and last wife of the great ruler of Ñuu Tnoo, Lord 8 Deer 'Jaguar Claw', was Lady 6 Wind 'Quetzal Feather of Royal Blood', from 'Town of Jaguars', i.e. Ñuu Ñaña (Cuyotepeji).

On the day 1 Grass in the year 12 Reed (1115), forty-five days after his birthday, Lord 8 Deer set out to hunt birds in the country of his wife, Lady 6 Eagle. They reached the Plain of the Magueyes, a frontier area at the foot of a mountain that was a 'hand', i.e. tributary, of 'Town of the Carrying Frame' (Tocuisi), identified as Zaachila, the Zapotec capital. There an ambush had been planned and Lord 8 Deer was killed. The names of the men who sacrificed him are 9 Wind and 12 Jaguar. A comparison with other pictorial manuscripts shows that 9 Wind must be read as the combination of 5 Flint and 4 Wind. With this act, Lord 4 Wind took revenge for his parents and brothers; they had been executed by Lord 8 Deer, as explained on the reverse side of Codex Bodley (p. 34-v) and in other Mixtec codices.

p. 14/13-iv The body of Lord 8 Deer was made into a mortuary bundle and decorated with a large feather crown, sign of his status as a Toltec ruler. The bundle was placed in a tomb, a dark sanctuary, with flowers to honour the deceased. Lord 8

Alligator 'Blood Coyote', the father of Lady 6 Eagle and ruler of Death Town, Ñuu Ndaya, supervised the burial rites. His presence suggests that the ruler's burial place was the collective sepulchre of the Ñuu Dzaui kings, the large Vehe Kihin cave on the Mountain of the Small Deer. The presence of Lord 8 Alligator also had political implications: by making the funerary arrangements, he manifested himself as the closest kin to the deceased ruler and paved the way for his daughter, Lady 6 Eagle, to obtain a leading position in the realm as the regent for her son, Lord 6 House.

On the day 4 Deer of the year 9 Rabbit (1138), the son of Lord 8 Deer and Lady 6 Eagle, Lord 6 House 'Jaguar That Came Down From Heaven', married. He was twenty-nine. His wife, Lady 9 Movement 'Jade Heart', was the daughter (possibly even the granddaughter) of Lord 1 Death 'Sun Serpent' and Lady 11 Serpent 'Flower, Quetzal Feathers', who were already rulers of Ñuu Sitoho (Juquila) in 1083 when Lord 8 Deer arrived on the coast (Codex Bodley, p. 9-iii). This connection with a princess from the Chatino people suggests that Lord 6 House not only succeeded his father in Ñuu Tnoo in the Mixteca Highlands, but also in Yucu Dzaa (Tututepec) on the Pacific Coast.

Only one son is mentioned from this marriage, Lord 5 Water 'Stone Jaguar'. He ruled Ñuu Tnoo together with his wife, Lady 10 Reed 'Quetzal Jewel'. She belonged to the Toltec branch of the family, being the daughter of Lady 1 Flower 'Quetzal, Jewel of Tollan' and Lord 8 Deer 'Plumed Serpent', who were rulers of Ñuu Niñe (Tonalá) (see p. 13-v).

p. 14

i

Cont
text

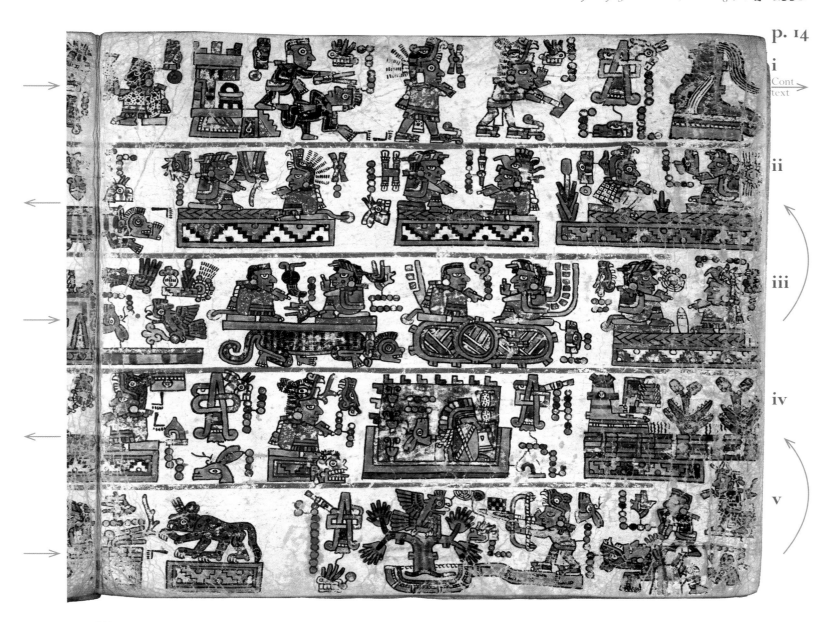

ii

iii

iv

v

p. 13/14-iii Lord 5 Water and Lady 10 Reed had eight children. The first son: Lord 8 Reed 'Pheasant', was probably born in the year 7 Rabbit (1162). The second child was Lady 5 Rabbit 'Jewel'. The third child, Lord 10 Rabbit 'Divine Heart', married Lady 10 Vulture 'Jewel Fan' from Monkey Place (probably Teita). The fourth child, Lord 7 Lizard 'Arrows', married Lady 2 Rain 'Red Fan' from Ñuu Niñe, a younger sister of his mother. Together they ruled the Plain of the Sinking Disk. The fifth child, Lord 4 Wind 'Sacred Rubber Ball', married Lady 10 Wind from Monkey Place (probably Teita), who is likely to have been a sister of the wife of his elder brother, Lord 10 Rabbit. The sixth child, Lord 4 Flower 'Digging Stick', married Lady 7 Lizard 'Irrigated Lands' from Stone of the Red and White Bundle (an important founding community of Ñuu Tnoo). The seventh child, Lady 6 Alligator 'Jewel Spiderweb', married Lord 13 Serpent 'Eagle' from Flint Town.

p. 14/13-ii The eighth child, Lady 9 Dog 'War Jewel', married Lord 1 Lizard 'Sacred Serpent' from Tollan-Cholollan. In this generation we see the last interaction of the Ñuu Dzaui dynasties with the Toltec nobility. The influence of the Toltec empire was coming to an end towards 1200.

Lord 8 Reed 'Pheasant', the first son of Lord 5 Water and Lady 10 Reed, married his younger sister, Lady 5 Rabbit 'Jewel'. This couple had two sons:

1) Lord 2 Movement 'Serpent with Markings' who, while in Ñuu Tnoo, married twice. His first wife was Lady 4 Eagle 'Blood Garment' from Monkey Place; she was the daughter of his uncle Lord 10 Rabbit 'Divine Heart' and Lady 10 Vulture 'Jade Fan'. 2) Lord 2 Eagle 'Smoke Eye', who married Lady 8 Serpent 'Flower Garland'. Their seat was at Flowered Feline Town.

Lord 2 Movement's second wife was Lady 10 Eagle 'Serpent Spiderweb' from Town of Head and Hands.

p. 13/14-i As the first-born son of Lord 8 Reed and Lady 5 Rabbit, Lord 2 Movement 'Serpent with Markings' was the heir to the throne. From his first marriage was born Lord 1 Lizard 'Blood Jaguar'; from the second, Lord 8 Grass 'Coyote Sacrificer'. Both half-brothers were engaged in religious duties. Lord 1 Lizard 'Blood Jaguar' made offerings in the Temple of Blood and Cacao. Lord 8 Grass 'Coyote Sacrificer' made offerings in the Temple of Heaven. Both played music, sounding the drum and the rattle, for the Sacred Bundle of 4 Alligator, the deified founder of the Ñuu Tnoo lineage. Then a conflict arose between the two half-brothers. Lord 1 Lizard 'Blood Jaguar' chased Lord 8 Grass 'Coyote Sacrificer' from the Temple of the Brazier. He beat him with sticks: this act suggests an accusation that he broke the vows of chastity.

As a consequence of this family conflict, Lord 8 Grass 'Coyote Sacrificer' and his father Lord 2 Movement 'Serpent with Markings' became the enemies of Lord 1 Lizard and went away 'with burning feet', i.e. waging war. In the year 12 Rabbit (1206), on the day 5 Lizard, they arrived in Mountain of Hair or Fibre.

p. 15

i

Start text →

ii

iii

iv

v

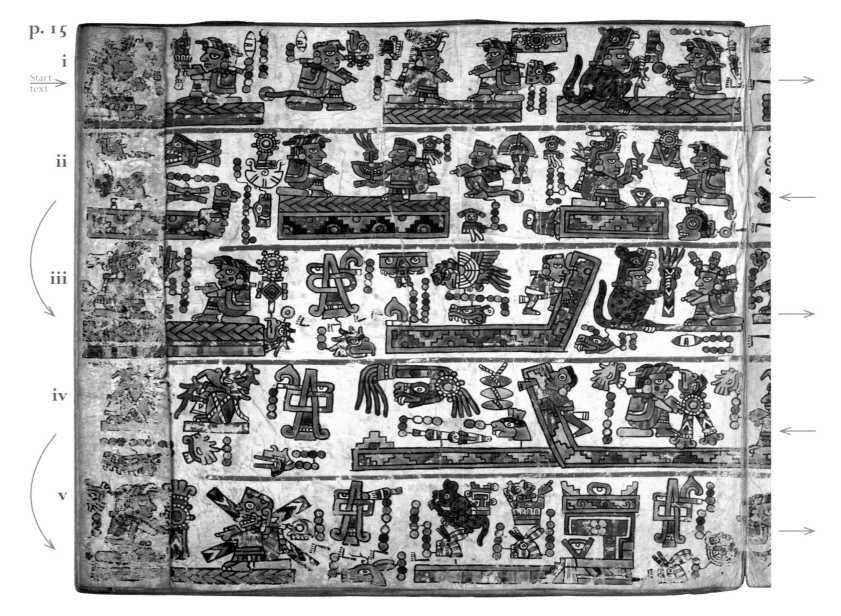

p. 15/16-i There Lord 2 Movement married again. His third wife was Lady 12 Flint 'Jewel Hummingbird'. They had a daughter, Lady 3 Flint 'Jade Bird'. Also Lord 8 Grass 'Coyote Sacrificer' married there. His wife's name was Lady 10 Jaguar 'Jewel of Heaven'. Meanwhile, Lord 1 Lizard, who had remained in his town of origin, married Lady 6 Reed 'Jewel'. She was the daughter of his great-uncle Lord 7 Lizard 'Arrows' and Lady 2 Rain 'Red Fan', the rulers of the Plain of the Sinking Disk. This marriage is mentioned after Lord 2 Movement's, but probably took place earlier, before Lord 1 Lizard chased his half-brother and his father away.

Lord 1 Lizard and Lady 6 Reed had the following six children: 1) Lord 12 Reed 'Coyote Sun'. 2) Lady 3 Jaguar 'Precious Butterfly Sun'. 3) Lord 8 Jaguar 'Burning Venus'. 4) Lady 6 Grass 'Heavenly Butterfly', who was to marry Lord 8 Rabbit of Flower Town, i.e. Chiyo Cahnu (Teozacualco).

p. 16/15-ii 5) Lord 7 Movement 'Blood Jaguar', who married Lady 3 Water 'Venus Garment' and so became ruler of Puma Town. 6) Lord 4 Jaguar 'Serpent, War Snare', who married Lady 13 Flower 'Jewel of the Rising Deity (the East)'. Both ruled Place of the Drum.

The first two children, Lord 12 Reed 'Coyote Sun' and Lady 3 Jaguar 'Precious Butterfly Sun', contracted a brother-sister marriage. They ruled in Ñuu Tnoo. Lord 12 Reed and Lady 3 Jaguar had two children: 1) Lady 1 Monkey 'Jade Garment', who married Lord 12 Rain 'Fire Serpent with Bloody Claw' of Ndisi Nuu (Tlaxiaco). 2) Lord 5 Rain 'Sun Movement', who married his niece, Lady 13 Lizard 'Truly Precious Butterfly', the daughter of his father's brother Lord 7 Movement 'Blood Jaguar' and Lady 3 Water 'Venus Garment', the rulers of Puma Town.

p. 15/16-iii Lord 5 Rain and Lady 13 Lizard had a son, Lord 13 Wind 'Fire Serpent', who married his father's cousin Lady 1 Eagle 'Jade Fan' on the day 3 Eagle of the year 5 House (1277). She was a daughter of Lord 12 House 'Fire Serpent That Flies through Heaven' and Lady 11 Alligator 'Quetzal Spiderweb', rulers of Broken Town, another sign for Chiyo Cahnu (Teozacualco). Codex Tonindeye (Nuttall), p. 31, reveals that these were both children of Lady 6 Grass and Lord 8 Rabbit.

Lord 13 Wind and Lady 1 Eagle only had one child, a son, Lord 9 Serpent 'Jaguar That Lightens the War'. He was to marry two sisters: Lady 8 Flint and Lady 7 Flower, from Mountain of Flowers (probably Yucu Ita), daughters of 6 Flower and

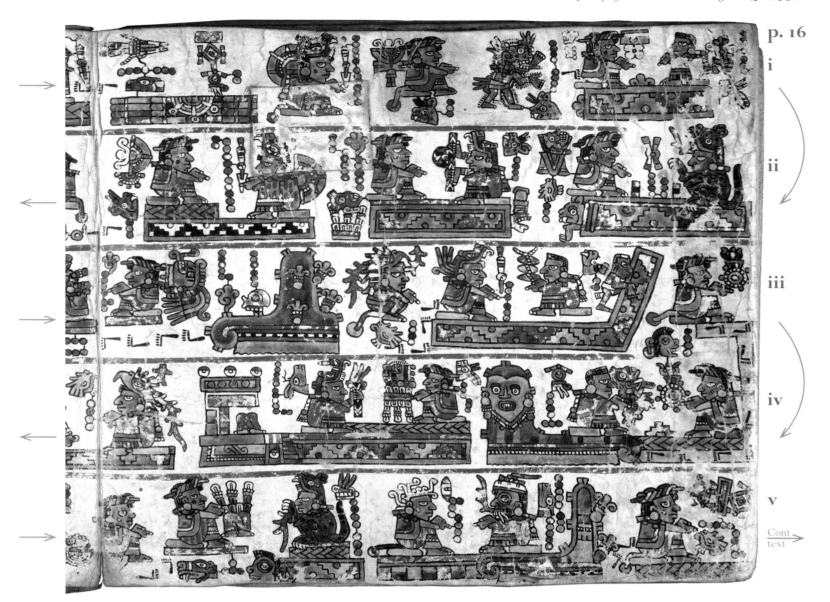

p. 16

i

ii

iii

iv

v

Cont → text

6 Death. With his two wives, Lord 4 Serpent had four children: 1) Lord 4 Water 'Blood Eagle', who was born in the year 3 House (1301), 2) Lady 6 Reed 'Plumed Serpent', who married her father's cousin, Lord 2 Dog 'Rope and Knives' of the dynasty of Chiyo Cahnu and Zaachila. The Map of Chiyo Cahnu shows how they took the road from Ñuu Tnoo to Chiyo Cahnu and entered the territory of the kingdom on her 'birthday', the day 6 Reed in the year 10 House (1321).

p. 16/15-iv 3) Lady 4 Monkey 'Precious Fire Serpent', who travelled far to marry Lord 7 Rain 'Flame of the Rising Deity (the East)', ruler of Mountain of the Precious Mask. 4) Lady 6 Rabbit 'Jewel Seed', who married Lord 12 Deer 'Fire Serpent That Lightens the War', ruler of Ndisi Nuu (Tlaxiaco).

Lord 9 Serpent's first-born son, Lord 4 Water 'Blood Eagle', married his niece Lady 6 Water 'Quetzal, Jewel of the Flower War', daughter of his sister Lady 6 Reed and Lord 2 Dog of Chiyo Cahnu.

On the day 7 Wind of the year 4 House (1341), Lord 4 Water 'Blood Eagle' died, together with a Lord 9 Alligator 'Eagle', possibly one of his own sons. The deaths of the two men together indicate an unnatural cause, probably war.

p. 15/16-v After the death of Lord 4 Water, his wife, Lady 6 Water 'Quetzal, Jewel of the Flower War', married again, now to Lord 4 Death 'War Venus of Ndisi Nuu', a son of Lord 10 Rabbit 'Ndisi Nuu Jaguar' and Lady 11 Rabbit 'Jewel of the Rising Deity (the East)', rulers of Ndisi Nuu. The wedding was celebrated in the year 6 Reed (1343), on the day 8 Deer.

This was the beginning of the third dynasty of Ñuu Tnoo and meant an alliance with the rising power Ndisi Nuu. The reverse side of Codex Bodley (p. 25-V) mentions the same marriage and clarifies that Lord 4 Death was the younger brother of the heir to the throne of Ndisi Nuu.

From this second marriage of Lady 6 Water, four daughters were born: 1) Lady 3 Rabbit 'Divine Spiderweb', in the year 8 House (1345). 2) Lady 4 Serpent 'Jewel of Ndisi Nuu', who married Lord 7 Grass 'Blood Jaguar' of Monkey Town (probably Teita). 3) Lady 8 Flint 'Cloud Head', who married Lord 13 Lizard 'Blood Rain' of Mountain of Flowers (probably Yucu Ita). 4) Lady 10 Water 'Ñuu Dzaui Fan'. Her given name is particularly interesting because it is an example of a name that contains a reference to Ñuu Dzaui, the People and the Land of the Rain God, and thereby demonstrates the existence of a feeling of ethnic identity.

p. 17

i

ii

iii

iv

v

Start
text

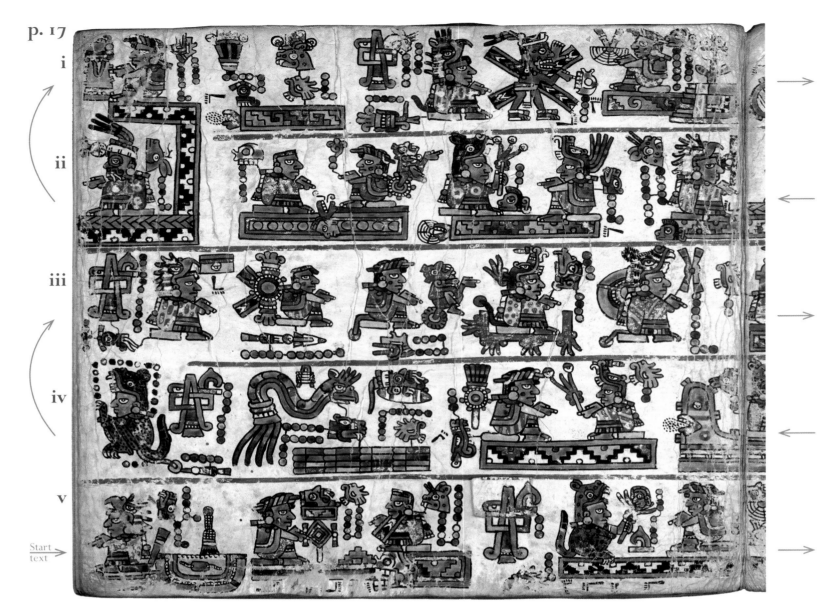

p. 17/18-v The last-born daughter, Lady 10 Water 'Ñuu Dzaui Fan', first married Lord 11 Serpent 'Eagle of the Ballcourt' from River of Gold and Feathers, and then Lord 13 Jaguar 'War Beard', king of Death Town, Ñuu Ndaya.

Lord 9 House, who through his military victories and bravery had gained the honorific name of 'Jaguar That Burns the Nahuas', then arrived in Ñuu Tnoo. He was the son of Lord 2 Dog and Lady 6 Reed, the rulers of Chiyo Cahnu. In the year 3 House (1353) on the day 4 Eagle, he married Lady 3 Rabbit 'Divine (Ñuhu) Spiderweb'. She was the heir princess of the Heaven Temple (of Ñuu Tnoo) and of the Mountain of Flowers (probably because of the marriage of her sister to a ruler of that place). Codex Añute (p. 12) tells that Lord 9 House led a military campaign into Nahuatl territory as far North as Cuauhtinchan.

Lord 9 House and Lady 3 Rabbit had the following six children: 1) Lord 2 Water 'Fire Serpent That Burns the Nahuas'—his birth-year is given as 4 House, but on the basis of another manuscript this must be corrected to 7 House (1357). 2) Lady 13 Flint 'Precious Quetzal'. 3) Lady 5 Eagle 'Flower Serpent', who married Lord 2 Vulture of Drum Town.

p. 18/17-iv 4) Lady 10 Deer 'Jaguar Garment'. 5) Lady 11 Serpent 'Plumed Serpent', who married Lord 6 Vulture 'Jaguar with Knife', ruler of the Mountain of Red and White Bundle. 6) Lady 1 Serpent 'Fan of the Rising Sun', who married Lord 2 Jaguar 'Breath of Earth', ruler of Añute.

The first-born son of Lord 9 House and Lady 3 Rabbit was Lord 2 Water 'Fire Serpent That Burns the Nahuas'. He had several wives, mentioned here in dynastic rather than chronological order. First the codex tells us about the marriage of Lord 2 Water and Lady 3 Alligator 'Jade Fan', daughter of Lord 11 Water 'Rain Knife' and Lady 13 Serpent 'Quetzal Serpent', who ruled Zaachila, the capital of the Beni Zaa (Zapotecs) in the Valley of Oaxaca. They had the following six children: 1) Lord 5 Reed 'Twenty Jaguars', born in the year 8 House (1397). He is remembered as ruler in the *Relación Geografica of Chiyo Cahnu* (Teozacualco).

p. 17/18-iii 2) Lord 5 Rain 'Eagle That Comes Down from Heaven', born in the year 12 House (1402). 3) Lady 11 Reed 'Jewel of the Flower War'. 4) Lady 8 Wind 'Flower of the Rising Deity (the East)'. 5) Lord 8 Vulture 'Fire Serpent in Flames'. 6) Lord 10 Movement 'Coyote Sun'.

Moreover, Lord 2 Water married Lady 2 Vulture 'Flower Jewel', daughter of Lord 7 Grass 'Blood Jaguar' and Lady 6 Rabbit 'Sun Garment', rulers of Monkey Town (Teita). This Lord 7 Grass had also married the younger sister of Lord 2 Water's mother (see p. 16-V).

Lord 2 Water and Lady 2 Vulture had a daughter: Lady 12 Flower 'Split Mountain Butterfly'. She married Lord 13 Eagle 'Blood Jaguar' of Chiyo Yuhu (Suchixtlan), the son of Lord 12 Movement 'Jaguar That Burns the Mexicans' and Lady 1 Jaguar 'Heavenly Fan'. Both ruled at Chiyo Yuhu and had several children.

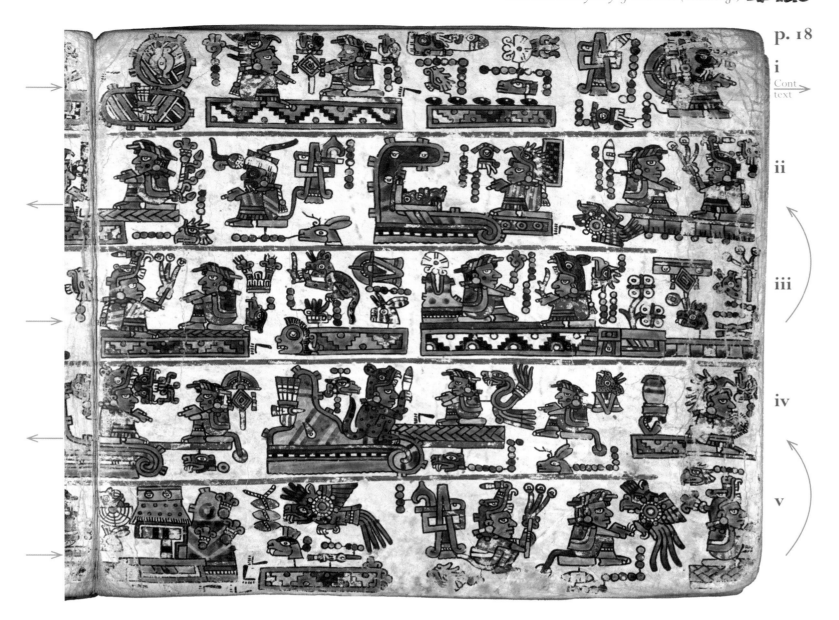

p. 18

i

Cont→
text

ii

iii

iv

v

p. 18/17-ii Before mentioning these, it is stated that Lord 2 Water also married his sister, Lady 13 Flint 'Precious Quetzal' (here written as 12 Flint), and fathered a son, Lord 11 Rain 'Dark Eagle', who went to attend a sanctuary in a cave.

The children of Lady 12 Flower and Lord 13 Eagle of Chiyo Yuhu were: 1) Lord 6 Deer, 'Rain God of Burning Tobacco', i.e. 'sacred rain', whose birth-year is given as 7 House, but which we propose correcting to 4 House (1393). 2) Lady 9 Eagle 'Cacao Flower', who married Lord 13 Jaguar 'War Eagle' of Monkey Town. 3) Lady 5 Serpent 'Plumed Serpent', who married Lord 3 Monkey 'Jaguar That Burns the Nahuas', ruler of Spiderweb Place, i.e. Andua in the Valley of Yanhuitlan. 4) Lady 2 Flower 'Jewel of the Rising Deity (the East)', who married Lord 6 Death from Place of Head with Mouth and Words, i.e. the twin capitals of Adzeque (San Miguel Adeques) and Ñuu Naha (San Pedro Cántaros) in the Valley of Nochixtlan.

The line of succession to the 'mat and throne' of the village-state of Ñuu Tnoo passed from Lord 2 Water via his daughter to his grandson, Lord 6 Deer, 'Sacred Rain'—the same sequence is found in the Map of Chiyo Cahnu.

Starting with Lord 2 Water, the birth years of the inheriting princes cause chronological problems. It seems that during the process of putting in the dates, the years associated with the births of the last rulers in the dynasty have shifted places, so that they became consistently associated with the ruler of the previous generation, leaving the last precolonial ruler of Ñuu Tnoo, curiously enough, without a birth year (p. 19-ii). This may be explained as the result of copying information from a sequential presentation of rulers with their birth dates. In such a format it is easy to make a mistake and associate the birth date with the previous generation instead of correctly putting it with the next one. That is why it is likely that Lord 6 Deer was actually born in the year 4 House, now wrongly associated with the birth of his grandfather.

p. 17/18-i Lord 6 Deer married Lady 13 Wind 'Seed of Split Hill', daughter of Lord 5 Water 'Ndisi Nuu Jaguar' of the Añute dynasty and Lady 7 Rain 'Ndisi Nuu Fan' of the house of Ndisi Nuu. Lord 6 Deer and Lady 13 Wind ruled in Ñuu Tnoo and had two sons: 1) Lord 4 Flower 'Pheasant' (here written mistakenly as 5 Flower) was born in the year 10 Rabbit which would correspond to either to 1386 or to 1438, but which we propose to correct to 7 House (now associated with the birth of his father): 1409. 2) Lord 4 Death 'War Venus', who married Lady 11 Monkey 'Jade Spiderweb', a princess from Chiyo Yuhu and Stone of the Red and White Bundle (apparently unified now within one village-state).

Lord 4 Flower married Lady 7 Vulture 'Quetzal Fan', the daughter of Lord 10 Water 'Rain Knife' and Lady 11 Lizard 'Butterfly, Fire Serpent', rulers of Bean Town, i.e. Ñuu Nduchi (Etla). They had the following seven children: 1) Lord 10 Rain 'Rain Sun', whose birth-date is given as the year 9 Flint, which would correspond to 1424, but which according to our hypothesis should be 10 Rabbit (associated with the birth of his father), i.e. 1438.

p. 19

i

Start
text →

ii

iii

iv

v

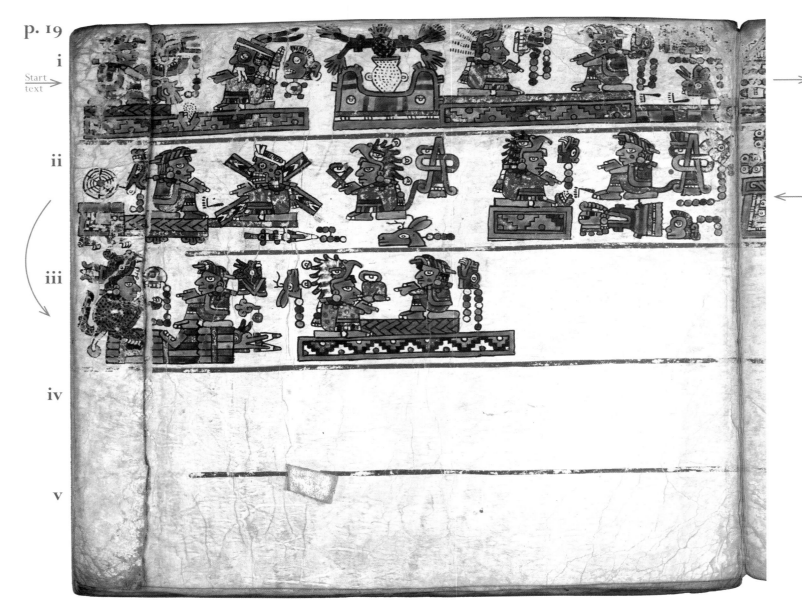

p. 19/20-i 2) Lady 7 Water 'Plumed Sun', who married Lord 1 Monkey 'Rain Sun' of Añute. 3) Lord 13 Grass 'Serpent with Markings', who married Lady 10 Vulture, the daughter of Lord 11 Jaguar and Lady 12 Flint, rulers of Mountain of Flowers (probably Yucu Ita). They established themselves in Valley of the Sand Pot, the Rosette and the Tree. 4) Lady 4 Water 'Butterfly with Red Spots', who married Lord 8 Monkey of Chiyo Yuhu (Suchixtlan). 5) Lord 7 Reed 'Blood Jaguar'. 6) Lord 11 Rain 'Sun Coyote', who settled in Black Valley and married Lady 8 Deer from Mountain of Flowers. She was probably the sister of his elder brother's wife: both came from the same town and probably belonged to the same generation.

p. 20/19-ii 7) Lady 9 Deer, who married Lord 8 Grass 'Rain Sun', the ruler of Ndisi Nuu.

The first-born, Lord 10 Rain 'Rain Sun', became ruler of Ñuu Tnoo. He married his cousin, Lady 5 Wind 'Cacao Flower', the daughter of his father's brother, Lord 4 Death 'War Venus', and Lady 11 Monkey 'Jade Spiderweb', rulers of Chiyo Yuhu. Lord 10 Rain and Lady 5 Wind had four children: 1) Lady 5 Monkey 'Seed of Split Hill', born in the year 12 Rabbit (1466), who married Lord 4 Serpent 'Blood Eagle', Prince of Añute. 2) Lord 4 Deer 'Ndisi Nuu Eagle', whose birth-year is not specified, but, according to our hypothesis, was 9 Flint (associated with the birth

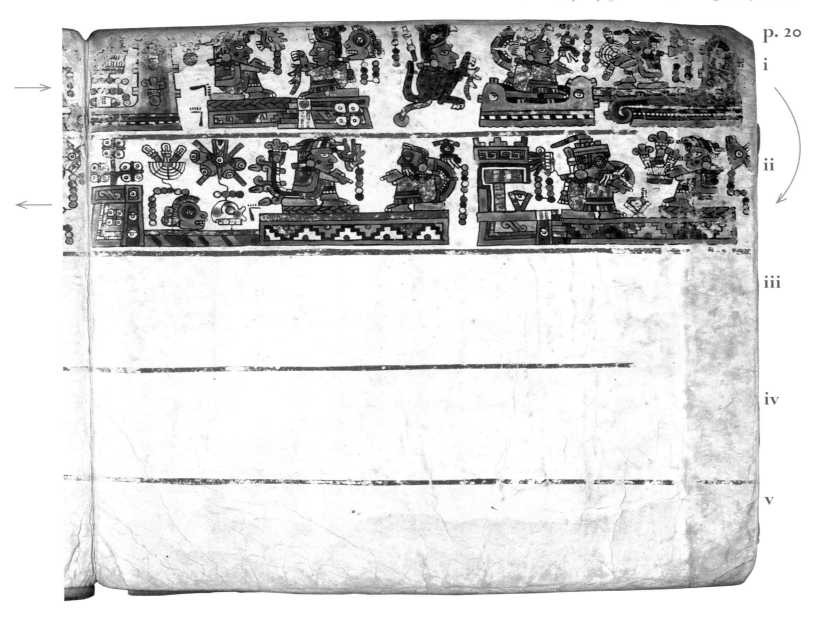

p. 20

i

ii

iii

iv

v

of his father), i.e. 1476—he was ruling in Ñuu Tnoo on the eve of the conquest, according to the Relación Geográfica of that town. 3) Lord 7 Reed 'War Venus', who married Lady 4 Alligator 'Spiderweb', a princess of At the Foot of the Altar (Sachio).

p. 19/20-iii 4) Lord 8 Death 'Jaguar, Fire Serpent', who married Lady 1 Flower 'Jaguar Garment'. They ruled in 'Plain with Mouth, Place of Bird with Arrow Beak', which must refer to Yodzo Cahi (Yanhuitlan), as an early colonial document identifies that as the place where this couple ruled. The names appear in alphabetic script as Namahu (8 Death) and Cauaco (1 Flower).

Lord 4 Deer 'Ndisi Nuu Eagle' married Lady 11 Serpent. The obverse side ends with the scene of this pair ruling Ñuu Tnoo. It is therefore plausible that the manuscript was prepared precisely for this marriage, leaving a lot of space open to continue the history with the children and grandchildren that this couple was expected to have. Curiously enough, no parentage statement is given for Lady 11 Serpent. Instead, the reverse side of the codex was occupied to include the dynasty of Ndisi Nuu, ending with the second marriage of Lord 8 Grass. The fact that Lord 4 Deer's given name contains a reference to Ndisi Nuu stresses his relationship to that village-state.

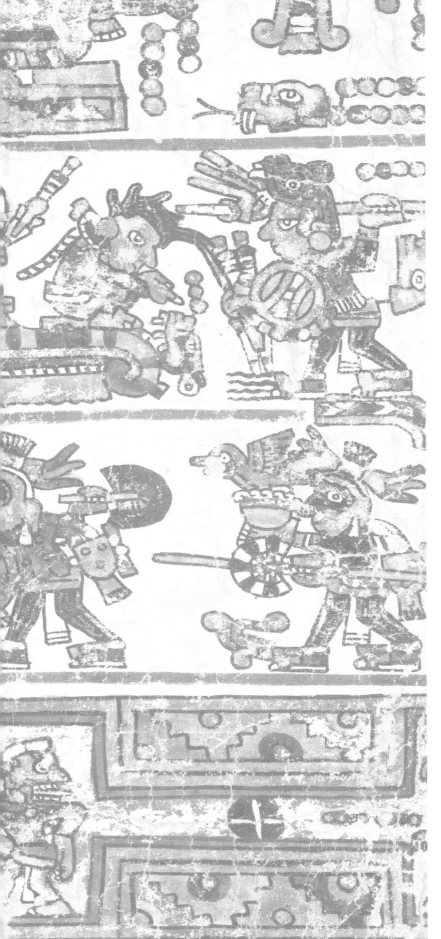

Book Two

The Dynasty of Ndisi Nuu (Tlaxiaco)

Please turn to pages 94–95 to begin Book Two and read the pages 'backwards' in pairs. As in the obverse side the pages of the reverse side of Codex Bodley are read in pairs but the overall reading order of the pages in this section is from the right to the left. The storyline on the reverse starts on p. 40-v and finishes on p. 21/22-iii. The commentary follows this arrangement and explains each pair of pages in that succession, so that pp. 94–95 of this book contains the photos and reading of pp. 40/39 of Codex Bodley, pp. 92–93 of this book refers to pp. 38/37 of the codex and so on until the end of the reverse side of Codex Bodley (pp. 22/21), which is reproduced and read on pp. 76–77 of this book.

p. 21

i

ii

iii

iv

v

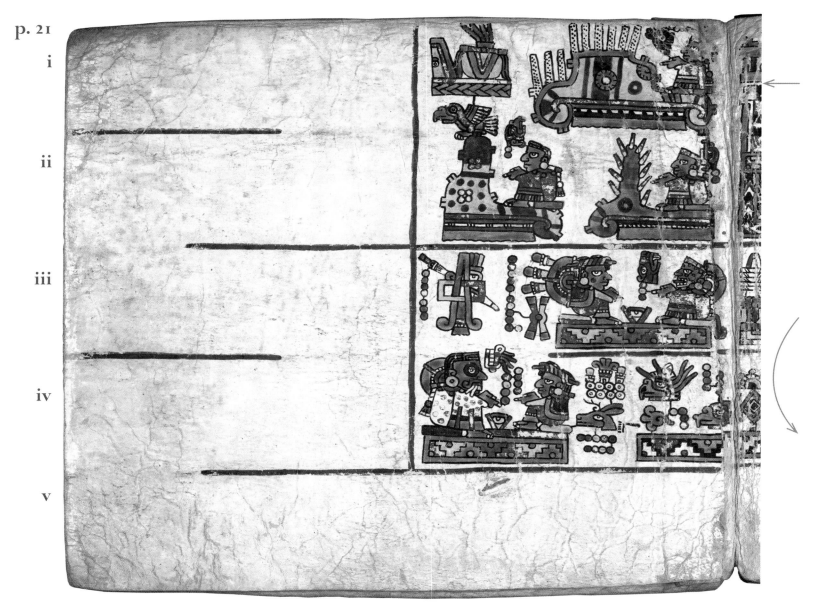

p. 22/21-i The double upper band is separate from bands ii and iii. It combines the story lines of Lord 3 Dog and his father, which occupy the two upper bands of the previous pages 25–23. Lord 7 Serpent had arrived in Mountain of the Precious Mask and watched the wedding of his half-brother, Lord 3 Water, with Lady 9 Monkey. Shortly after, Lord 7 Serpent married Lady 4 Serpent and went to live with her in the Mountain of the Precious Mask, where a Temple of Blood and Cacao was prominent in the ceremonial centre. It was there and then that Lord 3 Dog joined his father.

Lord 7 Rain 'Flame of the Rising Deity [the East]' was probably the son of this second marriage of Lord 7 Serpent, because he became the successor of that couple in Mountain of the Precious Mask. It was at that point that he married Lady 4 Monkey of the Ñuu Tnoo dynasty (Codex Bodley, p. 16-iv). Consequently he became the brother-in-law of Lord 4 Water of Ñuu Tnoo, of Lady 6 Reed, who had married Lord 2 Dog, the king of Chiyo Cahnu, and of Lady 6 Rabbit who was the wife of Lord 12 Deer of Ndisi Nuu.

Then, in the year 1 Rabbit (1338), the Mountain of the Precious Mask was attacked by Lord 9 House. He was the son of Lady 6 Reed and Lord 2 Dog, of the influential House of Chiyo Cahnu (Codex Bodley, p. 17-v). The intricate family relationships meant that Lord 9 House was actually a nephew of Lord 7 Rain of Mountain of the Precious Mask, who had married a younger sister of his mother.

Lord 9 House took Lord 7 Rain prisoner and had him sacrificed on the day 7 Alligator in the Temple of Blood and Cacao. Lord 9 House divided the conquered lands near the Mountain of the Precious Mask among his sons-in-law, Lord 2 Vulture and Lord 2 Jaguar (Codex Bodley, p. 18-iv). Probably the attack on Mountain of the Precious Mask was the beginning of the Ñuu Dzaui expansion into Southern Puebla, which followed immediately afterwards and is documented in other pictorial manuscripts.

This whole story explains to us why the lineage of Lord 7 Serpent and Lord 3 Dog did not succeed to the throne of Ndisi Nuu after the dynastic break at the death of Lord 12 Deer (Codex Bodley, p. 25-iv). Instead the ruling line shifted to Lady 11

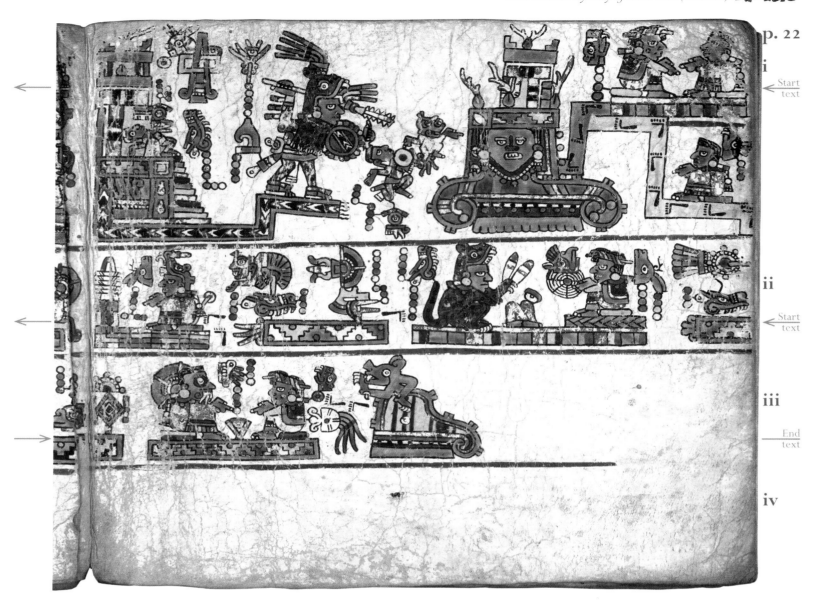

p. 22
i

Start text

ii

Start text

iii

End text

iv

Rabbit 'Jewel of the Rising Deity' from Ñuu Ndecu and her husband Lord 10 Rabbit 'Blood Jaguar' (Codex Bodley, p. 26-v (left side)/p. 25-v).

p. 22-ii Moving at a quicker pace, the genealogical account of the descendants of Lady 11 Rabbit and Lord 10 Rabbit on the lower bands of pages 24–23 has meanwhile proceeded to the final century of precolonial history. The last-mentioned couple was that of Lady 5 Flower and Lord 5 Rain (p. 23-iii). As the husband had been born in 1402 (p. 17-iii) we might tentatively date this marriage around 1420. Now several couples are mentioned and it is difficult to identify the exact relationships between them. Lady 8 Deer 'Quetzal Spiderweb' was probably the daughter of Lady 5 Flower and Lord 5 Rain. She married Lord 10 Alligator 'Jaguar with Claws like Flints', son of Lord 9 Wind 'Fire Serpent, Sun' and Lady 8 Alligator 'Fan of the Rising Deity', rulers of Ñuu Ndecu. Then the following persons are listed: Lord 8 Deer 'Fire Serpent', Lord 3 Serpent 'Venus Sun', and Lord 8 Grass 'Rain Sun'. They were probably not the children but rather the brothers of Lady 8 Deer. Of these,

Lord 8 Deer went to Zaachila. Lord 3 Serpent 'Venus Sun' remained in Ndisi Nuu and married Lady 11 Movement 'Jewel Sun'. This couple apparently succeeded Lady 8 Deer as rulers of Ndisi Nuu. The younger brother of Lord 3 Serpent, Lord 8 Grass 'Rain Sun', was born in the Year 7 Reed, which must correspond to 1435. He appears as Malinaltzin ('Lord Grass') in an early colonial chronicle from Central Mexico: he fought the invading Aztecs, but was ultimately subdued and sacrificed in 1511. Lord 8 Grass married two wives. His first wife was Lady 9 Deer 'Jewel Flower', daughter of Lord 4 Flower 'Pheasant' and Lady 7 Vulture 'Precious Fan' of Ñuu Tnoo. His second wife was Lady 1 Serpent 'Butterfly with Quetzal Feathers', who came from Bat Hill.

He was certainly a mighty king. His dominion, he claimed, reached from the Mixtec Highlands to the snow-topped volcanoes in the Valley of Cholula, the impressive Popocatepetl and Iztaccihuatl. Still today Ndisi Nuu is an important commercial centre for the Southern Mixteca Alta, strategically located in a large valley with connections to the Lowlands and the Coast.

p. 23

i

← Cont text

ii

← Cont text

iii

← Cont text

iv

v

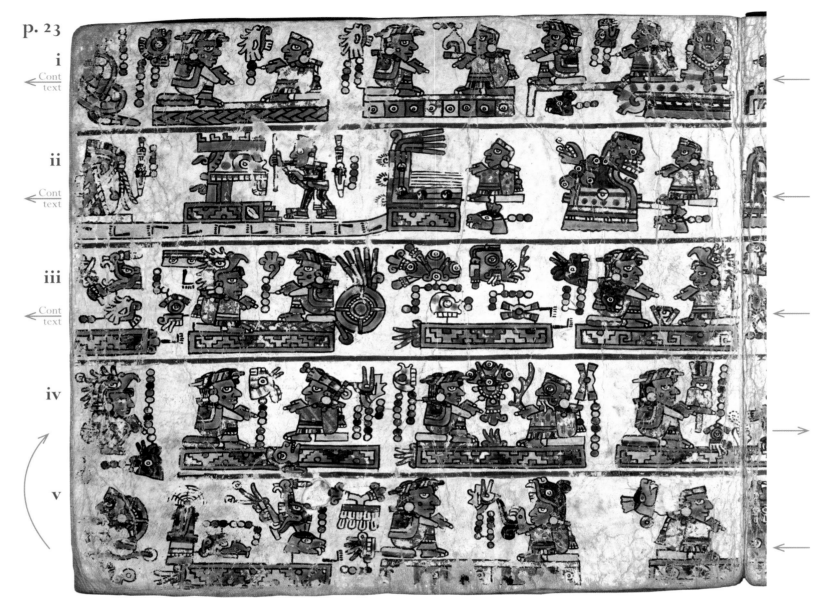

p. 24/23-i The upper band continues the story of Lord 3 Dog's father, started on p. 25-i. Despite the attack on his town, Serpent Mountain, Lord 7 Serpent seems not to have suffered a defeat. In the following scenes he is shown seated in different places, either taking possession of a wider realm or looking for counsel in different sanctuaries. The last of these places is Mountain of the Precious Mask. There he and his wife watched the wedding of his half-brother, Lord 3 Water, with Lady 9 Monkey.

p. 24/23-ii The second band continues the story of Lord 3 Dog's travels, started on p. 25-ii. The pilgrims had arrived at Sacred Precinct of Ashes. During the Bundle ritual there, Lady 9 Reed, the Patron Deity of Ndisi Nuu, who had been carried by the pilgrims, spoke to Lord 13 Serpent, who was Lord 12 Rain's brother-in-law, and to Lord 5 Reed, his fellow or kin. The priest, who on the day 6 Jaguar had taken up the task of carrying Lady 9 Reed (and here receives the calendar-name 6 Jaguar), was killed in sacrifice. It was a dangerous journey. In his place Lady 9 Serpent, Lord 3 Dog's wife, took care of the deity, following her husband.

Lord 3 Dog himself went hunting deer in the mountains. Afterwards he visited several sanctuaries: the oracle of Venus Mountain, the Great Plain of Feathers and Down Balls and the Temple of Death. Lord 5 Reed, who was probably accompanying him, died on the road.

p. 24/23-v The lower three bands continue the genealogical register of the rulers of Ndisi Nuu, started on p. 25-v. The crown-prince Lord 9 Rain 'Blood Jaguar' married Lady 7 Flint 'Quetzal Fan', the second daughter of Lady 6 Reed and Lord 2 Dog. This connected the House of Ndisi Nuu again with the powerful village-state of Chiyo Cahnu (Teozacualco), which by now had great influence in Ñuu Tnoo as well. The children of Lord 9 Rain 'Blood Jaguar' and Lady 7 Flint were: 1) Lord 11 Wind 'Smoking Claw'. 2) Lord 7 Vulture 'Jaguar with Claws like Flints', who went to Mountain of the Red and White Bundle and White Flower, where he eventually married Lady 11 Serpent 'Plumed Serpent', a daughter of Lord 9 House (Codex Bodley, p. 18-iv). 3) Lady 6 Wind, who went to Mountain of the Feline, where she married Lord 1 Dog.

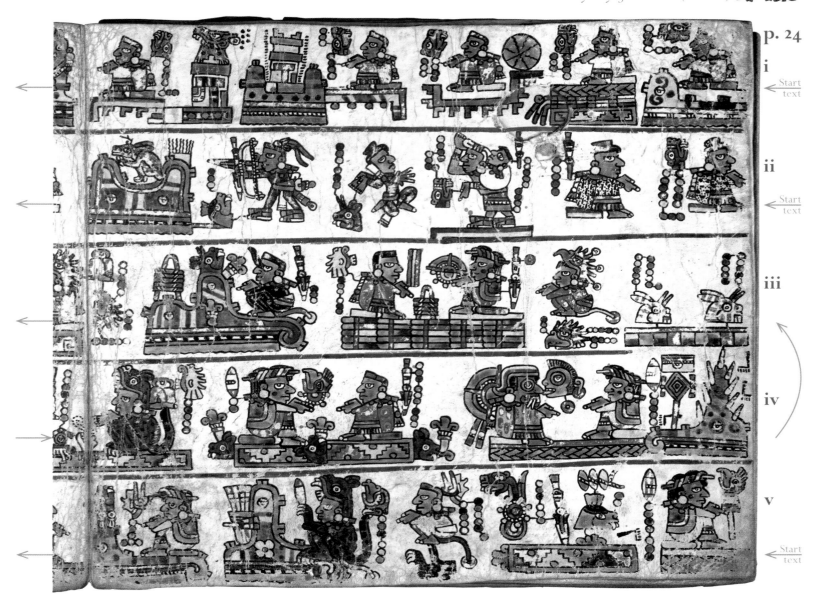

p. 24
i
Start text
ii
Start text
iii
iv
v
Start text

p. 23-v The first-born and successor to the Ndisi Nuu lineage, Lord 11 Wind 'Smoking Claw', married a princess from Ñuu Ndecu: Lady 4 Grass, 'Flower Jewel', daughter of Lord 4 Dog 'Fire Serpent That Burns the Nahuas' and Lady 9 Vulture 'Spiderweb of Split Mountain'. Their children were: 1) Lord 1 Monkey 'Rain-Sun'.

p. 23/24-iv 2) Lord 13 Jaguar 'Eagle'. 3) Lady 7 Rabbit, who married Lord 13 Wind from Monkey Town (Teita?). 4) Lady 12 Death 'Flower Jewel Venus', who married Lord 7 Movement 'Blood Shedding Rain' and ruled with him in Ñuu Ndecu. 5) Lady 7 Rain 'Ndisi Nuu Fan', who married Lord 5 Water 'Ndisi Nuu Jaguar' and ruled with him in Añute. 6) Lady 2 Flint 'Quetzal Jewel', who married Lord 9 Reed and ruled with him in Flowered Feline Town. The marital alliances in this generation demonstrate that by now the House of Ndisi Nuu played a pivotal role on the political scene of the Mixtec Highlands. Its main ally remained the religious centre Ñuu Ndecu.

Lord 1 Monkey 'Rain-Sun' married Lady 5 Flint 'Heavenly Fan'.

p. 24/23-iii She came from Mountain of Thorns, but was a descendant of Lord 10 Rabbit and Lady 11 Rabbit. Two children were born: 1) Lord 13 Eagle 'Eagle of Ndisi Nuu', the successor to the throne. 2) Lady 1 Reed 'Jewel Sun', who married Lord 6 Water from Zaachila. The next-born child, Lord 3 Reed 'Smoke Eye', may have been a son of Lady 1 Reed 'Jewel Sun' from an earlier marriage. He went to Zaachila, but according to historical sources was rejected there. Lord 6 Water of Zaachila also appears in Beni Zaa (Zapotec) pictorial manuscripts, such as the Lienzos of Guevea and Petapa.

Lord 13 Eagle 'Eagle of Ndisi Nuu' married his cousin, Lady 8 Jaguar, daughter of his father's sister Lady 12 Death 'Flower Jewel Venus' and Lord 7 Movement 'Blood Shedding Rain' of Ñuu Ndecu. They had a daughter, Lady 5 Flower 'Quetzal Sun', who married Lord 5 Rain 'Eagle That Came Down from Heaven'. This man was the son of Lord 2 Water of Ñuu Tnoo and Lady 3 Alligator of Zaachila (Codex Bodley, p. 17-iii) and was born in the year 12 House (1402). Lady 5 Flower and Lord 5 Rain did not become king and queen of Ndisi Nuu, but were an important link in the genealogy.

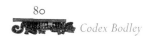

p. 25

i

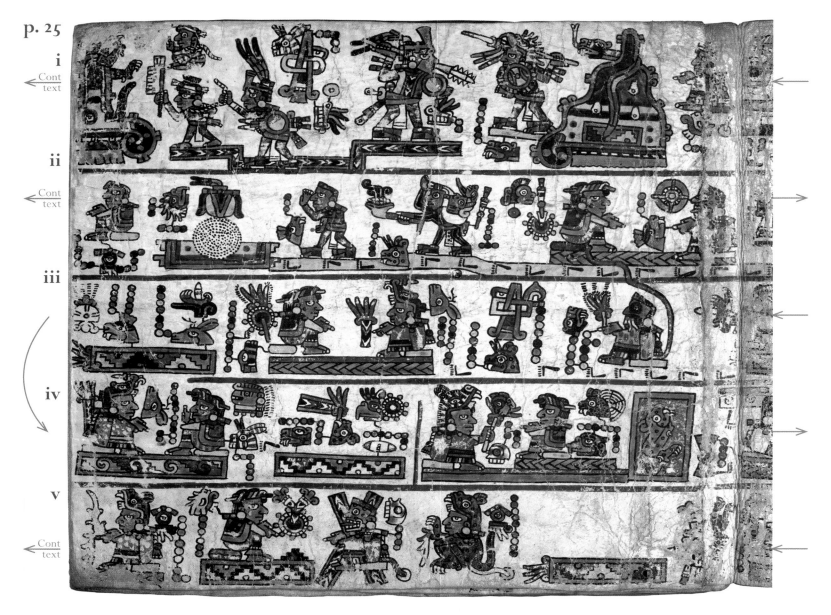
← Cont
text

ii

← Cont
text

iii

iv

v

← Cont
text

p. 26-iii (right side)/p. 26-iv (right side) Lord 1 Deer and Lady 5 Grass had two children: 1) Lady 13 Flower 'Jewel Spiderweb', who married Lord 13 Serpent 'Rain'. 2) Lord 12 Rain 'Blood Jaguar', who married Lady 1 Monkey 'Garment of Jade'. She was the daughter of Lord 12 Reed 'Coyote Sun' and Lady 3 Jaguar 'Sun Butterfly', from Ñuu Tnoo (Codex Bodley, p. 15-ii).

p. 26-iii (central section)/p. 26-ii (central section) Lord 12 Rain and Lady 1 Monkey had a daughter: Lady 8 Serpent 'Sun Spiderweb', who married Lord 3 Dog 'Venus Sun'. He was the son of Lord 7 Serpent 'Eagle' and Lady 3 Jaguar 'War Garment (War Fame)', rulers of the Dark Specked Mountain.

p. 26-i and p. 27-i A separate chapter clarifies the background and kinship relations of Lord 3 Dog. His line of descent goes back to Lord 1 Movement, the son of Lord 4/5 Grass and Lady 6 Reed, who were rulers of Dark Specked Mountain. The last-mentioned couple of this dynasty was Lord 4 House and Lady 5 House (p. 27-i). From this couple was born Lord 7 Serpent 'Eagle', who married Lady 3 Jaguar 'War Garment'. They were the parents of Lord 3 Dog.

At birth Lord 3 Dog was set on the road to Ndisi Nuu, which suggests that his marriage with the heir princess of the Ndisi Nuu dynasty was planned from the beginning. After the birth of this son, Lord 7 Serpent 'Eagle' and his wife became

rulers of Serpent Mountain. Then Lord 7 Serpent's father, Lord 4 House, married again, this time to Lady 9 Water. Lord 4 House and Lady 9 Water had a son: Lord 3 Water. On the day 1 Grass of the year 5 Rabbit (1290), an important ruler of unidentified provenance, Lord 2 Grass, attacked Lord 7 Serpent, who defended Serpent Mountain. The attack seems to have ended without a clear victory: none of the warring parties subdued or conquered the other. Lord 2 Grass took several prisoners and had them sacrificed in his hometown, Jaguar Mountain.

p. 26-iii (left side) Meanwhile the rest of the page continues by explaining that Lord 3 Dog and Lady 8 Serpent had two children: 1) Lord 12 Deer 'Fire Serpent That Lightens the War'. 2) Lady 10 Dog 'Jewel Butterfly of the Flower War', who married Lord 8 Deer 'Smoke Claw'. They ruled in Ñuu Ndecu.

p. 26-ii (left side)/p. 25-ii In the year 7 House (1305), Lord 12 Rain died in Split Wind Mountain. As a consequence there was a division into two roads, i.e. into two dynastic lines on the day 6 Jaguar of the year 7 House (1305). One 'road' was that of Lord 3 Dog, the son-in-law of Lord 12 Rain. First he spoke with his mother-in-law, Lady 1 Monkey. Both were seated on the marriage mat. This is an interesting example of the son-in-law marrying the widow of his father-in-law, i.e. the mother of his wife. Later (p. 25-iii) a son was born: Lord 11 Serpent 'Rain That Lightens the War', half-brother to Lord 12 Deer.

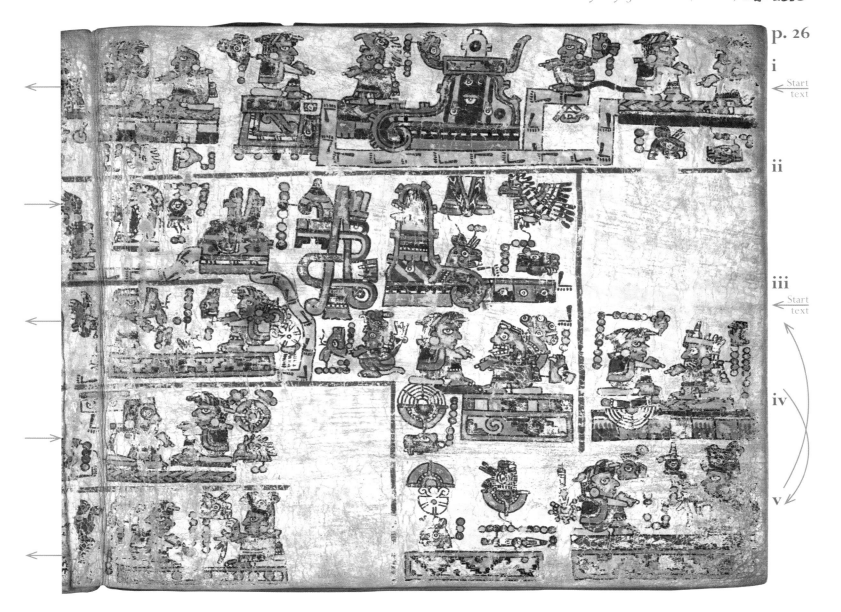

p. 26

i

Start
text

ii

iii

Start
text

iv

v

p. 25-ii The same day, 6 Jaguar of the year 7 House (1305), was the beginning of a religious pilgrimage for Lord 3 Dog. Painted black as a priest, he went on his way, followed by another priest, who was holding an incense burner and carrying the image of Lady 9 Reed, the Patron Deity of Ndisi Nuu (Codex Bodley, p. 30-v). On the next day, 7 Eagle, both arrived at Sacred Precinct of Ashes, a sanctuary dedicated to the West, where they celebrated the Bundle ritual. Lady 9 Reed sat down there, personifying the deceased Lord 12 Rain.

p. 25-iii The pilgrimage and wanderings of Lord 3 Dog explain why he did not become ruler of Ndisi Nuu. That privilege fell to the son that had been born to him and his first wife, daughter of the former ruler of Ndisi Nuu. This son was Lord 12 Deer. He is the other person who became active when Lord 12 Rain died in Split Mountain of Wind. His course of action is painted as a road.

On the day 6 Jaguar of the year 7 House (1305), Lord 12 Deer immediately married his niece, Lady 11 Lizard, 'Jewel of Flames (Ñuu Ndecu)', the daughter of his sister Lady 10 Dog 'Butterfly (Jewel) of the Flower War' and Lord 8 Deer 'Smoke Claw', rulers of Ñuu Ndecu.

p. 25-iv/p. 26-iv (left side) Later, Lord 12 Deer would marry a second wife, Lady 6 Rabbit, daughter of Lord 9 Serpent 'Jaguar That Lightens the War' and Lady 8 Flint 'Quetzal Jewel', of the prestigious Ñuu Tnoo dynasty. By then

Lord 12 Deer had become the next ruler of Ndisi Nuu (Codex Bodley, p. 16-iv). Apparently they did not have children (at least no children that survived): a vertical line indicates a dynastic break here. A new ruling family took over: it descended from Lord 6 Death 'Coyote That Burns the Nahuas' and Lady 9 Vulture 'Jaguar Spiderweb', rulers of Red Square with Mouth and Jaguar. Their son, Lord 4 Movement 'Rain That Came Down from Heaven', married Lady 2 Eagle 'Sun Flower'.

p. 26-v (left side)/p. 25-v They were the parents of Lord 10 Rabbit 'Blood Jaguar' who married Lady 11 Rabbit 'Jewel of the Rising Deity (the East)'. These became the new rulers of Ndisi Nuu in the 1330s. Lady 11 Rabbit 'Jewel of the Rising Deity' came from Flame Town, Ñuu Ndecu. It was probably through this family relationship that she inherited Ndisi Nuu from Lord 12 Deer. The intermarriage with the parallel dynasty of Ñuu Ndecu again proved essential for the continuation of the House of Ndisi Nuu.

At the moment of succession, Lord 10 Rabbit and Lady 11 Rabbit already had two sons: Lord 9 Rain 'Blood Jaguar' and Lord 4 Death 'War Venus of Ndisi Nuu'. Both would marry daughters of Lady 6 Reed and Lord 2 Dog of the House of Chiyo Cahnu and Ñuu Tnoo. The second son would marry the first-born daughter, Lady 6 Water 'Quetzal, Jewel of the Flower War', who was queen of Ñuu Tnoo, and so he too would become part of that dynasty (Codex Bodley, p. 15-v). The first-born son, Lord 9 Rain 'Blood Jaguar', was to continue the Ndisi Nuu dynasty.

p. 27

i

← Cont
text

ii

← Cont
text

iii

iv

v

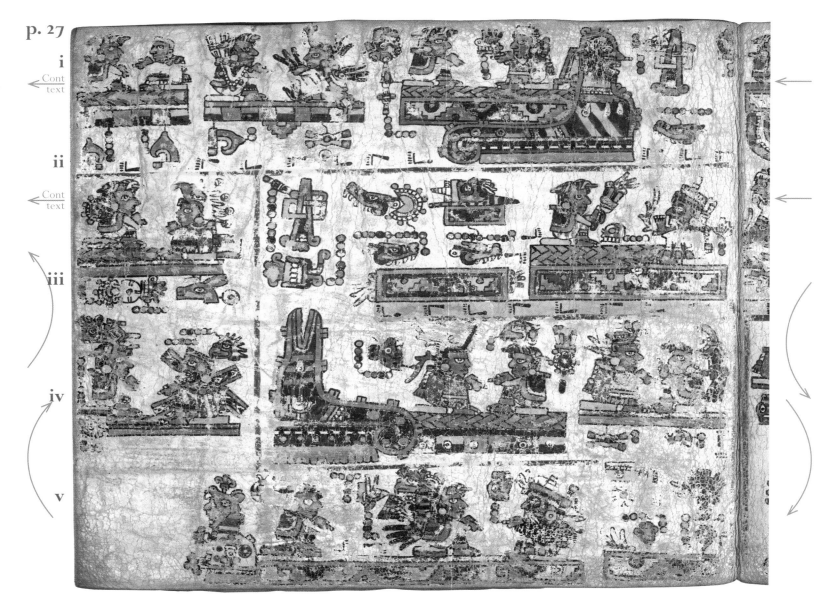

p. 29/28-i Before Lady 1 Eagle and Lord 1 Grass met their tragic destiny, two of the younger children of Lady 13 Flower were married: Lord 13 Serpent 'Eagle' wed his sister Lady 11 Deer 'Quetzal Jewel' in the year 8 Reed, on the day 5 House (1163). They were eleven and ten years old respectively. Eventually a son was born to them: Lord 7 Reed 'Pheasant'.

p. 28-ii/iii/iv (right side) One year after this marriage, on the day 6 Dog of the Year 9 Flint (1164 ad), Lord 4 Wind died at the age of seventy-two. Lord 13 Serpent 'Eagle' then married again, this time with Lady 6 Alligator 'Jewel Spiderweb'. She was the daughter of Lord 5 Water 'Stone Jaguar' and Lady 10 Reed 'Quetzal Jewel, rulers of Ñuu Tnoo (Codex Bodley, p. 14-iii).

p. 28-v/iv (left side) The year 3 Reed (1171) marked fifty-two years since Lord 4 Wind had come to power in Ñuu Yuchi. For the ritual, the day 7 Flower was selected, in remembrance of Lord 4 Wind's visit to the divine ancestor Lord 7 Flower in the year 4 Flint (1120) (Codex Bodley, p. 32-v). The Bundle in the temple of Flint Town was honoured, and the priests consulted with each other, singing songs about the glorious past. Then three men in red tunics, probably members of the Supreme Council, went out to arrange the future of the realm. First their leader, the Death priest Lord 9 Wind, spoke to Lord 1 Eagle 'Rain' in Ñuu Yuchi. This boy, only eleven years old, was dressed in a priestly tunic: probably he had

to fulfil certain ritual duties in order to become the designated heir. Immediately afterwards, Lord 4 Water and Lady 1 Grass, whom we consider his parents, are mentioned: supposedly they had to act as regents. From the earlier scenes we know, however, that Lord 1 Eagle and his mother, Lady 1 Grass, were going to die in the West, so he would not continue the dynastic line.

p. 28-iii (left side) A second member of the Supreme Council of Ñuu Yuchi, Lord 4 Lizard, spoke to Lord 7 Reed 'Pheasant', who was the son of Lord 13 Serpent of the house of Ñuu Yuchi (Codex Bodley, p. 28-i, left side) and also still a very small child. This happened in the Mountain of 6 Reed, probably Ñuu Hu-iyo (Tuctla). A third member of the Supreme Council, Lord 2 Vulture, then spoke to Lord 7 Water 'Red Eagle', ruler of Mountain with Mouth. Other codices inform us that the latter had been born in the year 7 House (1149); he was not a descendant of Lord 4 Wind, but belonged to the house of Chiyo Cahnu (Teozacualco). The date associated with this conversation was the day 1 Jaguar in the year 7 Reed (1175).

p. 28-ii (central section) The two boys spoken to were the youngest direct descendants of Lord 4 Wind, but too young and too weak to become successors to the deceased ruler. Lord 7 Water 'Red Eagle' was probably first called upon to act as their protector, but he took the opportunity to expand his own power: he had his son, Lord 13 Eagle 'Sacred Rain', attack the temple of Ndisi Nuu.

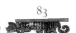

p. 28

i

← Start text

ii

iii

iv

v

p. 28-i Lord 8 Jaguar 'Blood Coyote' defended the temple. It is not clear who won the battle—maybe both parties claimed victory. Ndisi Nuu remained under control of Lord 8 Jaguar, who converted it into a mat and throne of his own.

He was married to Lady 2 Vulture 'Jewel Fan'. Together they ruled the kingdom River of the Animal. The date associated with this couple, year 6 House day 9 Eagle, may be the sacred foundation date or refer to their wedding. In the latter case, the year 6 House would correspond to 1161, still during the lifetime of Lord 4 Wind and well before the war broke out. Lord 8 Jaguar and Lady 2 Vulture ruled at least two kingdoms: River of the Animal and Split Mountain of Wind. From this couple originated a tripartite division of dynastic lines.

p. 27-i Their son, Lord 4/5 Grass 'Sun Knife' married Lady 6 Reed 'Venus Face', and they became rulers of Dark Specked Mountain. The date given with this couple is year 6 Rabbit, day 7 Alligator, probably a dynastic date. If it is historical (e.g. by referring to the enthronement of the ruler), the year could be correlated with 1174. The following generation consisted of: Lord 1 Movement 'Fire Serpent with Black Feathers', and his wife, Lady 2 House 'Precious Garment'. Their son, Lord 4 House, married Lady 5 House.

p. 28-ii (left side) and p. 27-ii (right side) There

was also a second dynastic line that came from the marriage of Lord 4/5 Grass 'Sun Knife' with Lady 6 Reed 'Venus Face'. Another son of this couple, Lord 2 Wind 'Blood Rain', married Lady 4 Death, daughter of Lord 10 Alligator 'Digging Stick of Ñuu Dzaui' and Lady 11 Alligator 'Jewel Alligator', rulers of Flame Town, Ñuu Ndecu. Lord 2 Wind and Lady 4 Death became the first official rulers of Ndisi Nuu (Tlaxiaco). The Lady from Ñuu Ndecu is painted as having the higher position.

p. 27-iii (right side) As Lord 2 Wind and Lady 4 Death did not have

any offspring, the main line of succession in the newly founded realm of Ndisi Nuu passed to another son of Lord 8 Jaguar 'Blood Coyote' and Lady 2 Vulture 'Jewel Fan': Lord 2 Movement 'Fire Serpent of Flames (Ñuu Ndecu)'. Lord 2 Movement married Lady 2 Death 'Feathered Sun'.

p. 27-iv/p. 27-iii (left side)/p. 27-ii (left side)

She was the daughter of earlier rulers of Ñuu Ndecu, Lord 10 (?) Flower 'Jaguar of Flames' and Lady 7 (?) Flower 'Butterfly of Heaven'. Lord 2 Movement and Lady 2 Death had a son: Lord 3 Serpent 'Rain of Flames', whose name suggests that he formed part of the Ñuu Ndecu dynasty. He married two princesses from Flowered Mountain of the Puma Warrior: Lady 12 Wind 'Quetzal Jewel' and Lady 7 Death. They had two children: 1) Lady 12 Water 'Quetzal Fan', who married Lord 10 Eagle 'War Venus' (from Ndisi Nuu). 2) Lord 1 Deer 'Eagle of Ndisi Nuu' who married Lady 10 Grass 'Precious Butterfly'.

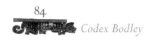

p. 29

i

← Cont text

p. 30/29–v In the year 6 Rabbit (1122), on the day 9 Reed, Lord 4 Wind presented cacao, tunics, quetzal feathers, and flowered ornaments to Lady 9 Reed, the goddess who resided in the Cacao-Blood temple of Ndisi Nuu (Tlaxiaco), at that moment not yet the important village-state it was to become, but still a sanctuary. On the days 2 Flower and 3 Alligator of the same year, Lord 4 Wind made offerings at the Temple of Flowers. Here he celebrated the ritual of new pulque, putting a flower crown on his head, together with two priests, both with the calendar name 6 Death (probably twins) and Lord 10 Rain, who was in charge of the cult of the Sacred Bundle in the Temple of the Falling Bird in Flint Town, Ñuu Yuchi. These rituals and festivities were probably in preparation for the marriages that were to follow.

p. 29/30–iv In the year 8 Flint (1124), on the day 7 Eagle, Lord 4 Wind 'Fire Serpent' married Lady 10 Flower 'Rain Spiderweb', the oldest daughter of Lord 8 Deer 'Jaguar Claw' and Lady 13 Serpent 'Flower Serpent' (Codex Bodley, p. 11-iii). Lord 4 Wind was now thirty-two years old, Lady 10 Flower only thirteen, having been born in the year 8 Reed (1111 AD). She united in herself the descent lines of both marriages of the high priest Lord 5 Alligator, with the added prestige of the great conqueror and Toltec-made king, Lord 8 Deer. This union was, at the same time, the reconciliation with Lord 8 Deer's faction and the usurpation of his legacy.

Two years after this marriage, in the year 10 Rabbit (1126), a daughter was born: Lady 13 Flower 'Precious Bird'.

On the day 3 Deer of the year 9 House (1125 AD), Lord 4 Wind married a second wife, Lady 5 Lizard 'Long Grass, Pulque Vessel'. She came from Town in the Deep Valley and was the daughter of its rulers, Lord 12 Dog 'Eagle' and Lady 5 Lizard 'Long Grass, Pulque Vessel'. They had three children: 1) Lord 1 Reed 'Jaguar with Flames'.

p. 30/29–iii 2) Lord 11 Flower, 'Tunic of Clouds'. 3) Lady 5 Wind, 'Hair of Clouds'. The Codex Bodley registers their respective birth-years as 9 Rabbit (1138), 2 Flint (1144), and 4 Rabbit (1146), but these seem too late; they must probably be corrected to: 10 Rabbit (1126), 3 Flint (1132), and 5 Rabbit (1134).

The last two of these children, Lord 11 Flower 'Tunic of Clouds', and Lady 5 Wind 'Hair of Clouds', were to wed each other. Lord 4 Wind set them up as rulers of Flame Town, Ñuu Ndecu, mentioned here for the first time as a separate kingdom. Meanwhile, the daughter of Lord 4 Wind's first marriage, Lady 13 Flower 'Precious Bird', wed Lord 4 Alligator 'Sacred Alligator', a son of Lord 8 Deer 'Jaguar Claw' and his first wife Lady 13 Serpent 'Flower Serpent'—he had been born in the year 9 Flint (1112) and was her maternal uncle (Codex Bodley, p. 12-iii).

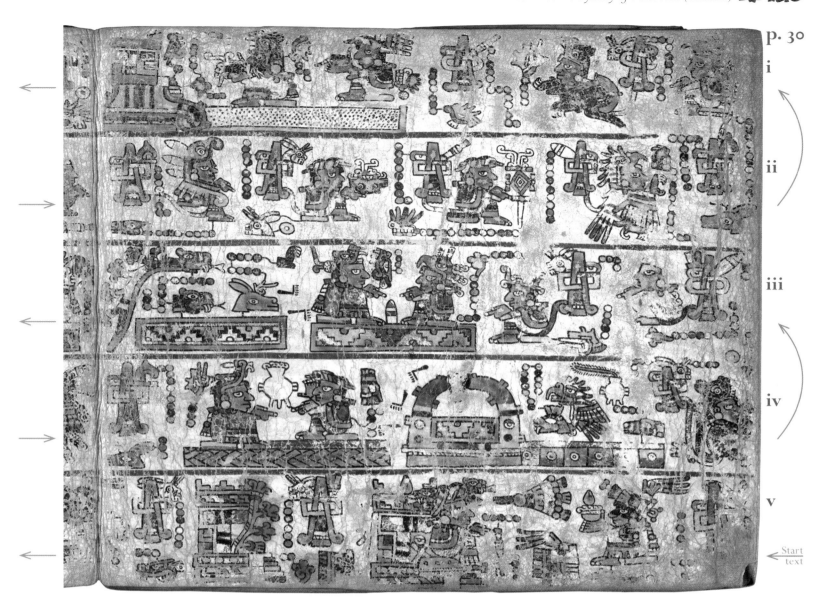

p. 30

i

ii

iii

iv

v

Start text

Lady 13 Flower and Lord 4 Alligator had several children. The first three sons married three daughters of Lord 11 Flower 'Tunic of Clouds' and Lady 5 Wind 'Hair of Clouds' (who were both children of Lord 4 Wind with his second wife, and who had been granted the rulership of Ñuu Ndecu). The three sons and their wives were: 1) Lord 7 Eagle 'Flames' and Lady 3 Serpent 'Sacred Jewel'. Both stayed in Flint Town. 2) Lord 4 Jaguar 'War Jaguar' and Lady 8 Jaguar 'Serpent Jewel'. Both stayed in Flint Town.

p. 29/30-ii 3) Lord 4 Water 'Rain Jaguar' and Lady 1 Grass 'Eagle Wing'.

The infant princess Lady 13 Flower 'Precious Bird' and her husband Lord 4 Alligator had many more children: 1) Lord 3 Vulture, 'Arrow Fire-Serpent', born in the year 6 Flint (1148). 2) Lady 8 Lizard 'Knife Butterfly', born in the year 7 House (1149). 3) Lady 1 Rabbit 'Breath of the Earth', born in the year 8 Rabbit (1150). 4) Lady 13 Grass 'Fan of Clouds', born in the year 9 Reed (1151). 5) Lord 13 Serpent 'Eagle', born in the year 10 Flint (1152).

p. 30/29-i 6) Lady 11 Deer 'Quetzal Jewel', born in the year 11 House (1153). 7) Lord 4 Wind 'Jaguar Sun', born in the year 12 Rabbit (1154). None of them, however, was to continue the dynasty of Flint Town.

In the year 13 Reed (1155), on the day 7 Water, Lord 4 Water 'Rain Jaguar' and Lady 1 Grass 'Eagle Wing' went to visit the shrine of 1 Alligator and 13 Flower, founding ancestors associated with Monte Albán. The invoked First Mother had the same calendar name as the infant princess and mother of Lord 4 Water: Lady 13 Flower. The ritual was probably done on her behalf, at a Sacred Precinct of Ashes, a sanctuary dedicated to the West. The result was the birth of a boy, Lord 1 Eagle 'Rain', five years later, in the year 5 Flint (1160). It is not clear if he was an eleventh and last son of Lady 13 Flower (only 34 years old at the time), or of the last-mentioned couple, Lord 4 Water and Lady 1 Grass. The day 1 Eagle is dedicated to the goddess of procreation, known as the Grandmother of the River, the Lady of the West, whose husband was Lord 1 Grass. The coincidence of both calendar names means that Lady 1 Grass and young Lord 1 Eagle had a spiritual connection with that divine couple. Maybe this was the outcome of a vow made during the ritual.

It would be the destiny of the boy to take care of a Toltec arrow, supposedly a Sacred Arrow, dating from the earlier contact with Lord 4 Jaguar. Eventually he would go with this cult object to the Ash River (Río Nejapa), the emblematic western frontier of Ñuu Dzaui, and deposit it there, as an offering to Lady 1 Eagle and Lord 1 Grass, the divine rulers of the West. After taking a ceremonial bath in the river he was to die there, together with Lady 1 Grass.

p. 31

i

ii

iii

iv

v

Cont text

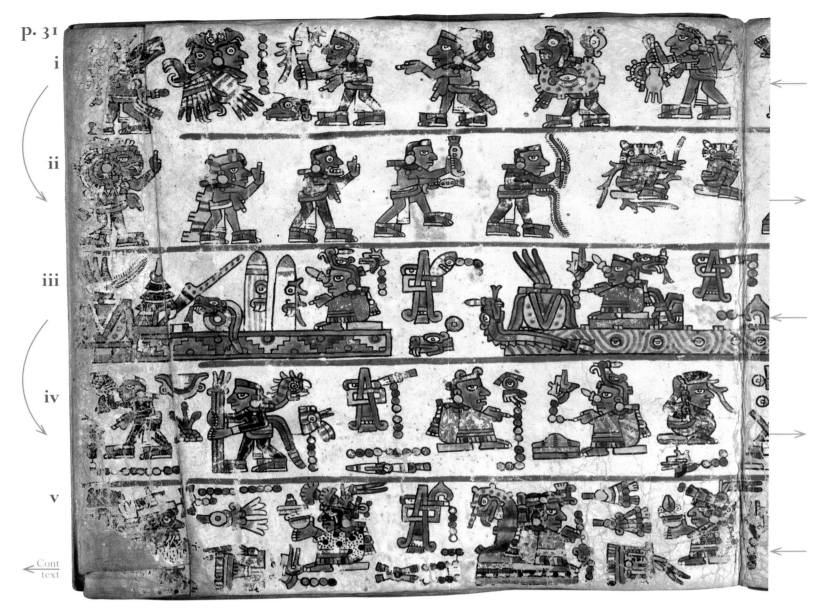

p. 32-i, p. 31-i, p. 31-ii, p. 32-ii, p. 32-iii A priest went ahead announcing his arrival by blowing a conch and sanctifying the air with incense, and guiding him towards a cave of water, the entrance to Ñuu Dzaui. The new ruler was accompanied by a long procession. In front walked five Toltec ambassadors with fans and staffs. They were important warlords: the first carried a rattle, the second carried a flute and had a parrot in his hand, the third carried a tobacco bag and was whistling, the fourth carried the drum, and the fifth a banner.

Immediately after these fierce captains came Lord 10 Jaguar 'Plant Carrier with Twisted Hair', with a knife in his hand. This latter attribute identifies him as one of the main participants in the killing of Lord 8 Deer (Codex Bodley, p. 14-v). Apparently he was a mercenary of Lord 4 Wind. Directly behind him came Lord 10 Flower 'Dark Mouth, Bow-Tail' from Dark Specked Mountain, who had been visited by Lord 8 Deer (Codex Bodley, p. 9-v), but now manifested himself as a close ally of Lord 4 Wind.

The other participants in the enthronement rituals constituted a diverse group. Among them we see several kinds of priests: a carrier of the Bundle of the Grass for Sacrifice, a carrier of the smoking brazier, a carrier of the Sacred Bundle, with a precious vessel, a priest who swayed grass or branches used for sacrificial rites.

Others seem to have been participants in a ritual performance that recalled the story of origin of the Ñuu Dzaui royal families: a dancer with gourd rattles, Jaguar Serpent and Coyote Serpent from Heaven, Divine Serpent and another Lord Serpent (probably representing the ancient lords), Stone Man and Rock Man weeping (representing the original population of the region, defeated by the founders of the Mixtec village-states), Lord Dog, the Jade Carrier (the god of wealth), and Monkey Man, the Jewel Carrier (emblem of richness and art), a priest of Death, the Rain God in a death aspect (possibly a priest in charge of the cult for the ancient Ñuu Dzaui lords from whom Lord 4 Wind descended). Logical participants were men whose names or titles suggest important military functions: War Lord and Double-Headed Eagle.

But, in accordance with the provocative tone set by the prominent presence of Lord 10 Jaguar, we find in this noble company two Owl Men, demonic magicians, one of them amid streams of blood, i.e. involved in murder. These fear-inspiring characters demonstrated how evil powers had helped Lord 4 Wind in killing Lord 8 Deer. Yet another man with a bloody knife is identified: Lord 8 Vulture. The procession closes with a man with blood on his hands and another with a knife, flanking a jaguar characterized by a skull. Given the context, we suspect that these three were

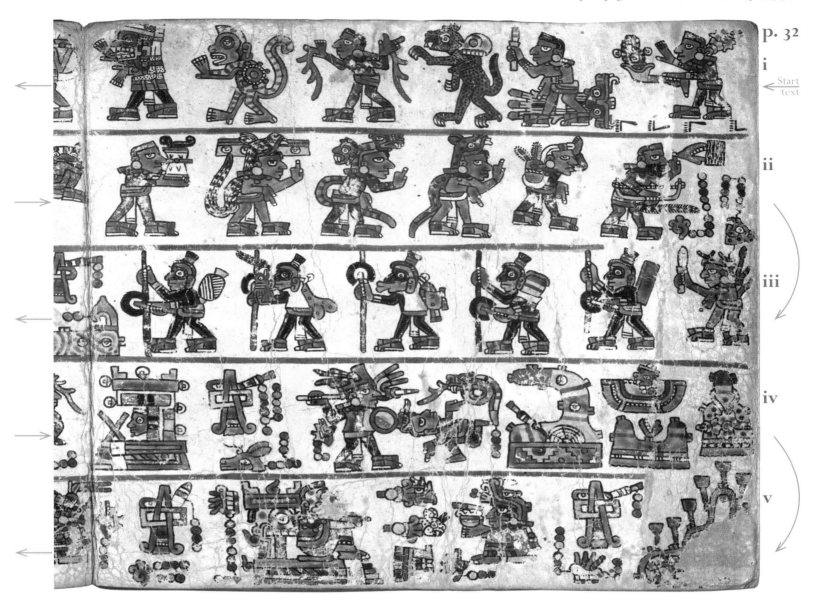

p. 32

i

Start
text

ii

iii

iv

v

performing a theatrical representation of the way Lord 8 Deer 'Jaguar Claw' had been killed by assassins loyal to Lord 4 Wind.

p. 31-iii On the day 2 House (twenty-four days after 4 Rain) in the year 3 Reed (1119), Lord 4 Wind put down the Sacred Bundle in Large Stone of the Fire Serpent, the place where he had grown up with the protection and orientation of Toltec priests. It was a sign of taking power and acceding to the throne. On the day 1 Serpent of the year 4 Flint (1120), Lord 4 Wind performed the Bundle ritual in Flint Town, Ñuu Yuchi (the site Mogote del Cacique, located between Añute and Ñuu Tnoo. The digging stick (yata) in the house may be understood as a phonetic writing of 'old' or 'of the past' (also: yata in Dzaha Dzaui): the new capital of Lord 4 Wind was a hamlet of old huts and serpents, i.e. a scarcely inhabited, forgotten place.

p. 31/32-iv Here Lord 4 Wind was seated. The priests Lord 12 Serpent 'Bowl of Blood' and Lord 5 Rabbit 'Guacamaya-Serpent' approached to salute him.

In following years he celebrated a series of rituals to honour major deities and divine ancestors. These activities are not given in a precise chronological order.

In the year 7 Reed (1123), on the day 9 Reed, dedicated to Goddess 9 Reed, Lord 4 Wind had a conversation with Lord 10 Rain, after which he went on to perform a self-sacrifice—presumably to Lady 9 Reed—in the temple of Ndisi Nuu (Tlaxiaco), here mentioned for the first time in the account.

In the year 11 Reed (1127), on the day 7 Deer, Lord 4 Wind captured Lord 4 Serpent 'Blood Serpent', who seems to have headed a rebellious alliance of Spider-web Town, Bent Red Mountain, Valley of the Mouth, River of Lord Dog, Mountain of the Conch and Mountain of the Standing Flowers. This armed conflict suggests that Lord 4 Wind's takeover of power was not completely peaceful and easy.

p. 32/31-v On the day 9 Grass of the year 3 Reed (1119), Lord 4 Wind honoured Lady 9 Grass in the Temple of Death, offering her tunics and flowers that represented the jaguar and the eagle, i.e. he consecrated to her the lives of his warriors. In the year 4 Flint (1120), on the day 7 Flower, Lord 4 Wind went to pay his respects to Lord 7 Flower, a deified ancestor, and at the same time a solar deity, in Mountain of the Turkey. He offered cacao, tunics, and flowered ornaments to the deity. The next year, 5 House (1121), on the day 13 Movement, Lord 4 Wind made offerings to Lord 13 Movement, probably another deified founding figure.

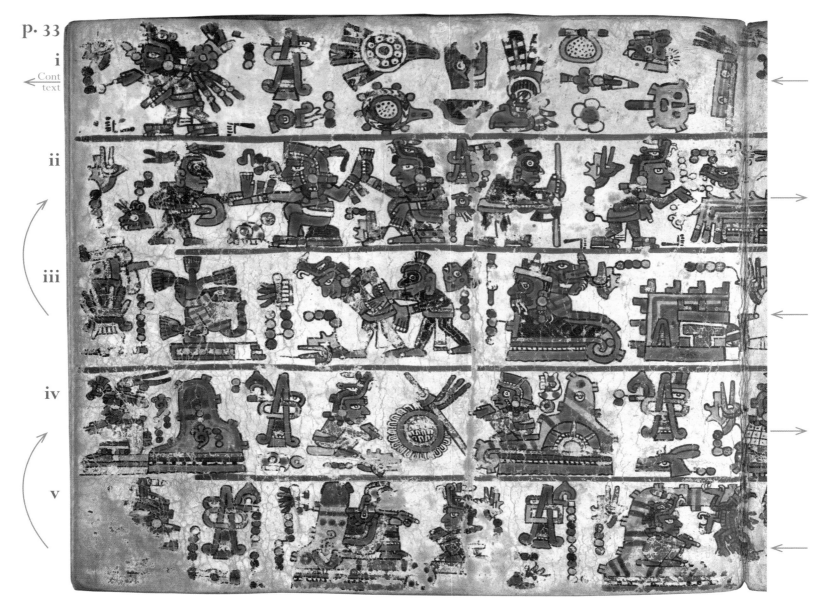

p. 33
i
← Cont text
ii
iii
iv
v

p. 34-ii/iii (right side) The following day, 11 Deer, Lady 6 Monkey married Lord 11 Wind 'Blood Jaguar' of Town of the Red and White Bundle. Two sons were born: Lord 4 Wind 'Fire Serpent' in the year 2 Flint (1092) and Lord 1 Alligator 'Eagle of the Ballcourt' in the year 4 Rabbit (1094).

p. 34/33-v In the Year 9 Reed (1099), Lord 11 Wind 'Blood Jaguar' died. Some years later, on the day 12 Monkey of the Year 11 House (1101), Lord 8 Deer 'Jaguar Claw' attacked Town of the Red and White Bundle. The two princes, Lord 10 Dog 'Venerated Eagle' and Lord 6 House 'Rope, Flints', children of Lord 11 Wind's first marriage, were taken prisoner. Other codices depict their execution and the killing of the queen, Lady 6 Monkey.

Lady 6 Monkey's son, Lord 4 Wind 'Fire Serpent', a young boy of seven at the time, managed to escape and hide in a cave. Four days later, on the day 3 Eagle, he went to consult Lady 9 Grass, not in Ñuu Ndaya but in another oracle place. After some time, but still in the year 11 House (1101), on the day 4 Movement, Lord 4 Wind consulted with the ancestral spirit Lord 7 Flower.

p. 33-iv/p. 34-iv (left side) In the year 2 House (1105), on the appropriate day 1 Death, Lord 4 Wind laid down his weapons for the Sun God

on Mountain of the Sun. This is probably a general reference to a sanctuary in the mountains, dedicated to the solar deity. Through the intervention of the Sun God, Lord 4 Wind, aged thirteen, could establish himself the next day (2 Deer) at Large Stone of the Fire Serpent. Two Toltec priests—Lord 5 Flower and Lord 5 Vulture—received him and offered him a bow and a tunic, i.e. took it upon themselves to educate him in the art of hunting and the ritual obligations of priesthood.

p. 34-iii (left side)/p. 33-iii The obverse side of Codex Bodley (p. 14-v) depicts the killing of Lord 8 Deer. Codex Iya Nacuaa (Colombino) explains that the ambush was organized by Lord 4 Wind. The reverse of Codex Bodley, however, remains silent about this crucial episode. In the Year 2 Rabbit (1118), on the day 6 Monkey, the Toltec ruler, Lord 4 Jaguar, arrived in Ñuu Dzaui as Lord of the Banners, i.e. supreme military commander, holding a precious shield and a wooden sword inlaid with blades of volcanic glass (obsidian). Actually it was a punitive expedition to capture the killer of Lord 8 Deer, but this aspect is left unclear in Codex Bodley's account.

Lord 4 Jaguar persecuted Lord 4 Wind, who escaped by hiding first in a steambath, then behind Black Rock, the land of the ancestor Lord 4 Reed 'Rain'. There he hid like a lizard, difficult to catch, making fun of his persecutors. At one moment

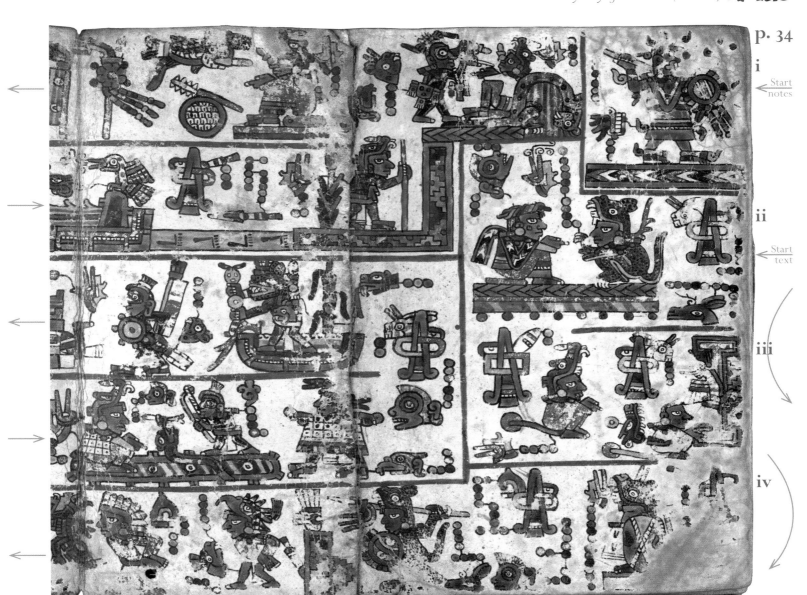

p. 34

i

Start
notes

ii

Start
text

iii

iv

Lord 4 Jaguar succeeded in catching the fugitive but, during the next days, 7 Grass and 8 Reed, Lord 4 Wind escaped again, by climbing in a tree as a lizard, making fun of his persecutors, or hiding amid the bushes and palm leaves.

p. 33-ii/p. 34-ii (left side) This hide-and-seek went on until the Sun God, Lord 1 Death, decided to stop it. He (i.e. a priest of the Sun God) arranged a meeting, where Lord 4 Jaguar arrived without arms, as an ambassador, with a fan in his hand. The god took both adversaries by the hand and made them reconcile. Apparently Lord 4 Jaguar had become tired of chasing Lord 4 Wind and had seen that a dangerous power vacuum was developing in the Ñuu Dzaui area: nobody actually had the influence or capability to take Lord 8 Deer's place. Although his first reaction had been one of feeling offended by the murder of his ally, he now saw another solution: simply to accept the murderer as the new strong man in the region.

On the day 10 Rain of the year 3 Reed (1119), Lord 4 Wind, accompanied by a Toltec ambassador, set out for Tollan-Cholollan, i.e. Cholula in Central Mexico. The next day, 11 Flower, has been added. Leaving the Ñuu Dzaui region, Lord 4 Wind honoured the memory of Lord 5 Alligator. Thirteen days later, on 11 Reed, he crossed the Yuta Ndeyoho or Huitzilapan, the river that gave its name to Puebla, and arrived in the Toltec capital. There he underwent the nose-piercing ritual, on the

first day of the next thirteen-day period, 1 Vulture. It was Lord 4 Jaguar himself who directed the ceremony and placed the turquoise ornament in his nose.

The power Lord 4 Wind received was expressed in a series of impressive titles, which describe the different roles and activities of Ñuu Dzaui rulers: He Who Received Shield and Lance (symbols of military prowess and valour), He Who Holds the Sacrificial Knife, He Who Holds the Staff of Authority (an emblem of the Ñuu Tnoo dynasty), Lord of the Feathered Banner, i.e. supreme war commander, Head of Stones and Sticks (the one in charge of punishment), Jaguar Head, i.e. head of the jaguars, leader of the jaguar warriors, He in Charge of the Bag with Powdered Tobacco (for fasting and visionary rituals), Keeper of the Flowered Arrow (possibly the one who held the power of declaring flower war and of realizing arrow sacrifice), He Who Has Access to the White Flower (probably the hallucinogenic datura), Eagle Head, i.e. head of the eagle warriors, Keeper of the Eagle Feathers (for the warrior rituals), He Who Carries the Lizard Bag (containing the eagle-down balls for sacrifice), He Who Controls the Black Ointment (for priestly functions), He in Charge of the War Brazier, He in Charge of the Round Stone Altar (to execute prisoners of war).

Three days later, on the day 4 Rain of the year 3 Reed (1119), Lord 4 Wind, carrying the staff of authority, set out on his way back to the Mixtec Highlands.

p. 35

i

← Cont
notes

ii

← Cont
text

iii

v

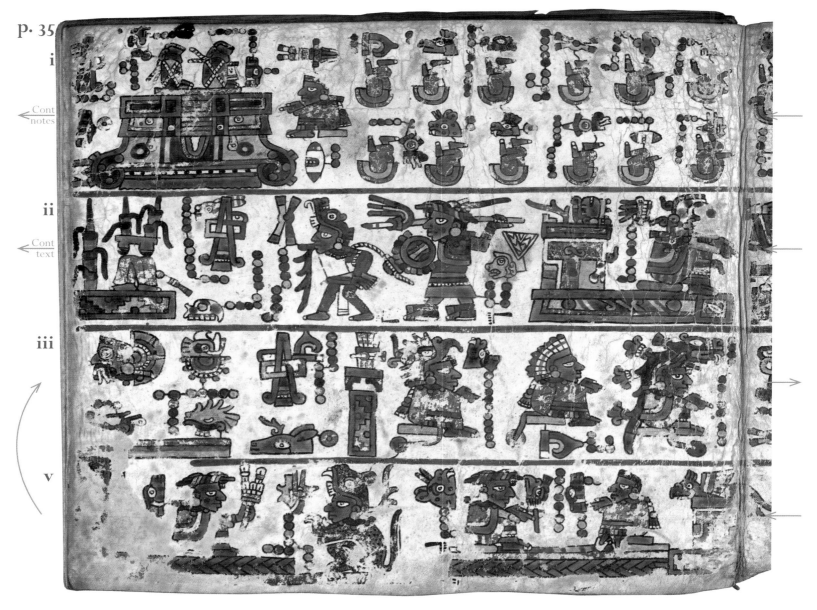

p. 36/35/34–i A fifth and final note is again set in Town of the Red and White Bundle. Lord 3 Flint celebrated here an important ritual in commemoration of the death of the ancient rulers of Monte Albán. In the nine-day period between 1 Lizard and 9 Grass of the year 6 Reed, he made a visit to Lady 9 Grass 'Death Goddess', the awe-inspiring Spiritual Guardian of the Vehe Kihin, the Funerary Cave in Ñuu Ndaya (Chalcatongo). In Place of the White Flower, probably a place within the territory of Town of the Red and White Bundle, Lord 3 Flint entered a subterranean passage, followed by his next of kin: his sister Lady 12 Flower, his brother Lord 9 Wind, and his sister Lady 9 Rabbit. Moreover he was assisted on that occasion by two other important priests: Lord 10 Rain 'Jaguar' from the Mountain of the Turkey and Lord 2 Dog from Death Town, Ñuu Ndaya, who also were accompanied by members of their families. All came in pairs, each consisting of a man and a woman. Lord 10 Rain 'Jaguar' brought his parents, Lord 7 Flower and Lady 5 Flint, as well as his brother, Lord 1 Dog, and two of his sisters, Lady 12 Movement and Lady 11 Serpent. Similarly the priest, Lord 2 Dog, brought his brother, Lord 4 Rain, and two of his three sisters, Lady 2 Jaguar and Lady 4 House.

After having passed through the subterranean passage, Lord 3 Flint arrived in front of the mummy bundles of Lord 12 Lizard and Lord/Lady 12 Vulture, who were venerated on altars. They had ruled in Monte Albán (see Codex Bodley, p. 3-ii). Maybe it was during this assembly, in front of the mummies of the ancient rulers, that Lady 12 Serpent 'Blood Knife' and Lord 7 Movement 'Face of the Earth' were declared the rulers of Town of the Red and White Bundle. At the same time, marital arrangements may have been made for their son and grandson. As a result an alliance was forged between their dynasties, that of Monte Albán and that of Ñuu Tnoo. The pivotal people in this political project were the three daughters of Lady 1 Vulture 'Cloud Jewel' and Lord 4 Rabbit 'Jaguar That Carries One Alligator in his Breast', established at Monte Albán (Codex Bodley, pp. 3-i, 4-iv and 4-v).

p. 36/35–iv Lord 9 Deer 'Jade Bone, Flute', the son of Lord 7 Movement 'Face of the Earth' and Lady 12 Serpent 'Blood Knife', married Lady 10 Alligator 'War Jewel' in Mountain of Pearls, probably Nuu Siya (Tezoatlan). She was the second daughter of Lady 1 Vulture 'Cloud Jewel' and Lord 4 Rabbit 'Jaguar That Carries One Alligator in his Breast', rulers of Monte Albán. Lord 12 Lizard 'Arrow Feet', the son of Lady 10 Alligator and Lord 9 Deer, succeeded his grandparents in Town of the Red and White Bundle, and ruled in Town of the Quetzal Temple, possibly Ñuu Ndodzo (Huitzo). He married Lady 5 Jaguar 'Quetzal Fan', the younger sister

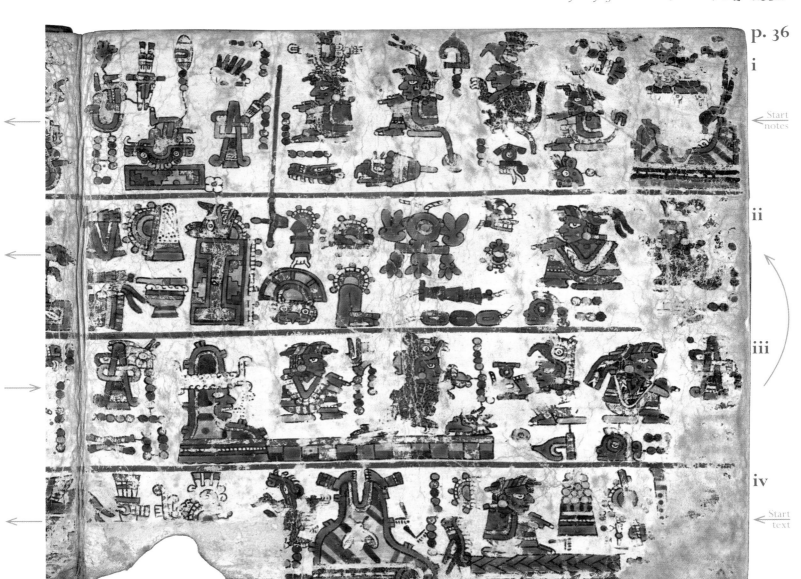

p. 36

i

Start
notes

ii

iii

iv

Start
text

of his mother. Their son was Lord 11 Wind, who married Lady 6 Lizard 'Jewel Fan', a daughter of the first marriage of Lord 5 Alligator, i.e. a half-sister of Lord 8 Deer (Codex Bodley, p. 8-iv). The matrimony was celebrated on the day 1 Deer of the year 10 House (1061); the bride was fourteen years old.

p. 35/36-iii They became rulers of Town of the Red and White Bundle, where three children were born to them: Lord 10 Dog 'Venerated Eagle', Lord 6 House 'Rope, Flints' and Lady 13 Serpent 'Flowered Serpent'. Some years later, it seems, Lady 6 Lizard died and Lord 11 Wind arranged a second marriage. Thus on the day 8 Movement of the year 13 Rabbit (1090), he sent a marriage ambassador, Lord 1 House 'Owl', with gifts of jade and gold, to the rulers of Añute, Lord 10 Eagle 'Stone Jaguar' and Lady 9 Wind 'Flint Garment', to ask for the hand of their daughter, Lady 6 Monkey.

p. 36/35-ii After the bride's parents had given their consent, Lord 11 Wind and Lady 6 Monkey went to the Temple of Death (Vehe Kihin) of Ñuu Ndaya (Chalcatongo) to offer precious gifts to Lady 9 Grass. The day has been scratched out. Several of the gifts were clearly related to the infernal atmosphere: jewels representing

a skull and a heart, a 'bat ballgame' with an 'owl ring'. The jewels were explicitly characterized as coming from Sand Mountain, i.e. the village-state of Añute. Other codices state that Lady 6 Monkey had visited this same funerary cave before, in the year 6 Reed (1083) day 6 Serpent, together with Lord 8 Deer (Codex Bodley, p. 9-iv). On that occasion, Lady 9 Grass had ordered her to marry Lord 11 Wind. Now the couple returned to express their gratitude and respect to the Spirit of the Cave.

On the day 10 Death of the year 13 Rabbit (1090), Lady 6 Monkey took a prisoner, Lord 10 Movement, when she conquered Place of Reeds, probably Yucu Yoo (Acatepec), a stronghold on the northern part of Monte Albán, overlooking the Valley of Oaxaca. Codex Añute (Selden) tells this story in much more detail, relating that priests from Zaachila had shouted, 'Thou shalt die by a knife' to the princess as she passed by on her way to the town of her future husband. Lady 6 Monkey interpreted these words as an insult or threat and killed the priests. In retrospect this seems to have been an act of tragic irony: she was indeed going to be killed because of this marriage. Episodes such as these strongly suggest that the codices were literary compositions meant to be the point of departure for public declamation and dramatic performance. The emotional impact of this form of storytelling helped to create a strong sense of communal cohesion and identity.

p. 37

i

←Cont notes

ii

iii

v

←Cont text

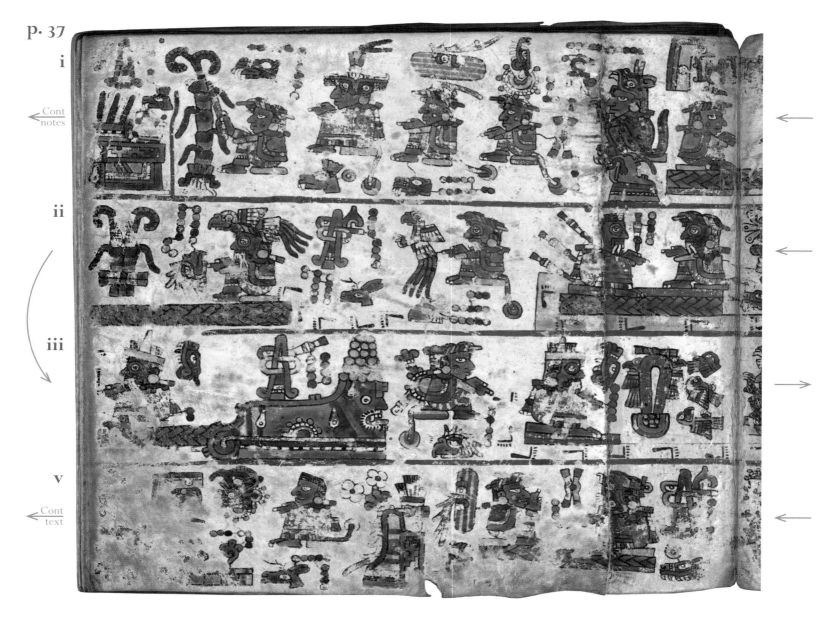

p. 38/37–ii His bride belonged to a dynasty with the sacred date year 5 Rabbit, day 7 Jaguar. The founders were Lord 7 Movement 'Rain, Visible Maize Flower', who held the titles 'Jaguar, Jade Toad, Turquoise Frog', and Lady 7 Grass 'Rain, Maize Tooth [i.e. maize kernel]'. The names and titles of both clearly refer to the symbolic sphere of the Rain God and agriculture. The couple had sprouted from the Mountain of the Feather Ornament, a precious place (of jade and gold), a place protected by the magic of the visionary beings, Coyote Serpent and Blood Serpent. It was their daughter, Lady 3 Serpent 'Flower of the Rising Deity (the East)', who would marry Lord 5 Reed. This couple had a daughter: Lady 13 Eagle 'Bird with Precious Tail'. The date for her marriage is given as the day 12 Deer of the year 8 House. The equivalent of this year would be AD 877 or 929, neither of which fit into the sequence of year dates here. A good solution would be to correct the year to 9 House (917). Lady 13 Eagle's marriage is further characterized by a big stalk of maize with flowers and cobs. The multiple references to maize establish a contrast between this family and that of Lady 9 Alligator and Lord 5 Wind of Yuta Tnoho, who had been qualified as 'rabbit and deer'. The account indicates that the early rulers were nomadic hunters and that the intermarriage with the noble house of Lord 7 Movement and Lady 7 Grass introduced them to maize cultivation.

p. 37/38–iii Lady 13 Eagle's husband was Lord 5 Alligator 'Rain'. He had been born in the year 8 Reed (903) and came from the precious Mountain of Pearls

with Face, which may represent Nuu Siya (Tezoatlan) in the Mixtec Lowlands. Lady 13 Eagle and Lord 5 Alligator had a daughter: Lady 6 Eagle 'Jewel, Flower'. When the time came for her to marry, her father, Lord 5 Alligator, received the visit of Lord 2 Rain 'Jaguar, Sun'. He did not come empty-handed, but offered a large number of birds that he had shot with his blowgun when they were perched on a tree on the Hill of Vapours in the territory of the Rain God, i.e. in Ñuu Dzaui. Apparently this is a brief reference to the difficult task that he had to accomplish in order to be deemed worthy to receive the hand of Lady 6 Eagle.

It is further stated that Lord 2 Rain had been born from an arrow thrown by the God of the Morning Star, Lord 1 Movement, into Mountain of the Brazier and the Jaguar. The arrow of a celestial deity may be understood as a metaphor for a ray of light. Thus, Lord 2 Rain was a 'Child of (the first) Light'. In other words, he belonged to the people created at the beginning of history. The sacred foundation date of this place included the day 1 Alligator, the first day of the calendar. The area where the year sign should be has been damaged. It is likely to be year 1 Reed, day 1 Alligator, which is a frequently occurring metaphoric date for 'beginnings'.

p. 38/37–iv In the year 4 Rabbit (938) Lady 6 Eagle and Lord 2 Rain had their first child: Lord 7 Movement 'Earth Face'. In the following years, 6 Flint (940) and 9 Reed (943), the same couple had a second son, Lord 1 (?) Dog, and a daughter, Lady 5 Reed 'Jewel Pulque-Vessel'. In the Year 5 House (965), on the day 1

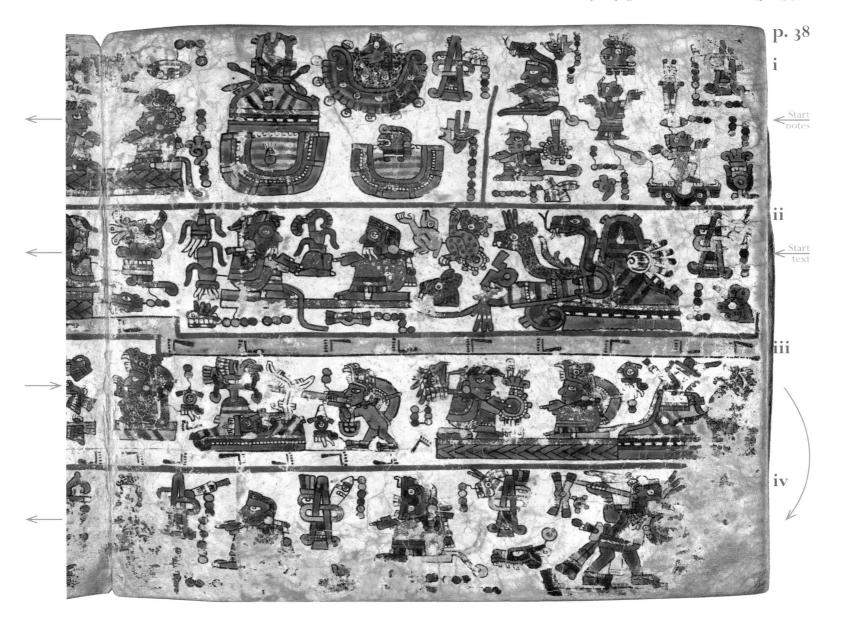

p. 38

i

Start
notes

ii

Start
text

iii

iv

Alligator, the eldest son, Lord 7 Movement, married Lady 12 Serpent 'Blood Knife': they became the rulers of Town of the Red and White Bundle, at that moment allied with the Mountain of Blood and White Flowers. Their son was Lord 9 Deer. Lady 12 Serpent 'Blood Knife' was the daughter of Lord 7 Flower 'Quetzal Jewel' and Lady 5 Flint 'Flaming Heads from Heaven'.

p. 38/37-i A note clarifies the family background of Lady 12 Serpent 'Blood Knife'. She came from a realm that consisted of several places, none of them identified. Its sacred date was year 5 Rabbit day 9 Wind. The founders were Lord 7 Flower 'Quetzal Jewel' and Lady 5 Flint 'Flaming Heads from Heaven'. Their first-born son was Lord 10 Rain 'Jaguar'. He lived at the Mountain of the Turkey and occurs elsewhere as an important priest. He had four sisters: Lady 12 Movement 'Jade Alligator', Lady 12 Serpent 'Blood Knife', Lord 1 Dog 'Feather Ornament, Earth' and Lady 11 Serpent 'Who Hits the Corn Stalk'.

p. 39/38-i This note is preceded by another, describing Lord 3 Flint 'Arrow': he was born from the earth in Town of the Red and White Bundle, related to the Mountain of the Fire Serpent, possibly located in the Valley of Oaxaca. Later the manuscript describes Lord 4 Wind escaping Lord 8 Deer's attack on the Town of the Red and White Bundle by hiding in a cave of the Curved Mountain of the Fire Serpent (p. 33-V). In Codex Tonindeye (Nuttall), p. 19, the Curved Mountain

of the Fire Serpent is part of the complex landscape of Monte Albán. No year of birth is given, only sacred dates: Year 1 Reed (?) day 1 Alligator and Year 13 Rabbit day 7 Flower. Lord 3 Flint's parents are not mentioned: the genealogical record was apparently not preserved or not deemed important. After him were born—supposedly at the same place—Lady 12 Flower 'Precious Seed', Lord 9 Wind 'Serpent', and Lady 9 Rabbit 'Jade with Ribbon'.

p. 37/36-i A fourth note deals with Altar of the Feathers in Valley of the Feathers, belonging to Death Town, Ñuu Ndaya (Chalcatongo). This was the place of origin of Lord 2 Dog, who appears in Codex Yuta Tnoho (Vindobonensis) as an important primordial priest, who participated in the founding of the Ñuu Dzaui communities. The associated date is badly damaged: a day 2 (?) Dog in a year Reed. Again, there is no earlier genealogical record: Lord 2 Dog's parents are not mentioned, only his brother and sisters: Lady 2 Jaguar 'Flower of (town of) Death', Lord 4 Rain 'Quetzal Jaguar', Lady 4 House 'Quetzal Flower Fan' and Lady 10 Alligator 'Jade, Gold'. These first four pages of the reverse side of Codex Bodley present the ancient and complex origin of the dynasty of the Town of the Red and White Bundle. This was the background of Lord 4 Wind, who was seen as the founder of the mat and throne of Ndisi Nuu. The different 'notes' suggest that the painter-historian had access to very old documents. He incorporated them to emphasize the ancient roots of what in reality was a rather young dynasty.

p. 39

i

← Cont
notes

ii

← Cont
text

iii

v

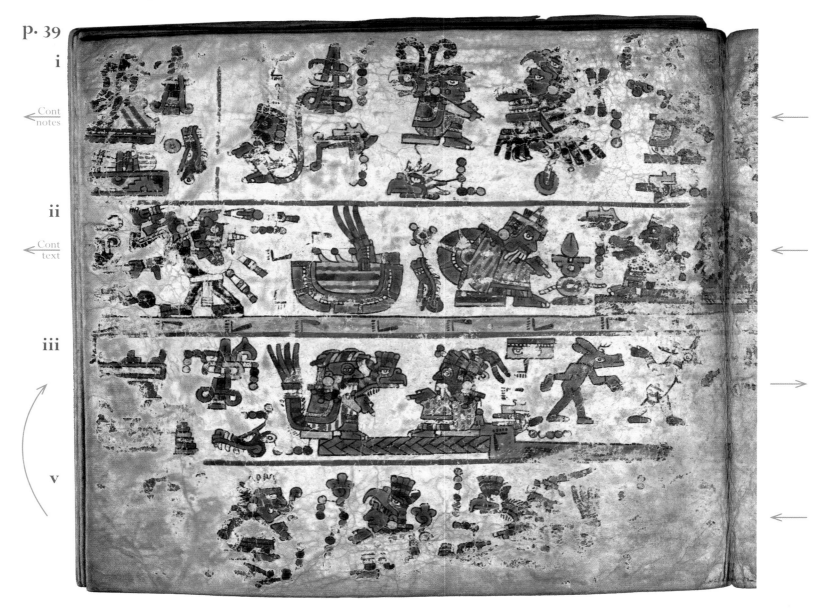

The layout of captions in English, reading left to right, is hard to match with the images of Book II which read from right to left. The images must be read two pages at once, across the opening. The English captions for each opening always start on the left-hand page.

old Lord 4 Alligator and Lord 11 Alligator, who approached them as ambassadors to arrange the marriage for Lady 9 Alligator. They had been sent by the parents of the prospective groom, the rulers of Carrying Frame and Sweatbath, i.e. Ñuu Niñe (Tonalá) in the Mixtec Lowlands.

START: p. 40/39-iv The beginning of this part has been heavily damaged, but can be reconstructed to a large extent with the help of other Mixtec codices. As on the obverse, the opening scene contained a sacred date. Lord 1 Flower 'Quetzal' and Lady 13 Flower 'Quetzal' were born in the Place of the Two Rivers, Yuta Tnoho. Their daughter was Lady 9 Alligator 'Rain, Plumed Serpent'. The father and mother, Lord 1 Flower and Lady 13 Flower, listened to the words of the

p. 40/39-i A special note at the top of the page gives additional information about the royal family of Ñuu Niñe. Its sacred foundation date contained the day sign Flower, probably with the number 7. The founders of the dynasty were Lord 8 (?) Alligator 'Coyote, Bird' and Lady 7 Flower 'Quetzal', born from Earth: their names represent successive days in the calendar. On the day 9 Wind of the year 6 Flint, Lord 9 Wind 'Flint Serpent' was born. He later married Lady 4 Wind 'Orna-ment of Flowers'. Their son was Lord 4 Movement 'Eagle', who married Lady 6

p. 40

i

Start
notes

ii

iii

iv

Start
text

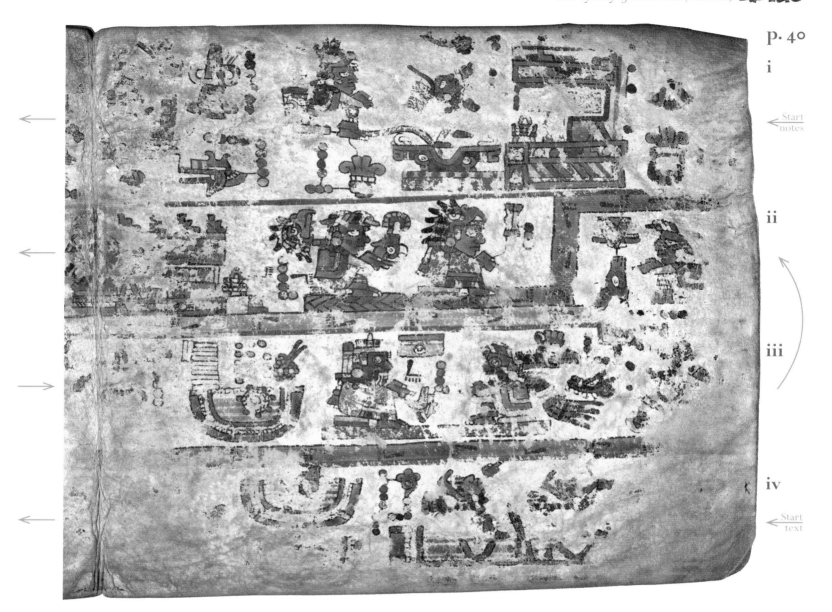

Eagle 'Parrot-Maize Flower': they were the parents of Lord 5 Wind 'Rain That Came Down from Heaven', born in the Year 5 Reed. This date may well be historical as it fits the chronological sequence: if so, it would correspond to 835 AD.

p. 39/40–iii Lord 5 Wind married Lady 9 Alligator, whose parents were from Yuta Tnoho (Apoala). The associated year is 7 House, which we propose to change into 8 House (877). Both Lady 9 Alligator and Lord 5 Wind are wearing the mask of the Rain God. This may be interpreted as a name-element, but also connects them to the Patron Deity of Ñuu Dzaui. As this is a detail they have in common with most people represented in this codex, it suggests an emphasis on the fact that they belonged to the Ñuu Dzaui people and were devotees of the Rain God. Moreover, they are called 'people that were like rabbits and deer', i.e. wandering people, living

in the mountains. An offering was made at the river: paper, beads, a rosette of leaves, and a jewel were deposited there. This is probably a reference to the cult rendered to these important ancestors. Lord 5 Wind and Lady 9 Alligator had two children: Lord 5 Reed 'Arrows in the Back' and Lady 8 Deer 'Decorated Garment'.

p. 40/39–ii Lady 8 Deer went to see her paternal grandparents, Lord 4 Movement 'Eagle' and Lady 6 Eagle 'Parrot-Maize Flower', rulers of Ñuu Niñe; she would later become the ruler of that village-state. Lord 5 Wind was approached by a 'marriage ambassador', Lord 1 Alligator 'Rain Sun', who arrived with a gift of tobacco and cacao, jade and gold, to ask for the hand of his son. After having made the arrangements, Lord 5 Reed was carried by another ambassador, the priest Lord 1 Wind 'Wind', from Yuta Tnoho to the home of his bride.